abcdefghijklmnopqrstuvwxyz

ABC CANADA

The first Canadian collection
of contemporary calligraphy

Even a fool, if he keeps silent, is considered wise; if he closes his lips, intelligent

Death and Life
are in the
power
of the tongue

Fine
words are out of
place
in a fool

A · WORD · SPOKEN
IN · DUE · SEASON
HOW · GOOD · IT · IS

Power of
Words

Like golden apples in
silver settings are
HE · WHO · SPARES · HIS · WORD · IS
TRULY · WISE · AND · HE · WHO · IS · CHARY · OF · SPEECH · INTELLIGENT
words spoken at the proper time
IVAN ANGELIC © 1996

IVAN ANGELIC. *POWER OF WORDS*. Pointed brush, Brause and Mitchell nibs, Copperplate nibs, gouache on Grandee Cover. 45 x 30 cm.

CANADA

The first Canadian collection
of contemporary calligraphy

Lindley McDougall

Arbor Studio Press

ABC Canada:
 the first Canadian collection
 of contemporary calligraphy

Copyright 1996 ©
Lindley McDougall

Arbor Studio Press Ltd.
Box 81091, Lake Bonavista Promenade
Calgary, Alberta, Canada T2J 7C9

(403) 271-1731 FAX (403) 278-4327

For ordering information, please see page 165.

Canadian Cataloguing Publication Data

McDougall, Lindley, 1948-
 ABC Canada

 Includes bibliographical references and index.
 ISBN 1-896160-01-8

 1. Calligraphy--Canada. I. Title.
Z43.M32 1996 745.6'1'0971 C96-910208-9

All artwork dimensions are in centimetres,
width x height, unless otherwise noted.

Associate Editor: Patti Duddridge Riegert
Layout and design: Lindley McDougall
Typography: Patti Duddridge Riegert
Design consultant: Lynda Boesenkool

Printed and bound in Canada
by Friesens Corporation

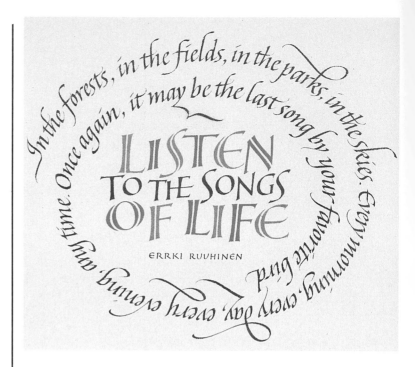

This book is dedicated to the memory of six Canadian calligraphers whose work and teaching have inspired many others.

ESMÉ DAVIS, VICTORIA
(1910 - 1988)

DONNA DUNCAN-REILLY, CALGARY
(1951 - 1996)

ALF EBSEN, TORONTO
(1908 - 1994)

STAN JONES, VANCOUVER
(1948 - 1995)

JOHN WHITEHEAD, OTTAWA
(1929 - 1995)

WENDY WILSON, VANCOUVER
(1922 - 1994)

CONTENTS

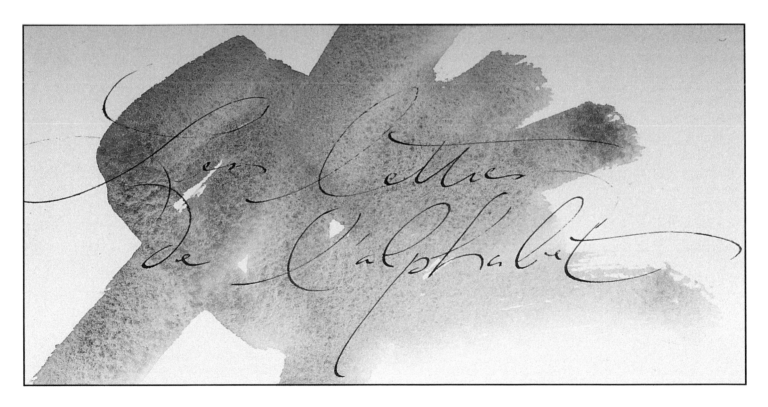

(left)
FRED SALMON. Pointed brush, Mitchell nib, gouache and FW inks; gold leaf on gesso; Arches hot pressed watercolour paper. Author: Errki Ruuhinen.

(above)
GINETTE MORIN.

ACKNOWLEDGEMENTS

Each person who submitted work to *ABC Canada* spent many hours organizing, photographing and documenting artwork; composing a biographical statement; mailing, faxing and phoning us with additional information and material; and responding to our editorial processes.

Betty Locke, Fred Salmon and the late Stan Jones gave me valuable advice. They also promoted the project and encouraged calligraphers to submit their work.

Ross McDougall, Merle Harris, Doug McArthur, Mavis Lueck, Jim Beckel, Karyn Lynn Gilman, Joanne Fink, Richard Riegert, Colin Bate and Lynda Boesenkool never hesitated to answer my questions or give me their opinions.

Patti Riegert's intelligence and efficiency have made a daunting task go smoothly, and her wit and enthusiasm make her a joy to work with.

Our families, Ross, Dylan and Katie McDougall; and Richard, Steven and Philip Riegert, have lived with this project on the table, on the stairs and under the bed for nearly two years. They have never once complained, within my hearing.

Many thanks to all, and to my mother, Catherine Shantz.

1
KIRSTEN HOREL. *TEXT AND TEXTURE BOUND* (detail). Artist's book. Acrylics, coloured pencil, gouache, graphite and ink on Arches Text Wove paper. 40 x 30 cm.

2
FRANCIE ALBERTS BREDESON. Pointed pen, Pigma pen, watercolour. 30 x 40 cm. Artist's own words.

3
GAIL STEVENS. *GAIL'S MOTTO*. Watercolour on Roma paper. 10 x 24 cm. Author: George Eliot.

4
PATRICIA C. DUKE. Author: John Ruskin.

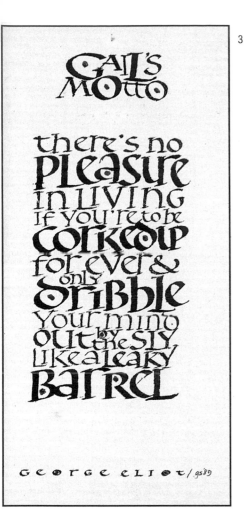

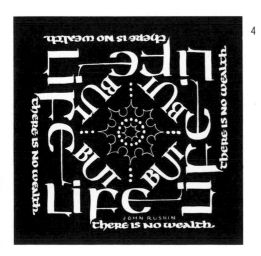

PREFACE

Who are the Canadian calligraphers? What kinds of work are they doing? How do they learn to make beautiful letters and how do they combine their skills with contemporary media and subject matter?

These were some of the questions I hoped to answer as I compiled the artwork and biographies in this book. As an avid reader of Canadian and international publications about calligraphy, I was aware of an increasing level of sophistication in the work that was being exhibited and published. My goal was to contact as many artists as I could and invite them to submit calligraphic artwork to this collection, in hopes of providing a starting point for representing Canadian calligraphy.

A Call for Entries was sent out to all of the calligraphic societies in the country, and a press release went to arts publications in every province and territory. The response was strongest, both in number and in quality, from places where calligraphy societies thrive. As a forum for education and exhibition, these groups provide their members with access to quality instruction, current information and an atmosphere of encouragement and creativity.

Knowledge of letterforms and page design can bring the confidence necessary to experiment. Gestural strokes and innovative tools have become as much a part of calligraphy as carefully made letters and traditional techniques. For many of us, the search for lively, graceful letters is an endless and exciting quest. The letters themselves are the vehicle for our voices, and we invite you to look and listen.

Lindley McDougall
Calgary, 1996

GALLERY I

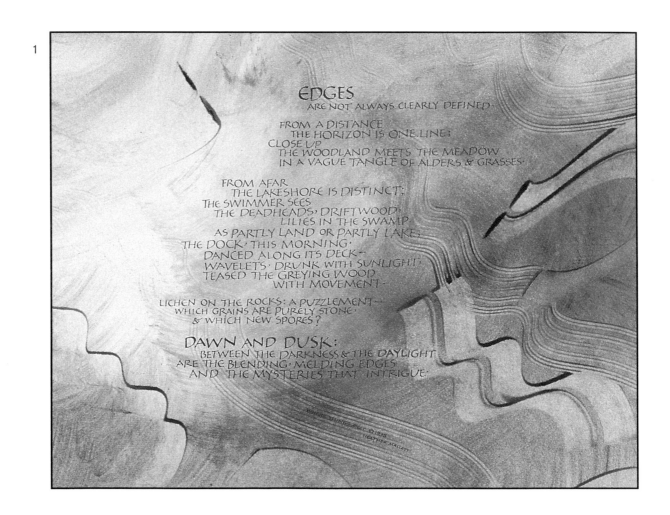

1

EDGES
ARE NOT ALWAYS CLEARLY DEFINED·

FROM A DISTANCE
THE HORIZON IS ONE LINE;
CLOSE UP
THE WOODLAND MEETS THE MEADOW
IN A VAGUE TANGLE OF ALDERS & GRASSES·

FROM AFAR
THE LAKESHORE IS DISTINCT;
THE SWIMMER SEES
THE DEADHEADS, DRIFTWOOD,
LILIES IN THE SWAMP
AS PARTLY LAND OR PARTLY LAKE;
THE DOCK, THIS MORNING,
DANCED ALONG ITS DECK—
WAVELETS· DRUNK WITH SUNLIGHT·
TEASED THE GREYING WOOD
WITH MOVEMENT·

LICHEN ON THE ROCKS: A PUZZLEMENT—
WHICH GRAINS ARE PURELY STONE·
& WHICH NEW SPORES?

DAWN AND DUSK:
BETWEEN THE DARKNESS & THE DAYLIGHT
ARE THE BLENDING, MELDING EDGES
AND THE MYSTERIES THAT INTRIGUE·

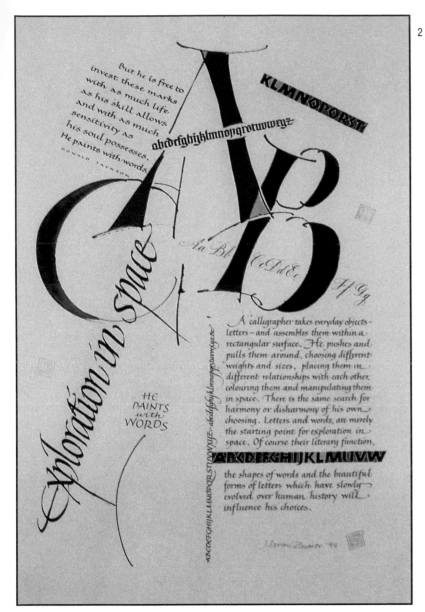

2

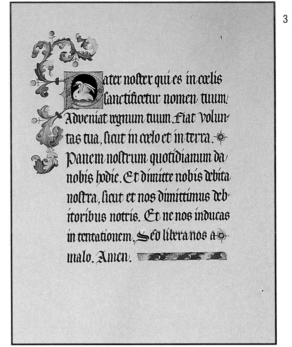

3

4

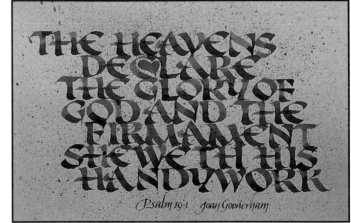

1
HEATHER MALLETT. *EDGES*. Paste paper. 40 x 30 cm. Artist's own words.

2
MARION ZIMMER. *ABC*. Mitchell nibs, gouache, watercolour pencils, collage. 50 x 65 cm.

3
RONALD MARSHALL. *PATER NOSTER*. Steel nibs, brushes, gouache and gold leaf on gum ammoniac. *Designed in the style of Les Très Riches Heures de Jean, Duc de Berry.*

4
JOAN GOODERHAM. *THE HEAVENS DECLARE*. Mitchell nibs, gouache and watercolour on Diploma Parchment paper. 30 x 20 cm. Text: Psalm 19:1.

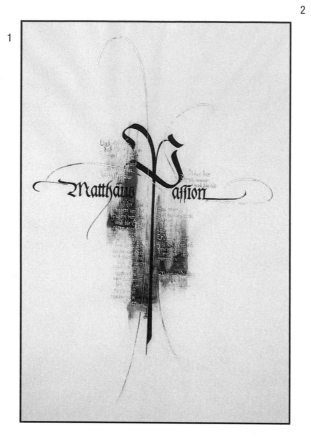

1

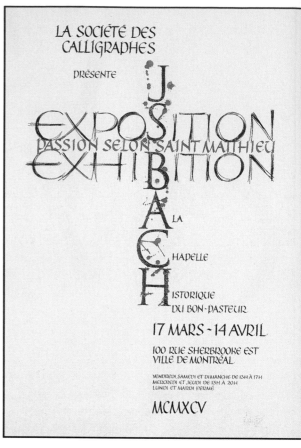

2

1
YANNICK DURAND. *CET HOMME ÉTAIT LE FILS DE DIEU.* Brause nibs, ink, gouache and gold leaf on goatskin parchment.

2
KATHY FEIG. *PASSION SELON ST-MATTHIEU.* Quill, steel nib, ruling pen, gouache and gold leaf on goatskin parchment paper. 48 x 62 cm. *Designed for an exhibition on the theme of J.S. Bach and the St. Matthew Passion, this artwork was chosen for the invitation and the program booklet.*

3, 4
TRUDY NOVACK. *INSPIRATION 1 AND 2* Diptych. Ruling pen on Arches watercolour paper. 70 x 55 cm. *The theme of J.S. Bach and St. Matthew Passion was chosen for an Easter exhibition at La Chapelle du Bon Pasteur. I turned on the music and this was what flowed out of my ruling pen!*

5
ELYSE PROULX. *AVE MARIA.* Watercolour, white gouache, graphite.

6
LUC SAUCIER. *LA PASSION SELON ST-MATTHIEU* Exhibition poster. Automatic and Speedball pens, watercolour and ink on Rives paper. 45 x 60 cm. *An initiative of La Société des Calligraphes, participating members were commissioned to create works based on J.S. Bach's Matthäus-Passion.*

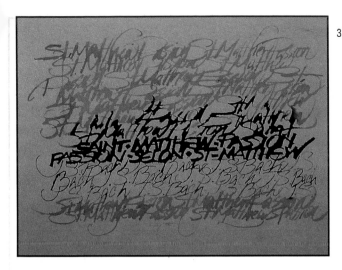

3

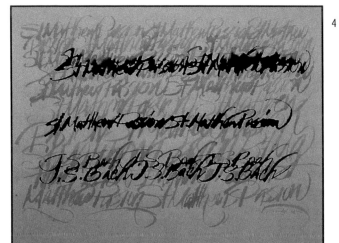

4

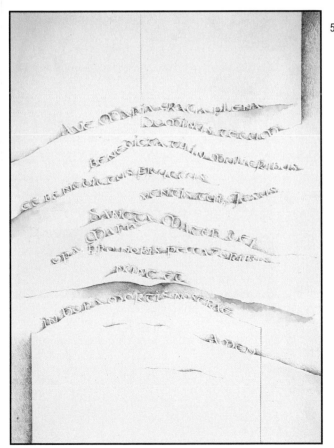

5

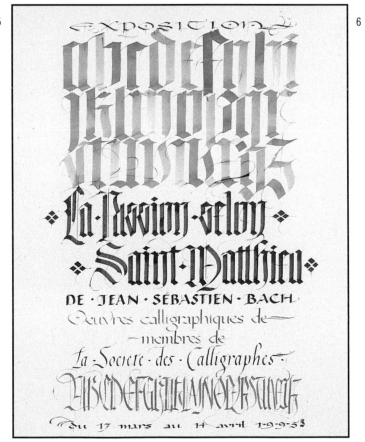

6

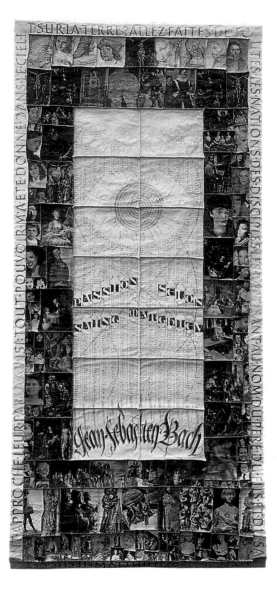

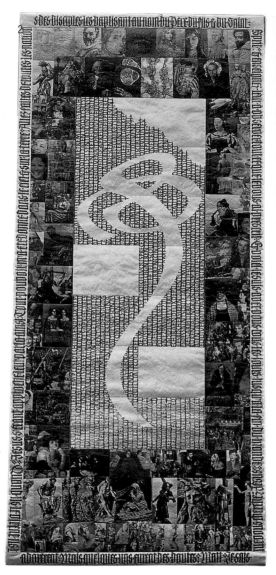

1
JEAN-LUC FERRET. *CONTREPOINTE* (recto). A hanging banner. Ink and gouache on pre-washed paper; cut images sewn together with gold thread. Collaboration with Marguerite Soucy. 45 x 108 cm.

2
JEAN-LUC FERRET. *CONTREPOINTE* (verso).

3, 4
JEAN-LUC FERRET. *CONTREPOINTE* (detail).

5
MARION ZIMMER. *MENORAH*. Mitchell nibs, gouache, markers. 65 x 50 cm.

6
LYNN SLEVINSKY. *AS FOR MAN*. Steel nibs, sumi ink, Rotring ink, coloured pencils and watercolour on Arches hot pressed paper. 49 x 28 cm.

3

4

5

6

AS FOR MAN הוא DAYS ARE LIKE GRASS he flourishes like a flower of the field; the wind blows over it and it is gone, and its place remembers it no more but from everlasting to everlasting, the Lord's love is with them that fear him and his righteousness with their children. Psalm 103: 15-17 Lynn Slevinsky 93

1

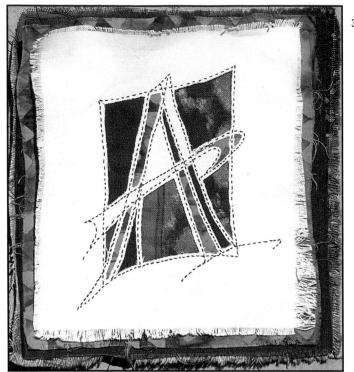

3

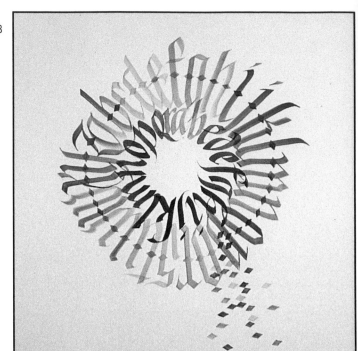

2

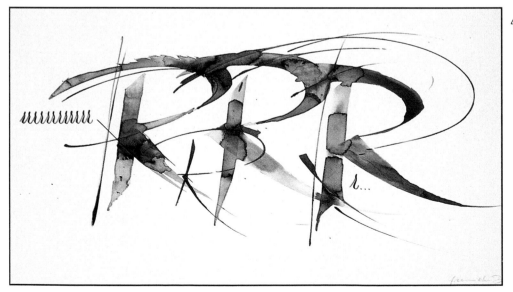

4

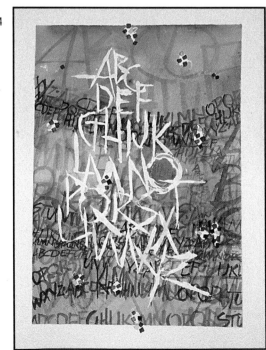

14

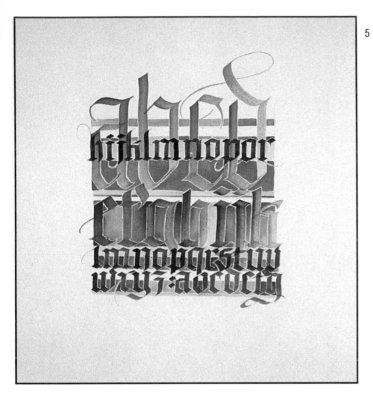

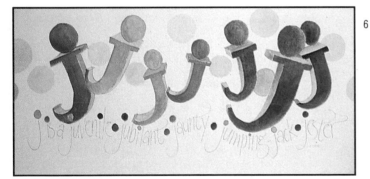

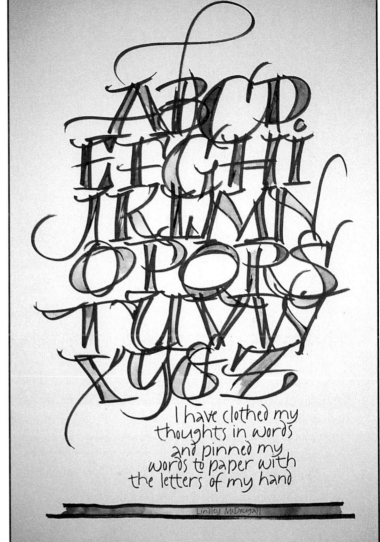

1
CHERRYL MOOTE. *CANADIAN A.* Polished linen, quilting cottons. 14 x 16 cm. *By layering several different materials together and quilting the black outline through all of them, I created a subtractive palette. Using very sharp scissors, I cut away one layer of material at a time, exposing various colours below.*

2
YANNICK DURAND. *R.* Automatic pen, pointed pen, Ecoline inks on Cornwall paper.

3, 4, 5, 6
BETTY LOCKE. *FOUR ALPHABET PAINTINGS.* Watercolour.

7
LINDLEY McDOUGALL. *ALPHABET HAIKU.* Markers, Pigma pen and watercolour on Arches paper. 35 x 45 cm.

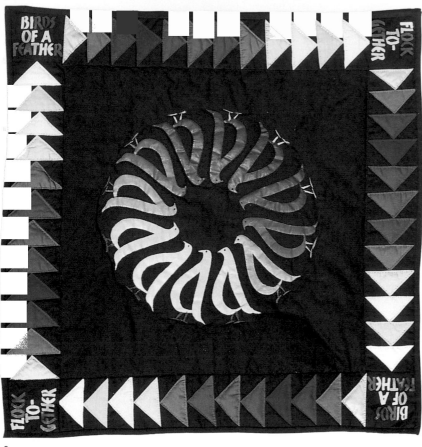

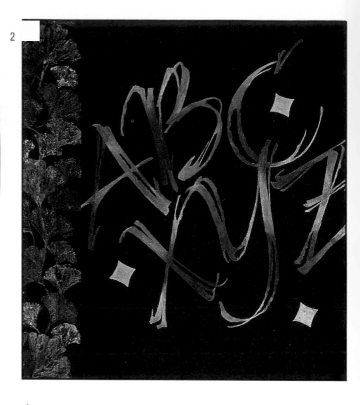

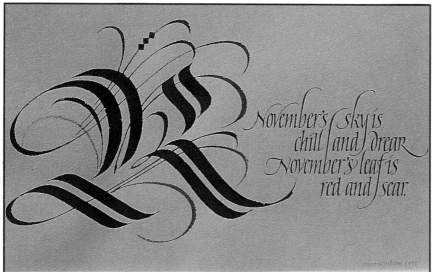

1
CHERRYL MOOTE. *BIRDS OF A FEATHER.* Quilted fabric. Flat brush, acrylic paints, broadcloth. 65 x 65 cm.

2
CINDY ROMO. *ABC XYZ.* Portfolio cover. Designed with ruling pen and ink on bond paper. Rendered with pointed brush and acrylic paint on black fabric. Leaf prints with acrylic paint. 24 x 30 cm.

3
MARTIN JACKSON. *RED.* Reed pen and Mitchell nib, Rotring ink and gouache on Saunders cold pressed watercolour paper. 18 x 32 cm.

4
HOLLY DEAN. *ALPHABET.* Nibs and sticks, oil pastels, metallic gold, gold leaf and acrylic varnish. Letters scraped out of mixed media ground. 50 x 40 cm.

5
YANNICK DURAND. *ABÉCÉDAIRE.* Automatic pen, Ecoline inks, Canson paper.

6
LYNN HOLLIWELL LEFLER. *ALPHABET ZTEW.* Coloured pencil on Ingres paper. 32 x 25 cm.

4

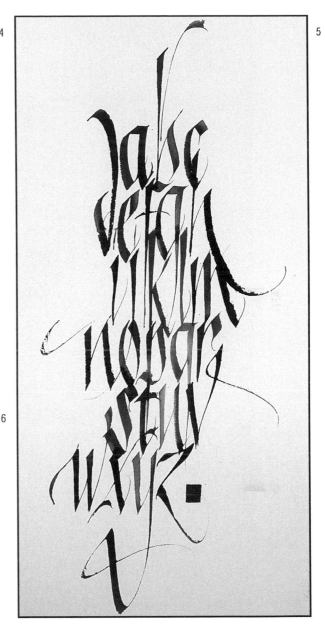

5

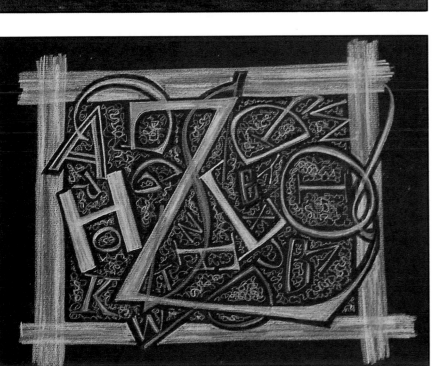

6

17

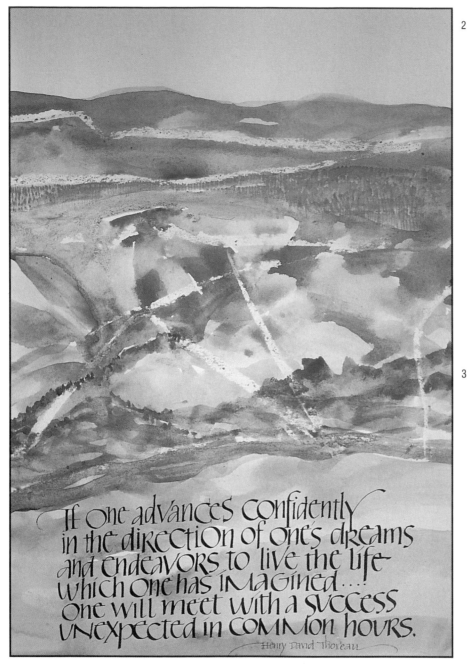

If one advances confidently
in the direction of one's dreams
and endeavors to live the life-
which one has imagined....
one will meet with a success
unexpected in common hours.

Henry David Thoreau

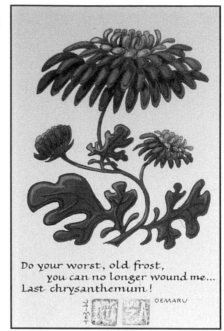

Do your worst, old frost,
 you can no longer wound me...
Last chrysanthemum!

OEMARU

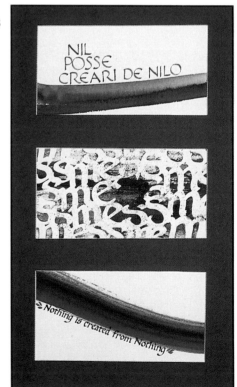

NIL
POSSE
CREARI DE NILO

Nothing is created from Nothing

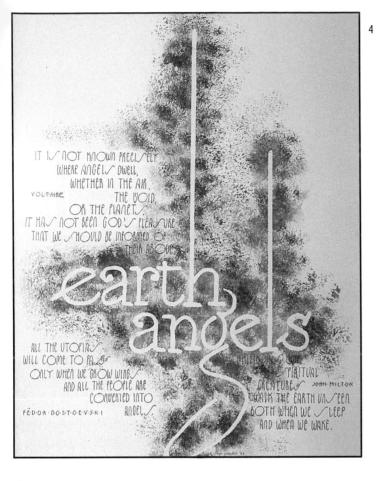

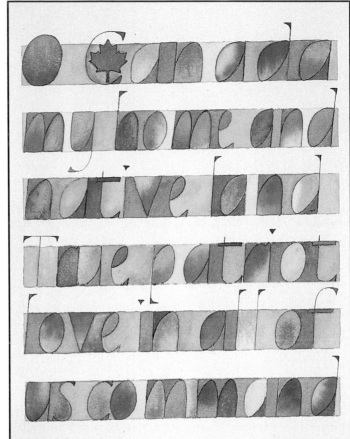

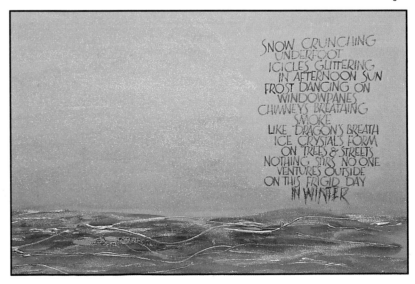

1
JUDITH BAIN DAMPIER. Watercolour, Chinese ink. 30 x 40 cm. Author: Henry David Thoreau.

2
JUDITH JAIMET BAINBRIDGE. *Last Chrysanthemum*. Author: Oemaru.

3
SHANNON READ. *Nothing is Created from Nothing*.

4
GAYE MACKIE. *Earth Angels*. Watercolour crayons, resist, gold gouache on BFK Rives paper. 25 x 35 cm.

5
DIANA HAINES. *O Canada!* We came to Canada by boat, then took the train from Montreal to Edmonton - a perfect way to see our new country. After many days of grey sea and fog, we were greeted by the colours of Canada in the fall, which I have tried to re-create in this piece.

6
MARGARET VAN DIEST. *Winter*. Gouache and silver fabric paint on watercolour paper. 40 x 30 cm. Artist's own words.

1
KIRSTEN HOREL. *SHE OPENED THE DOOR*. Pointed brush, gouache, graphite and acrylic paint on Stonehenge paper. 43 x 43 cm. Artist's own words.

2
LORRAINE DOUGLAS. *THE HAND IS FULL OF MEMORY*. Watercolour, gouache, ink; gold leaf on PVA; on Canson paper. 25 x 15 cm. Text: Kiowa saying.

3
PAMELA BARLOW BROOKS. *W.* Inks and acrylic paints. 30 x 22 cm.

4
BEANY DOOTJES. *MOTHERHOOD* (detail). A medallion design with the artist's name repeated eight times.

5
CHRISTINE MITCHELL. *POSTCARDS*. Pen, brush, rubber stamps, gouache on Lana Laid paper. Artist's friends' words.

6
NICOLE GUYOT COULSON. *JOY AND PEACE*. Chinese ink, watercolour pencils on Arches Text Wove.

1
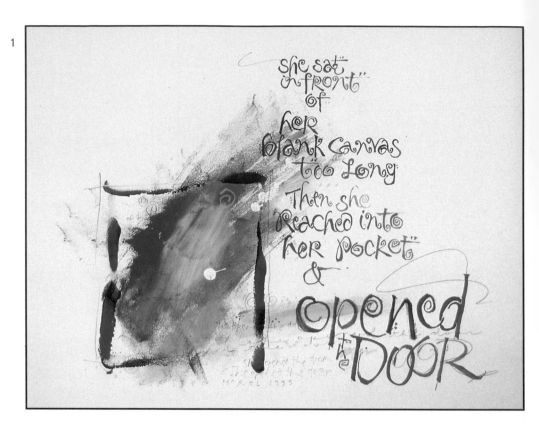

2
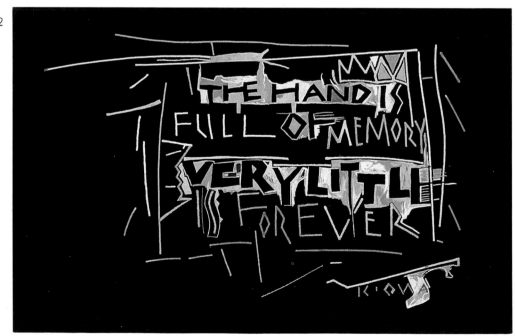

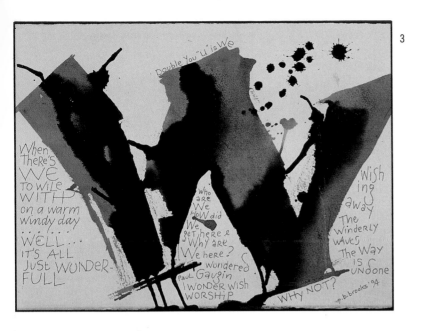

3

When
There's
WE
to wile
WITH
on a warm
windy day
WELL...
IT'S ALL
JUST WONDER-
FULL

Double You "u" is We

Who
are
We
How did
We
get there &
Why are
We here?
...wondered
Paul Gaugin
I WONDER. WISH
WORSHIP

Wish
ing
away
The
winderly
waves
The Way
is
undone

WHY NOT?

-p. b. brooks '94

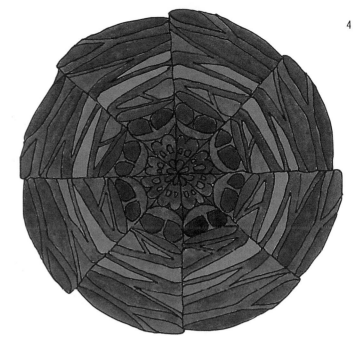

4

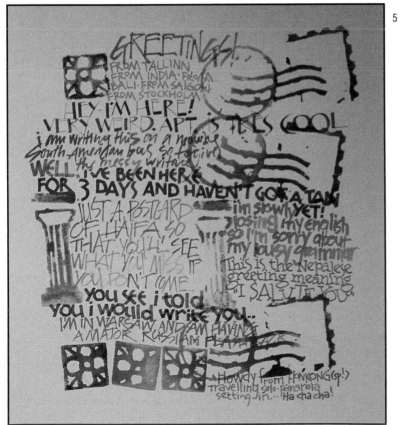

5

GREETINGS!
FROM TALLINN·
FROM INDIA· FROM
BALI· FROM SAIGON·
FROM STOCKHOLM·
HEY· I'M HERE!
VERY WEIRD· APT· IS THIS COOL
I am writing this on a humble
South American bus so forgive
WELL the messy writing·
FOR 3 DAYS AND HAVEN'T GOT A TAN
JUST A POSTCARD i'm slowly YET!
OF HAIFA SO — losing my english
THAT YOU'LL SEE so I'm sorry about
WHAT YOU MISS IF my lousy grammar
YOU DON'T COME This is the Nepalese
greeting meaning
"I SALUTE YOU"
You see i told
you i would write you...
I'M IN WARSAW AND AM HAVING
A MAJOR RUSSIAN FLAVOUR
·Howdy from HONKONG (sp!)
travelling solo· paranoia
setting in... Ha cha cha!

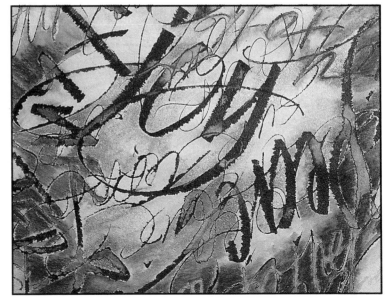

6

1

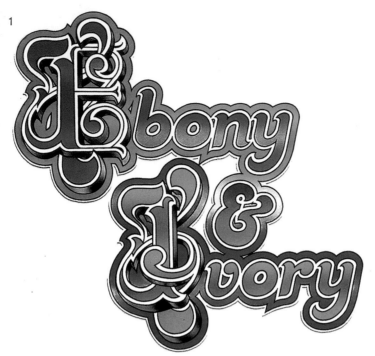

2

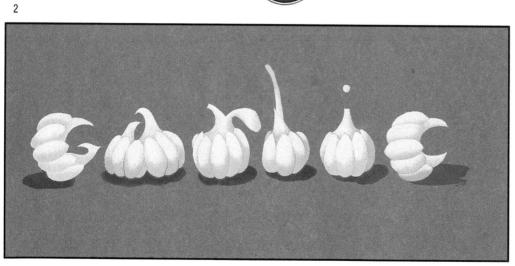

3

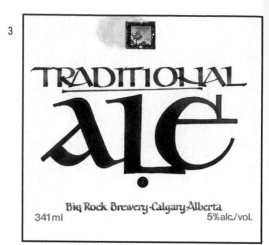

TRADITIONAL
ale

Big Rock Brewery·Calgary Alberta

341ml 5%alc./vol.

4

MAGPiE
rye ale de Seigle

341 ml 5% alc. vol.

Brewed by Big Rock Brewery, Calgary, Alta. Canada.

5

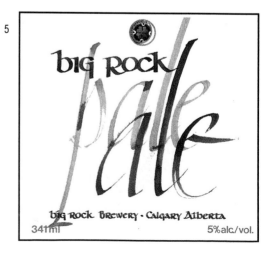

big rock
pale

big rock brewery · calgary alberta

341ml 5%alc./vol.

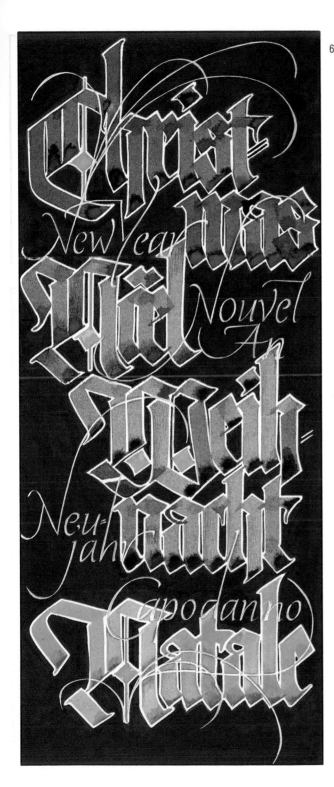

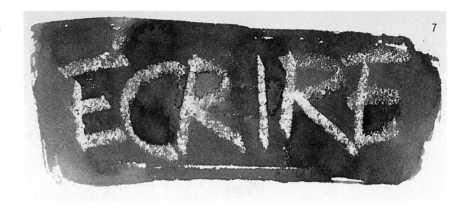

1
KARLA CUMMINS. *EBONY & IVORY.* Design for T-shirt and postcard. Drawn letters coloured with airbrush.
2
MARY CONLEY. *GARLIC.* Dry brush, gouache and stencils.
3, 4, 5
DIRK VAN WYK. Labels for Big Rock Brewery. 8 x 8 cm.
6
MARK LURZ. *CHRISTMAS CARD.* Steel nibs, flat brush, Rotring inks and gouache. 11 x 26 cm.
7
GINETTE MORIN. *ÉCRIRE.*
8
IVAN ANGELIC. *TYING THE KNOT.* Wedding invitation. Lettering drawn with Bullet Tip Marker and technical pen. Printed with rainbow fountain on Confetti cover. Open size 50 x 7 cm.

8

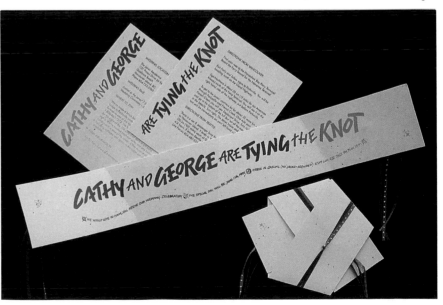

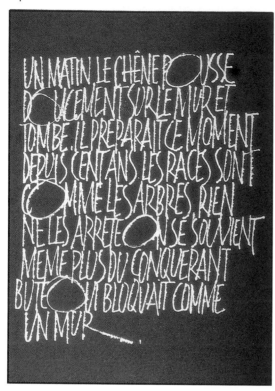

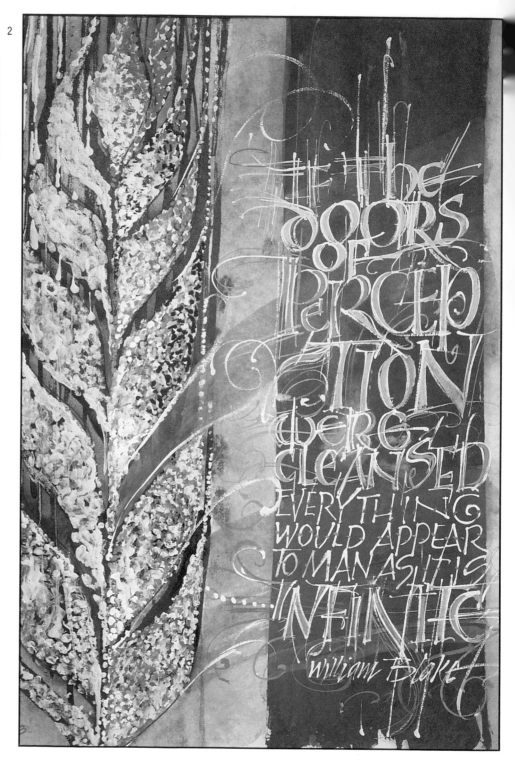

1
GINETTE MORIN. *UN MATIN LE CHÊNE*.

2
JUDITH BAIN DAMPIER. *DOORS OF PERCEPTION*. Chinese ink, Chinese painting colours, Pentel brush, metallic paints. 40 x 53 cm. Author: William Blake.

3
LINDLEY McDOUGALL. *O WONDERFUL!* Chinese ink, Pigma pen, coloured pencil on Mayfair paper. 30 x 30 cm. Author: William Shakespeare.

4
CHRISTINE MITCHELL. *ST. PETERSBURG*. Pen and gouache on mat board. Artist's own words.

THE
CONTRIBUTORS

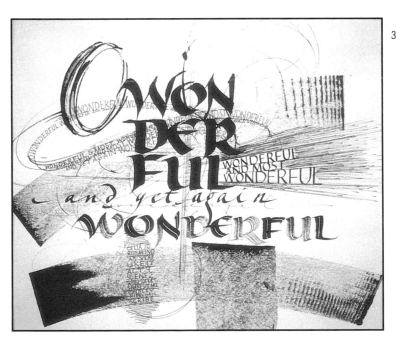

3

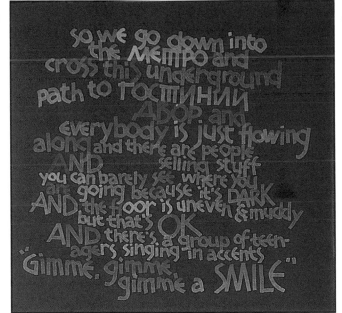

4

JEAN-LUC FERRET was born in Bordeaux, France, in 1950 and came to Canada in 1976. He recalls seeing "decadent" calligraphy done by his grandfather, as taught by the Christian brothers, with red ink and a square-cut twig from an elder hedge.

Jean-Luc has a Masters degree in language education and he earns his living as a teacher of French as a second language. He has studied fine arts and has become experienced in illustration and graphic art, but the most important part of his calligraphic training has been through La Société des Calligraphes de Montréal. Through their workshops and those of the Calligraphy Society of Ottawa, he has studied with some influential calligraphic instructors: Dick Beasley, Charles Pearce, Donald Jackson, Ward Dunham, Sheila Waters, Julian Waters, Susan Skarsgard and Reggie Ezell, to name a few.

The writings of Edward Johnston and Donald Jackson have been inspirational for Jean-Luc. While raising his two daughters in Chicoutimi, Quebec, he has worked hard to bring three calligraphy exhibitions to that city, and he has participated in several more. He enjoys working in collaboration, especially with his girlfriend, the companion of his life, who is also an artist.

Jean-Luc would like to see the Western world show more respect for writing as fine art, as Eastern societies do. He hopes to use his time to create more calligraphic work, while continuing to teach and promote the art to those who appreciate the beauty of written words.

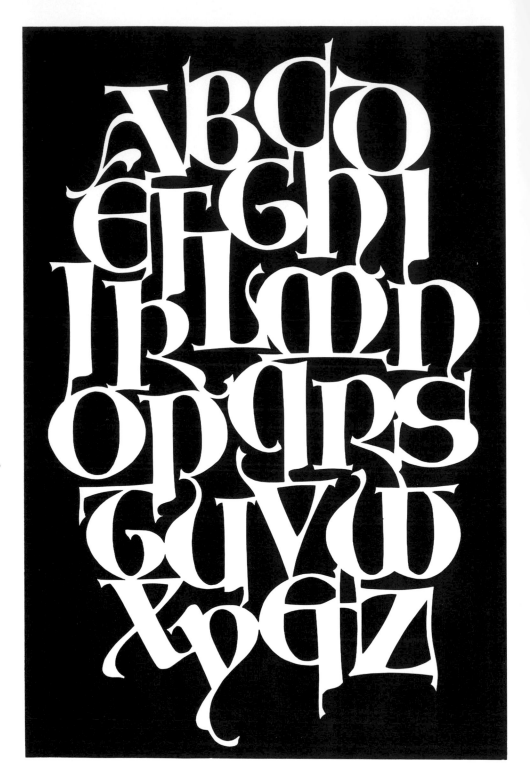

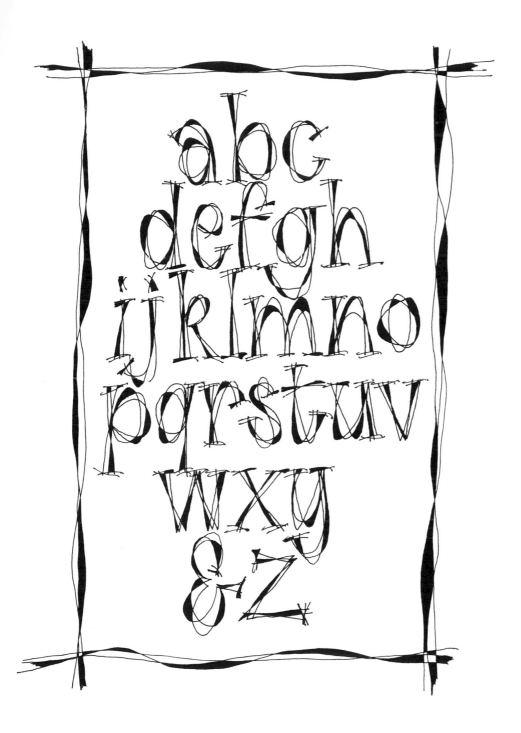

Mavis Lueck began learning about pottery, painting and weaving when she was very young. Her mother made pottery to sell at an annual craft show in Edmonton, and Mavis, who went along to help out, was delighted by the endless variety of arts and crafts.

A desire to make her own greeting cards led Mavis to enroll in a calligraphy class taught by Betty Locke, who invited all the students to a meeting of the Bow Valley Calligraphy Guild. Mavis began to take courses and workshops offered by the guild and has since studied with many international and local instructors. A workshop with Gottfried Pott was very exciting for her, and she says that his rhythmic, gestural interpretations of letterforms were "very much what I wanted to do with my calligraphy." Mavis has also appreciated the influence of Lindley McDougall, who has encouraged her to take on new challenges in her work.

In addition to her calligraphy studies, Mavis continues her education in related fields. She has taken courses in papermaking, marbling, Japanese woodblock printing, watercolour painting, silkscreen printing, bookbinding and card making. Her explorations with artist's books provide opportunities to combine various techniques with calligraphy.

In 1993, the directors of the Bow Valley Calligraphy Guild appointed Mavis to organize and produce *The Spirit of Calligraphy*, a full-colour book of members' calligraphic artwork. She accomplished this daunting task, and had three pieces of her own work selected for inclusion in the collection.

Although her full-time job as Production Coordinator in a busy design firm often leaves Mavis short of time for her own pursuits, she continues to improve her skills and increase her knowledge of calligraphy and related book arts.

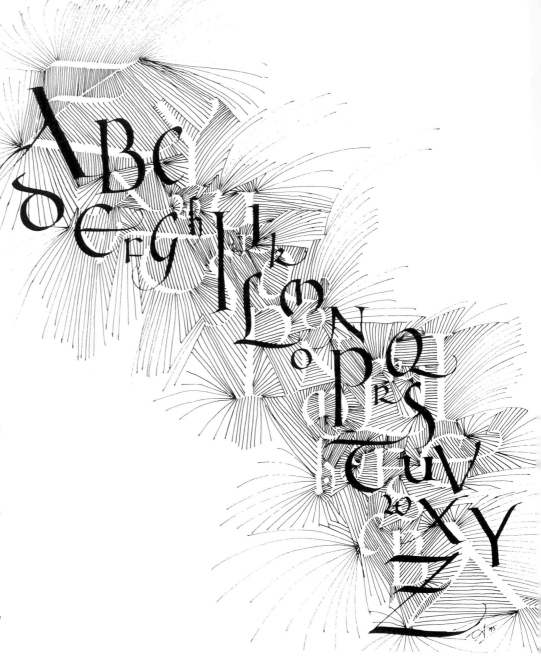

AMANDA LEWIS's training in dance and theatre has greatly influenced her calligraphic work. She believes that a calligrapher is like an actor, and she approaches her interpretations of words with a sense of performance, aiming for a visual representation of sound, movement and emphasis.

Amanda has made many hand bound blank books using Japanese papers and her own paste paper artwork. She personalizes these for her customers and encourages them to explore their own handwriting abilities. She has been greatly influenced in this work by Nancy Culmone and Paul Maurer, and by the words of Tim Ely: "Books are time based sculptures."

Her commitment to promoting handwriting and literacy to children has inspired Amanda to write two books which respond to a child's natural interest in written forms. *Writing: a fact and fun book* and *Lettering* are both published by Kids Can Press.

Amanda taught calligraphy for ten years at the University of Waterloo, where she converted her classes into a video and audio correspondence course. She has instructed many classes in calligraphy, dance and drama, sponsored by community colleges and Boards of Education in Ontario. In 1988, she left her successful freelance calligraphy business in Toronto. With her husband Tim Wynne-Jones and their three children, she "went to live among the rocks and cedar trees of Eastern Ontario." Amanda is now a member of a rural community of craftspeople and artisans who promote each other's work through regular studio tours.

I've been playing with calligraphic faxes, trying to come up with interesting textures and forms within the limitations of that medium. The design for this alphabet came after some serious doodling over my light table, exploring counterspaces and interspaces. I treated the edges of letterlines as if they were mirrors, reflecting rays off of their surfaces, and played with how those rays refracted. I then wrote the A-Z alphabet over top of this pattern, using the same variety of Mitchell nibs and gouache. I tried it out on my fax machine and it works wonderfully!

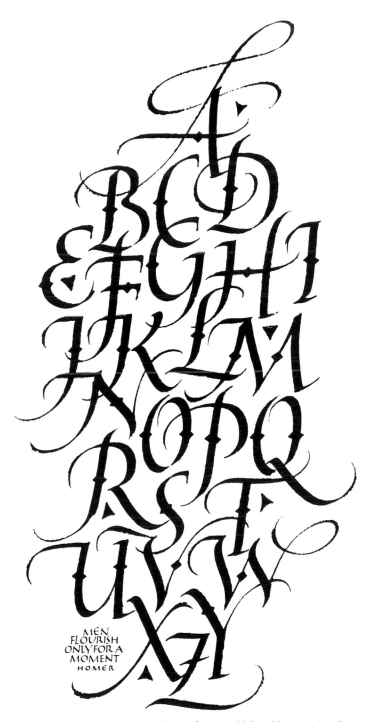

MEN
FLOURISH
ONLY FOR A
MOMENT
HOMER

MARTIN JACKSON was born in Sheffield, England, in 1939 and immigrated to Canada in 1966. He recalls having seen, at the age of fourteen, a beautiful letter which had been written in Italic by his uncle, who was an art teacher. It was a turning point in Martin's life.

After leaving school at the age of sixteen, Martin began a five-year apprenticeship in the studio of an advertising agency. At the age of twenty-one, he received a letter from the Queen inviting him to "waste two years of his life" in the armed forces. An offer not to be refused!

Martin has been teaching calligraphy for about twenty years, and he delights in seeing an increased awareness and appreciation of beautiful letter forms. He finds the works of Donald Jackson and Julian Waters to be particularly inspiring.

Martin claims that he is still waiting to produce a piece of real significance, and he continually strives to make letters that have integrity. When not working on his calligraphy, Martin collects and rears butterflies and moths.

FLOURISHED ITALIC CAPITALS. 18 x 30 cm. Saunders 90 lb. cold press watercolour paper, homemade brass pen, Rotring inks in blues and burgundies, aluminum and gold leaf on gum ammoniac.

VALERIE ELLIOTT has always loved letters. She is moved by the power of words and enjoys communicating her excitement. The discipline of learning historical letterforms occupied her first years while studying with Fred Salmon of Victoria. Other influential teachers have included Alan Blackman, Jenny Groat, Karlgeorg Hoefer and Gottfried Pott.

Using calligraphy as a means of reflecting her feelings about the world around her, Valerie often donates her work to benevolent societies such as Amnesty International, Child Haven International and various AIDS organizations. She believes that calligraphy provides a unique advantage in communicating a social message.

Valerie's commissions have included lettering design for the 1995 Commonwealth Games, the Queen's Printer and a series of twenty artist's books for a private collector and art dealer. Her self-published cookbook, *Val's I Hate to Wait Vegetarian Cookbook,* was entirely hand lettered. Now residing in Germany, Valerie hopes to resume publishing when she returns to Victoria.

During her stay in Germany, Valerie enjoys the opportunity to observe and admire beautiful letterforms. Such artists as Rudolf Koch, Friedrich Neugebauer and Karlgeorg Hoefer have impressed her with their linear sense of design and vibrant spirit. Not a great fan of the computer age, Valerie believes that "we need to learn and remember how letters feel in our bodies, not just how they look to our eyes."

Valerie does not expect to master the craft of calligraphy, but she embraces its possibilities. *I am happy just to know that in beautiful words I will find beautiful letters that will last me a lifetime!*

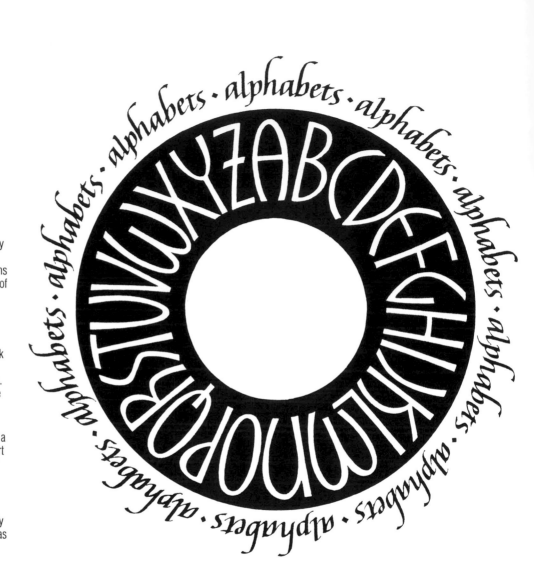

abcdefghijklmn
opqrstuvwxyz

Shelter

Featuring: flat roof &
overhang, low branching
extended leg and generous
counterspace. Executed
with a flexible pointed nib

ABCDEFGHIJKLMN
OPQRSTUVWXYZ

&1234567890

RUTH BOOTH has a studio in her Mississauga home, where she lives with her husband and two young children.

Ruth has been developing and refining her lettering skills since 1985. The pursuit of letterforms has led her to participate in more than twenty courses and workshops, including Reggie Ezell's *Fundamentals of Calligraphy* and *New Dimensions in Calligraphy*. Many instructors have had an appreciable effect on her work, and she has been strongly influenced by her local study group and other friends and artists in the Calligraphic Arts Guild of Toronto.

As a lettering artist, Ruth has been actively exhibiting and selling her work in galleries and juried shows in the Metro Toronto area since 1992, and she continues to accept private and corporate commissions. She enjoys teaching calligraphy, papermaking and related arts at local art facilities and through the Peel Board of Education.

Ruth embraces the diverse challenges of calligraphy. She finds a satisfaction inherent in achieving consistency and precision while being creative and expressive. She feels that "there is a spirit within these strokes, spaces and counterspaces which can only be born of a free and devoted hand." Currently, her studies are focused on the effects of various tools and media on different surfaces, and she plans to explore the expressive marks they can create.

SHELTER. *These forms were first created in monoline and then further developed with a flexible pointed nib.*

Ivan Angelic still has some letter samples that he did in a high school art class in Sudbury, Ontario. During a three-year Graphic Design course at Cambrian College, however, lettering was not taught at all. A book by Ken Brown was his only source of calligraphic study during that time.

After moving to Calgary in 1982, Ivan became involved with the Bow Valley Calligraphy Guild, and each workshop that he attended helped him to develop another aspect of his skill. He credits Denys Taipale for her commitment to precision and patience; Richard Stumpf for introducing pointed brush and flourishing; Teri Stumpf for encouraging spontaneity; Nancy Culmone and Susan Skarsgard for refining letterforms; and Julian Waters for demonstrating the versatility of the ruling pen.

Now living in Surrey, British Columbia, Ivan and his wife Andrea Hoffmann are partners in Hoffmann & Angelic Design. Their business includes doing specialty lettering for ad agencies in Canada and the United States. Ivan has joined the Westcoast Calligraphy Society and continues to develop his awareness of the variety of letterforms by constantly observing letters wherever they appear, whether it be a child's handwriting or a computer generated font. His graphic work has been widely published, and he was a featured artist in *The Creative Stroke 2*.

Ivan has welcomed computer technology into his work, and he believes that a whole new avenue of possibilities has opened up. He is acutely aware of the changes taking place in the design field and is eager to work according to the new parameters.

Checkerboard Alphabet. Pointed brush, ruling pen, Brause nib, bullet tip marker on various papers.

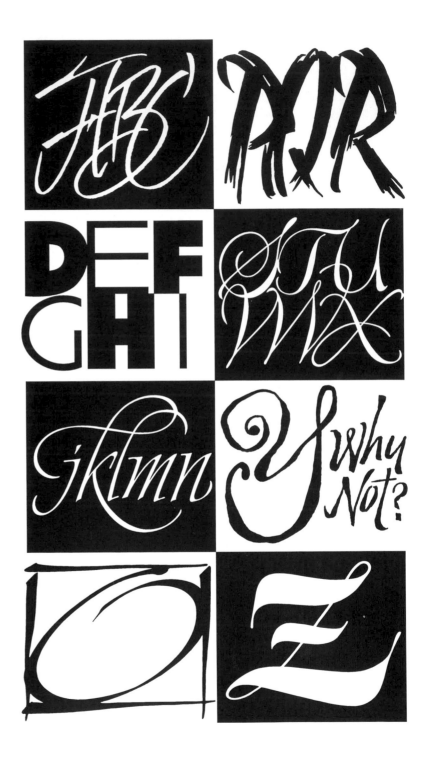

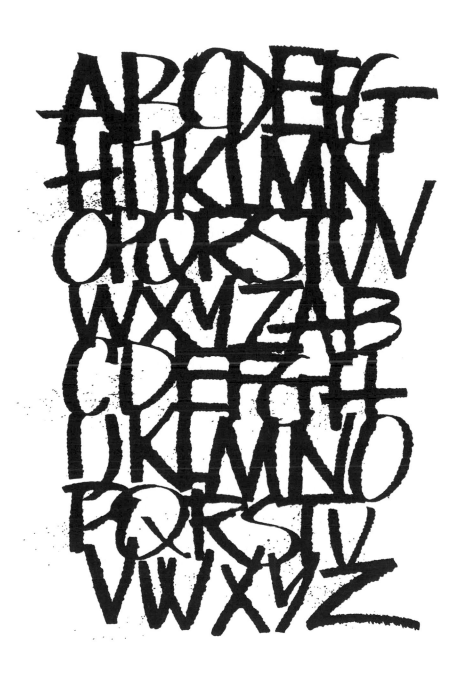

I created this alphabet with a large ruling pen and black ink during a workshop with Julian Waters. Working quickly on watercolour paper produced some ink spray, which I feel adds to the jauntiness of the letterforms. Use of tight spacing and overlapping gives a cohesiveness to the alphabet.

HOLLY DEAN. Weaving a natural theme through her art, Holly portrays statements that hold deep meaning in her own life. Worked in a variety of media in non-traditional ways, her pieces evoke a medieval mood. Influenced by Arthurian legend and the work of Arts and Crafts founder William Morris, she also finds inspiration in the "imperfect" beauty of nature.

Raised on a horse farm near Uxbridge, Ontario, Holly began a career in the printing industry at the age of sixteen. Now, as Pre-Press Manager at Performance Printing in Smiths Falls, Ontario, she is excited about the merging of traditional and electronic processes.

Holly discovered calligraphy in 1979 and began evening classes to learn the "Alf Ebsen" style of Italic. After joining the Calligraphic Arts Guild of Toronto, she met Ebsen himself, and he was very supportive of her work. Holly began a calligraphy and graphic design business, and later took workshops from Gottfried Pott, Mark Van Stone and Julian Waters.

In 1988, Holly moved to the artists' community of Merrickville, Ontario. She is now an active member of the Merrickville Artists' Guild and the Calligraphy Society of Ottawa, both of which have provided many opportunities for her to exhibit her work. Everything seems worthwhile to Holly when she successfully communicates to others through her art. When people recognize and react to the very essence of what is being conveyed, she finds many kindred spirits.

Holly lives in a 150-year-old saltbox, Rosebud Cottage, with Larry, her daughter Meg and Basil the cat. She is surrounded by antiques, books, herb gardens, a Power Macintosh and, of course, her art. Holly continues to work in calligraphic design and aspires to produce painted furniture and books.

Susan D. Pinard has been immersed in calligraphy and related book arts since 1986 when she received a calligraphy starter set for Christmas. A year later, she took her first class, and she has gone on to study with many instructors through the Calligraphy Society of Ottawa. Nancy Culmone, Judy Bainbridge, Nancy Ellis and Heather Mallett have all influenced the development of her work.

In 1973, Susan graduated from Carleton University, where she majored in Russian, and she went on to study German and spent two summers in Germany. She has worked in the library at Carleton for twenty-two years, and she finds that her job complements her interest in art and lettering.

A calligraphy instructor since 1993, Susan has been a contributor to juried exhibitions, one of which was hosted by the National Library of Canada. She is currently serving as the president of the Calligraphy Society of Ottawa.

Susan is actively exploring a number of crafts related to calligraphy, including bookbinding, paste paper, marbling and card making. She values simplicity in her work. She finds inspiration by observing nature, and she enjoys spending time camping with her husband and two daughters.

This Uncial alphabet came about as a result of a homework assignment during a workshop with Nancy Culmone and Paul Maurer. We were to use our most comfortable script, and try out many variations in slant, size, x-height, spacing, etc. My favourite script is Uncial, and I was attracted to it on a forward slant, slightly compressed.

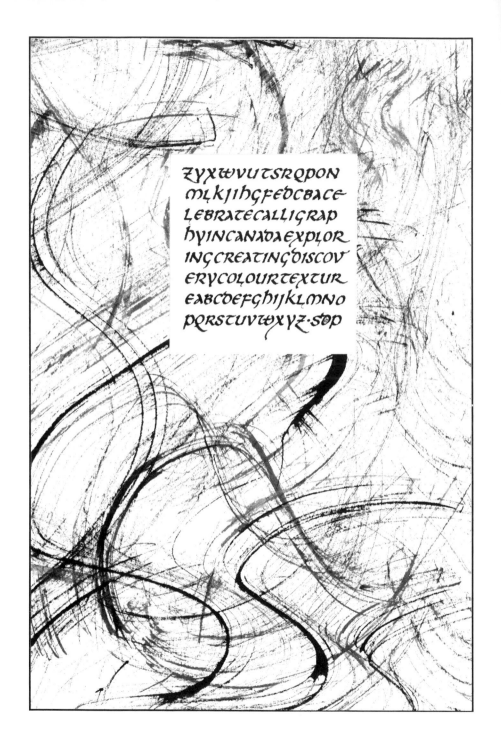

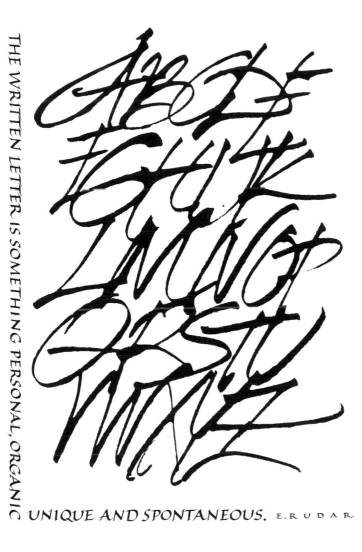

THE WRITTEN LETTER IS SOMETHING PERSONAL, ORGANIC

UNIQUE AND SPONTANEOUS. E. RUDAR

TANJA BOLENZ was born and raised in Munich. In 1980, she and her family immigrated to Vancouver, where she studied printmaking and painting at the Emily Carr Institute of Art and Design. Tanja's father was an antiquarian book dealer, and her love of old books inspired her to travel to Germany and Switzerland to study book restoration and fine binding. She has operated her own bindery in Vancouver for nine years.

Having always admired beautiful writing, Tanja began her calligraphy studies in 1986, first with Wendy Wilson and later with Irene Alexander. In 1994, she went to the Roehampton Institute in London to study under Gaynor Goffe, Gerald Fleuss, Margaret Daubney and Ewan Clayton. She has recently completed a one-year certificate course in Calligraphy and Bookbinding.

During her studies at Roehampton, Tanja's work has been influenced by her tutors and by the letter designer and stone carver Tom Perkins. She has become more aware of the German tradition in calligraphy, as seen in the work of Rudolf Koch and Hermann Zapf. She finds the brush lettering and ruling pen pieces by Werner Schneider, Friedrich Poppl and Karlgeorg Hoefer especially inspiring. *I am drawn to the simplicity and clarity of design, and fluency of lettering by these German artists. It is something that I am aspiring to as well.*

Tanja is continuing to explore calligraphy for a second year at the prestigious Roehampton Institute. She would like to combine her bookbinding and calligraphy skills, and she hopes to teach after returning to Vancouver.

Excellence and beauty of formal penmanship is achieved chiefly by three things: sharpness, unity and freedom.
Edward Johnston

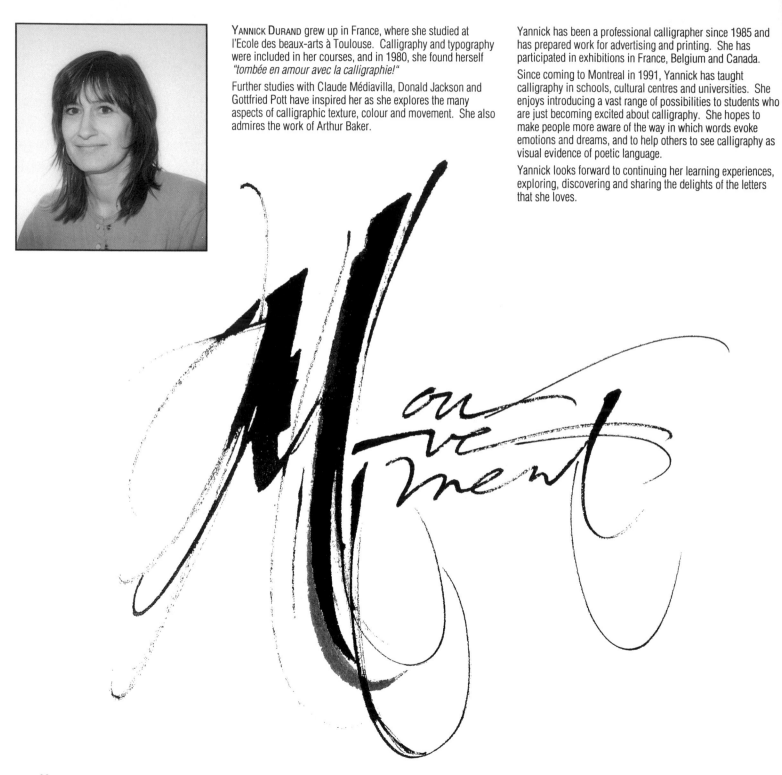

YANNICK DURAND grew up in France, where she studied at l'Ecole des beaux-arts à Toulouse. Calligraphy and typography were included in her courses, and in 1980, she found herself *"tombée en amour avec la calligraphie!"*

Further studies with Claude Médiavilla, Donald Jackson and Gottfried Pott have inspired her as she explores the many aspects of calligraphic texture, colour and movement. She also admires the work of Arthur Baker.

Yannick has been a professional calligrapher since 1985 and has prepared work for advertising and printing. She has participated in exhibitions in France, Belgium and Canada.

Since coming to Montreal in 1991, Yannick has taught calligraphy in schools, cultural centres and universities. She enjoys introducing a vast range of possibilities to students who are just becoming excited about calligraphy. She hopes to make people more aware of the way in which words evoke emotions and dreams, and to help others to see calligraphy as visual evidence of poetic language.

Yannick looks forward to continuing her learning experiences, exploring, discovering and sharing the delights of the letters that she loves.

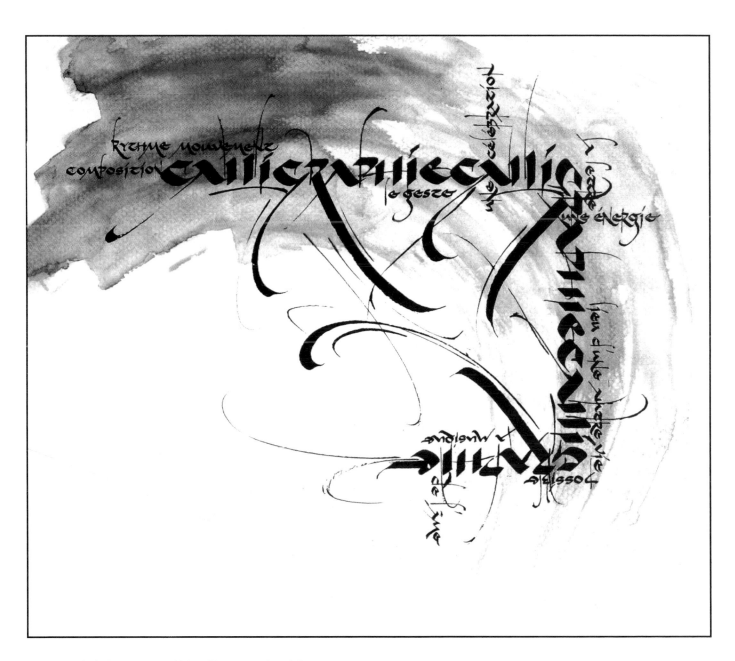

MOUVEMENT (left). Brause pens and ink on Rives paper. A study in movement.
EXPERIMENT IN CALLIGRAPHIC LETTERS (above). Brause pens and ink on Canson paper.

JUDITH JAIMET BAINBRIDGE remembers making the discovery, as a preschooler, that letters on a page can tell a wonderful story. In 1980, having completed her studies in nursing and philosophy, and continuing her education in psychology, literature and fine arts, Judy realized that calligraphy was her ideal avenue to investigate and express the human condition. She has found that many people appreciate the way in which calligraphy is used to commemorate marriages, births, deaths and special achievements.

After becoming a founding member of the Calligraphy Society of Ottawa in 1985, Judy served as the group's first librarian, and she has taken almost every workshop offered. In 1986, she became a founding partner of Calligraphy Associates, the jointly-owned business of four full-time calligraphers. Judy considers her own specialty to be "traditional scribe stuff."

Judy teaches segments of Calligraphy Associates' three-year curriculum as well as workshops in various Gothic hands, manuscript design and illumination, and crafts for calligraphers. She has been influenced by the work of Rudolf Koch and Donald Jackson, and by Japanese design. She is especially interested in combining haiku, painting and gilding in handmade books, which she constructs with unusual papers.

Judy's most interesting commission involved calligraphy, gilding and heraldic renderings for the *The Merchant Navy Book of Remembrance*, which is now on display in the Peace Tower in Ottawa. This collaboration with John Whitehead, Heather Mallett and Nancy Ellis resulted in a hardcover vellum book in the historical manuscript tradition. Judy feels that the book provides a link between Canada's past and future.

Angel · Blitzen · Cranberry jelly · Dickens · Evergreen · Frankincense · Gifts · Holly · Icicles · Joyeux · Kings · Lord · Merry · Noël · Oranges · Plum pudding · Quail · Reindeer · Santa · Turkey · Unwrapping · Visitors · Wassail · Xmas · Yuletide · Zither ·

This was made as an exemplar for my Bâtarde class and later it became my Christmas card. I used felt pen, coloured markers and signature gold. 43 x 28 cm.

Jacquie Myers lives with her husband in Kelowna, British Columbia, and works as an elementary school secretary. The founding president of the Kelowna Calligraphers' Guild, she remains very active on its executive.

Her calligraphic training has included courses and workshops with Judith Bain Dampier, Martin Jackson and Julian Waters. She combines teaching and freelancing with her continuing calligraphic studies. Her work has been exhibited in Vancouver, Calgary and Medicine Hat and has appeared in several publications.

Upon discovering calligraphy in 1988, Jacquie felt that she had found the medium of artistic expression that she had long been seeking. Good penmanship had always been important to her, and she realized that there was much more awaiting her as she began to experiment with writing as design and texture.

Pure, traditional letterforms have been her source of peace and pleasure, but Jacquie is excited about venturing into new territory and she welcomes the spontaneity of the ruling pen as a contemporary tool with many surprises in store!

ALPHABET. An exercise in contrasting weights. Ruling pen, Pelikan ink on Gilbert bond paper.

Laurie E.R. Broadhurst received her first broad-edged tool, an Osmiroid fountain pen, as a gift at the age of fifteen. Although she could find neither a book nor a teacher, she discovered that if she simply wrote with it, her "McLean's" style of handwriting became wonderfully altered.

Handwriting was Laurie's initial interest, and she attended several lectures by the Scottish writing master, Tom Gourdie, when he visited Vancouver in the early 1970's. Finally, at the age of twenty-eight, she received her first formal instruction from Irene Poskitt of North Vancouver, and became a member of the Westcoast Calligraphy Society.

After moving to Victoria, Laurie joined the Fairbank Calligraphy Society and took many workshops during the 1980's with top British and American calligraphers. She found the Fairbank tradition of an annual raffle to be very inspiring and began to combine letter and image.

With renewed college study in Fine Arts in the 1990's, Laurie's interests have turned to letterform as image and as texture. Thus, letterforms have appeared as images in her multi-media drawings, as design elements in sculptural canvas banners and collages, and as mass areas on her intaglio plates. In her most recent experiments, she has used her own hand-carved lettering stamps to apply quotations or textural letters to ceramic works.

These lettering stamps, hand-carved from leather-hard red clay using x-acto knives and lino cutting blades, were bisque fired to cone 06 to provide durability. The 1" high letterforms are based on those taught by Ann Hechle. Shown pressed into wet clay, the stamps can be used to create quotations or texture on ceramics.

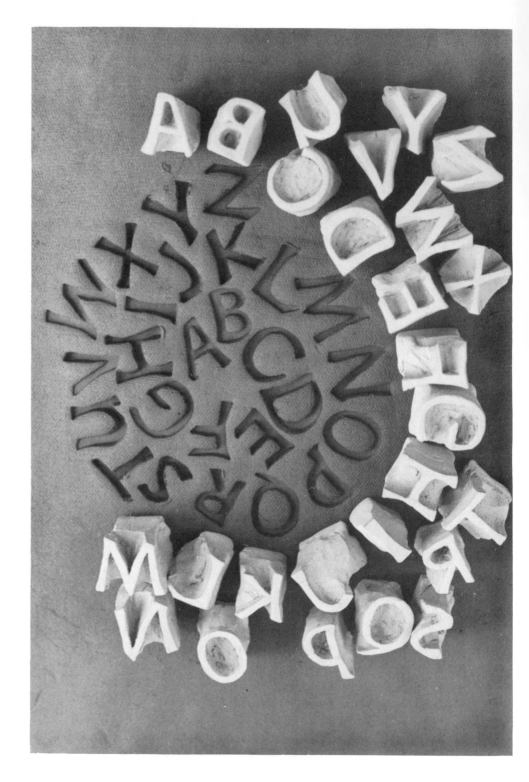

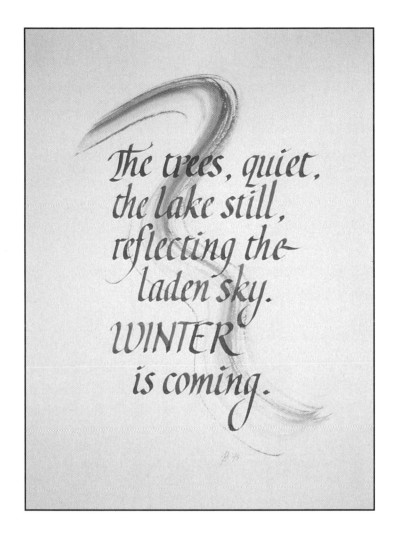

The trees, quiet,
the lake still,
reflecting the
laden sky.
WINTER
is coming.

Speedball nib and brush, gouache on 90 lb. watercolour paper. 23 x 30 cm. Artist's own words.

Jo BAARSCHERS was born and raised in Holland. Her interest in writing and lettering was encouraged at home, where her grandmother taught her the old German alphabet. In school, writing was taught in the Copperplate style with metal "crown" nibs.

After high school and secretarial training, she emigrated with her husband to South Africa. The writing of many letters, by hand, included the annual ritual of making Christmas cards. These incorporated family photographs for relatives and friends, and greetings in Dutch, Afrikaans and English.

Another emigration, this time to Canada, brought Jo to Thunder Bay in northwestern Ontario. In 1980, she began to take calligraphy courses with Doris Arnold through a community program. Over the years, Jo's teachers have included Jacqueline Svaren, Martin Jackson, Betty Locke, Tim Botts and Jean Formo, all of whom have influenced the development of her skills. Jo is a member of several societies, including the Bow Valley Calligraphy Guild, the Minneapolis Colleagues of Calligraphy and the Calligraphic Arts Guild of Toronto. The newsletters of these societies are important to her as sources of information and inspiration.

Combining calligraphic text with her husband's photographs, Jo designs greeting cards which are sold through outlets in northwestern Ontario. She has been a regular contributor to the Quetico Quills calendars and to the publications of various guilds, including *A Celebration of Life* and *The Spirit of Calligraphy,* both produced by the BVCG.

Jo values the friendships of other calligraphers, who provide a continuing source of stimulation and encouragement.

PAMELA BARLOW BROOKS loves the life on Pender Island, in the southern Gulf Islands of British Columbia. Each week she teaches creative movement and ballet to children on the island. Each week she travels to attend education courses at the University of Victoria. Most weeks she also works on calligraphy, sign painting, designing, choreography, gardening and teaching. She recently completed a session of handwriting and calligraphy classes for students at the Pender Island School.

As a young student growing up in England, Pamela recalls studying Edward Johnston's model alphabet in art class. Later, when she was living on Cape Breton Island in Nova Scotia, she took a ten-month course in sign writing. She began studying books by Nicolete Gray and took a workshop with Pat Russell, who came as a visiting instructor from England. When she moved to Victoria, Pamela met Michael Hemming, Ann Tresize and the late Esmé Davis, and became a founding member of the Fairbank Calligraphy Society.

Pamela attended the very first conference, *Calligraphy Connection,* in Minnesota, where she first saw Thomas Ingmire's expressionist calligraphy and became aware of a greater sense of freedom among her contemporaries. She began to realize that calligraphers can use their own words in their work. With the aid of a Canada Council Explorations grant, she undertook a unique project, completing a short animated film depicting the sequential formation of strokes of the Roundhand alphabet.

After discovering George Faludy's poem, *The Dancer,* Pamela began to study ballet and is still attending classes eleven years later. As a member of the Canadian Bookbinders and Book Artists Guild, Pamela has exhibited some of her "wildest work" across Canada and in Japan.

ABCDEFG
IJKLMNO
PQRSTUV
WXYZ

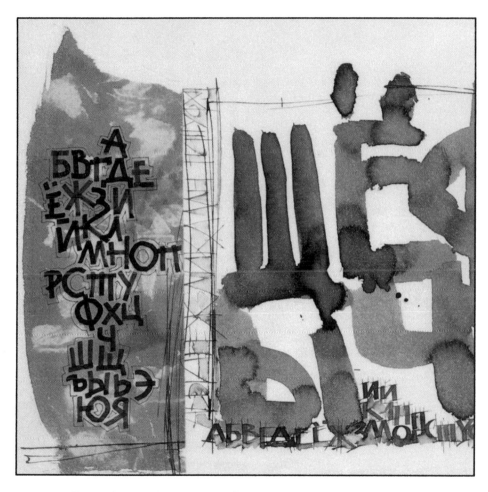

RUSSIAN ALPHABET. Pen and brushes, Chinese ink, gouache on Lana laid paper.

CHRISTINE MITCHELL has been doing calligraphy since her early teens and was often the youngest participant in workshops given by the Edmonton Calligraphic Society and the Bow Valley Calligraphy Guild. She is a graduate of the BFA program in Art and Design at the University of Alberta, where she specialized in drawing, painting and visual communication design. During those four years of study, she found her calligraphy experience to be invaluable.

Christine is now completing her Master of Arts degree at the U. of A. in Slavic and East European Studies. She is concentrating on Russian linguistics and she spent a semester in 1994 studying in St. Petersburg. Her keen interest in the Russian language is heightened by her delight in the Cyrillic alphabet.

Calligraphy provides an important link between Christine's two main interests: art and language. She feels that calligraphy sits on the border between *linguistic* communication and *visual* communication. She believes that calligraphic work is most effective when the artist is aware of this boundary, and emphasizes it, either by pushing the work to one extreme or the other, or by blurring the boundary, forcing the viewer to make simultaneous interpretations on multiple levels.

The intuitive ability to understand and manipulate context and meaning, Christine believes, is the skill most vital to a calligrapher. Notwithstanding her respect for traditional calligraphy, she feels that the artist will benefit by embracing the newest technologies as they become available.

WENDY PATERSON was born into a creative and resourceful family, and she describes her early life in an isolated northern community as "the best childhood ever!" She was first impressed by the power of calligraphy when a teacher labelled her notebook in beautiful script.

Since 1987, Wendy has taken one or two workshops each year, and she has taught classes in Saskatoon and elsewhere in Saskatchewan. She greatly admires Martin Jackson's excellent letterforms and she appreciates his exceptional skill as a teacher.

Through resources such as guilds, books and visiting artists, Wendy draws on the worldwide calligraphic community for her inspiration. She is involved with the Saskatoon Lettering Artists and the Bow Valley Calligraphy Guild, both of which have provided her with much encouragement, as have her friends Cindy Romo and Elaine Muth.

When asked about her calligraphic accomplishments and aspirations, Wendy modestly replies, "I did a nice O once. I'd like to do Roman caps that don't embarrass me."

Wendy has recently returned to her university studies as a full-time student. She observes: *The trick seems to be to embrace the pursuit of excellence without being frozen into inaction through fear of dissatisfaction with our imperfect efforts: Courage! Onward!*

CELTIC VARIATION. Metal nib on rough watercolour paper, glued onto black paper.

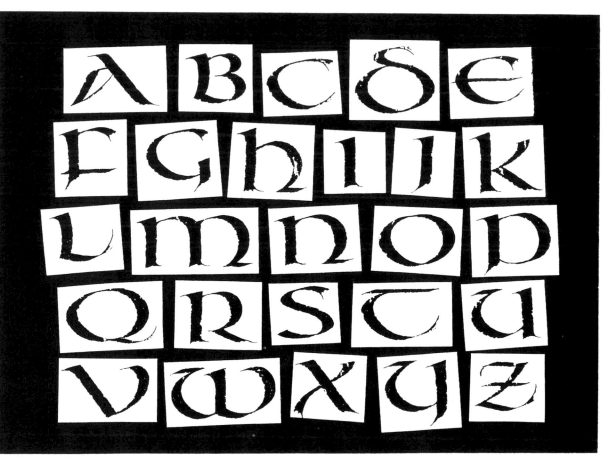

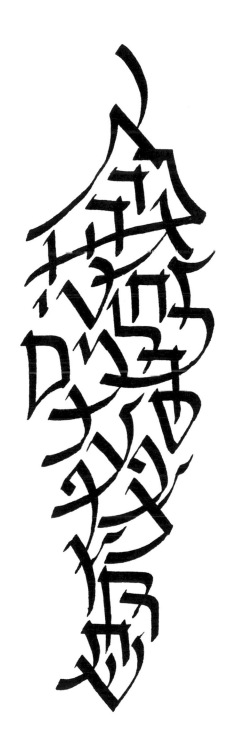

Laya Crust was born and raised in Winnipeg. In 1978, she moved to Toronto, where she studied at the Ontario College of Art and at the Three Schools of Art. She spent a year and a half in Israel taking general courses and researching historical manuscripts.

Moved by the sound of the Hebrew liturgy and its English translation, Laya took a course in Hebrew calligraphy and then began to experiment with different hands in both Hebrew and English. She found that the written letterform could communicate the warmth of the spoken and written language.

Laya has expressed her love of art and letters through the creation of hand lettered and illustrated books, illuminated Jewish marriage contracts, and a wide variety of commissioned calligraphic art pieces. Most of her work is done in watercolour and ink, but she has also created designs for fabric, needlework and metal. Many of Laya's themes are drawn from the liturgy, and her texts are imbued with emotion and imagery.

Laya's work has been exhibited in Jerusalem and, in Toronto, at the Koffler Gallery, the Beth Tzedec Museum and the North York Arts Council. She has taught both English and Hebrew calligraphy in schools, and she is a member of the Calligraphic Arts Guild of Toronto.

Laya lives in Toronto with her husband Les Lightstone and their six children. She is always looking for new challenges for her art and calligraphy, and she finds inspiration in art history, manuscript art from other cultures, visual art in various media, and book illustration. She believes that, by keeping an open mind to all visual stimulation, one can always present calligraphy in a fresh and exciting way.

SUZZANN ANDERSON WRIGHT was raised on a farm near Riverton, Manitoba, and has lived in Ottawa for seventeen years. She began her calligraphic studies in 1987 with Elizabeth McKee, and she has continued her exploration of lettering arts through classes and workshops with Heather Mallett, Gottfried Pott and many other local and international calligraphers. As an instructor with the Ottawa Board of Education, Suzzann strives to instill in her students the excitement and wonder, tempered with practice and discipline, that have been so important to her own learning.

A full-time calligrapher, Suzzann began her freelance career in 1989 establishing her own company, The Wright Image. Since 1992, she has been a member of Calligraphy Associates, a partnership of independent full-time calligraphers. Although she spends most of her time working on official documents and certificates, it is the interpretation of words that are meaningful to others that brings her real pleasure. For more than three years, Suzzann has been involved in producing Letters Patent for the Chief Herald of Canada. Generally, the heraldic artists complete their work first; the scribe must then choose the appropriate script and design initials to complete the formal documents.

Suzzann has been a member of the Calligraphy Society of Ottawa since 1987. She has served as the group's workshop coordinator and vice-president, and she currently edits their publication, *Capital Letters.* She was active in organizing *Calligraphy Day 93,* the CSO's first local lettering conference.

While maintaining her professional workload, Suzzann plans to spend more time producing interpretive artwork in book and broadside forms. She says, however, that her "number one priority is to continue learning, discovering and sharing."

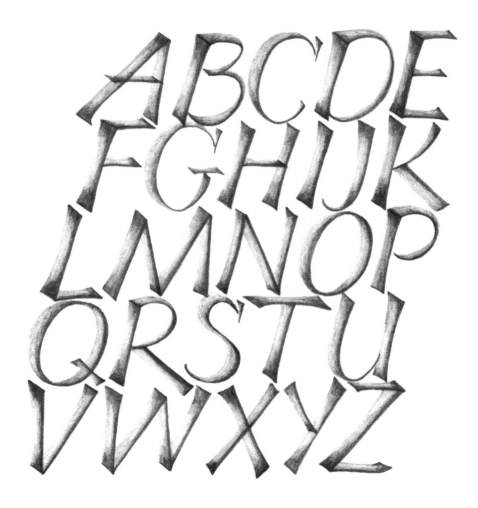

This alphabet is a direct result of my love for doodling and trying to turn every writing instrument into a calligraphic tool. While talking on the phone one day, I began by laying the pencil tip on its side to imitate a brush letter shape. That part was easy! Then came the reworking of the alphabet and finding just the right surface and just the right pencil. Ever since Nancy Culmone showed us what we could do with coloured pencils, I have often used the gradation technique.

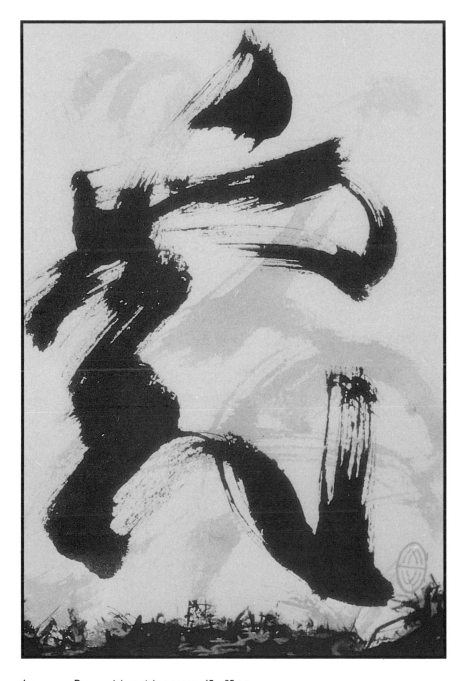

LOVE ON THE PRAIRIE. Ink, pastel on paper. 45 x 65 cm.

MYKEN WOODS began her study and practice of classical Chinese calligraphy under the direction of master painter, calligrapher and Taoist philosopher Chin Shek Lam. She is fascinated by the beauty, grace and power of calligraphic brush strokes.

While concentrating on developing her own unique style and expression within the context of oriental calligraphy, Myken studied at Alberta College of Art and the University of Calgary, completing her Bachelor of Fine Arts degree in 1992. Her work has been exhibited in more than forty group and solo shows in Alberta, Ontario and Hong Kong, and is represented in corporate and private collections.

Myken seeks to combine and balance eastern and western artistic traditions and techniques. In many of her works, calligraphic brushwork appears to "float" on a background that is more western in its application of colour. She believes that such juxtaposition, along with traditional concerns of colour and composition, creates the dynamic in her work.

For me, the appeal of calligraphic brush work lies in its expressiveness ... its ability to combine and balance that which speaks of the external, physical world and that which speaks of the spiritual and ethereal inner world ... My direction is to continue to explore the relationships between contemporary abstract expressionism and the ancient art of Chinese calligraphy.

Myken's work has recently been published in Harbin, China, and she has received an invitation to visit and exhibit there.

KATHIE MCILVRIDE is a freelance lettering artist and illustrator who works out of her studio in Vancouver. Kathie combines traditional discipline with freedom of form "to express a whimsical approach to life." Her work is inspired by two major sources: the playful wonder and innocence of children; and the beauty and grace of dance. Kathie sees hope and beauty through the eyes and lives of children, and she uses her brushes and pens to communicate this joy and vulnerability. She feels that her work is a dance celebrating life.

Over the past fifteen years, Kathie has been influenced by several internationally recognized calligraphers. She has studied both lettering arts and watercolour techniques in North America and Great Britain. Her instructors have included Donald Jackson, Carl Rohrs, Lothar Hoffmann, Nancy and David Howells, Mark Van Stone, Susan Skarsgard and Martin Jackson.

Kathie has recently moved from Ontario to Vancouver where she is now a member of the Westcoast Calligraphy Society. She is a former member of the Calligraphic Arts Guild of Toronto, and her work has been published regularly in their journal, *The Legible Scribble.* Her broadside work has been displayed in numerous exhibitions and galleries. She has worked as a graphic artist in the greater Toronto area, and her card designs have been produced by Northern Cards Publishing. Kathie is the proud mother of two children, to whom she refers as her "greatest creations."

Nibs, brush, crayon, torn paper. *The "O" looked like a sun, and I placed it in the centre, because our calligraphic scripts are often based on the shape of the "O." I find it symbolic that the other letters rotate around it!*

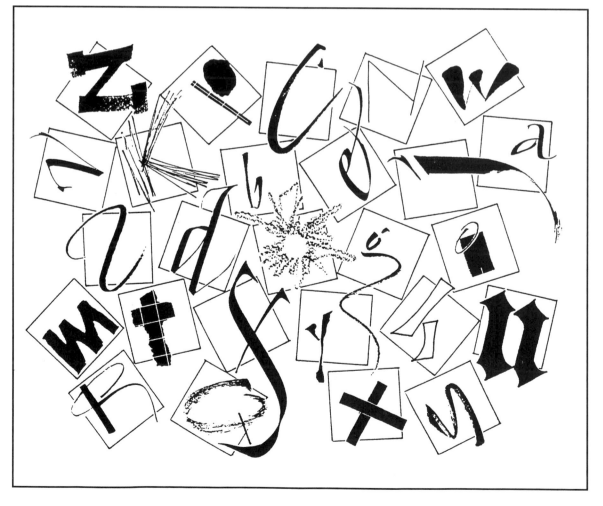

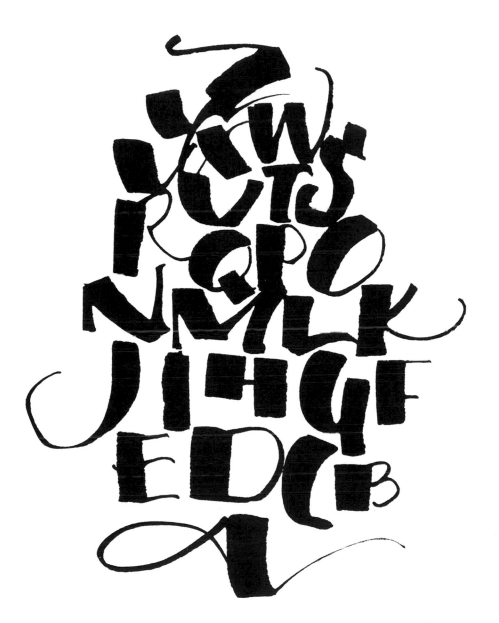

Nancy Ellis began studying calligraphy in 1979 and has been a professional calligrapher since 1985. Working out of her home studio as a scribe, teacher and artist, she maintains a chaotic balancing act between work and family.

The Calligraphy Society of Ottawa, for which Nancy has served as secretary and president, has been a source of learning and camaraderie. She also receives constant support and inspiration from her three talented colleagues at Calligraphy Associates, a unique cooperative partnership which provides a wide range of calligraphic services to government, business and education. Nancy finds it challenging and rewarding to respond to the lettering demands of the marketplace.

Since 1980, through continuing education programs and through the CSO, Nancy has taught more than sixty evening courses and numerous workshops. With Calligraphy Associates, she has taught within an ongoing comprehensive program for serious calligraphy students.

Nancy continues her own studies with local and international instructors, and has attended many week-long conferences and retreats. While seeking new ways to blend beautiful letterforms into calligraphic compositions, she finds opportunities for creativity as she prepares, twice yearly, for exhibitions. Three pieces of her work were accepted for publication in the *1995 Letterforum Perpetual Calendar*.

In 1992, a personal and calligraphic highlight of Nancy's career was her part in a collaboration with three others to plan, write and decorate *The Merchant Navy Book of Remembrance*. It has now been bound, dedicated and installed with the other memorial books in the Peace Tower in Ottawa.

KELLY BROWN grew up in the Vancouver area, where she first encountered calligraphy in junior high school and later took private lessons from Stan Jones. After moving to Calgary in 1989, she joined the Bow Valley Calligraphy Guild and found many opportunities to study with local and international instructors. Influential teachers have included Betty Locke, Leana Fay, Gail Stevens, Carl Rohrs, Connie Furgason, Gottfried Pott, Fran Sloan and Martin Jackson. Kelly now serves as education director for the BVCG.

In recent years, Kelly has completed many commissioned calligraphic artworks. She believes that such pieces raise her clients' awareness of beautiful lettering and bring joy into their lives as they see their chosen words interpreted as visual art.

Kelly feels that it is important to use her skills to interpret the truths she discovers in her life while making words visible to others. She is ambivalent about the computer's place in lettering, and continues to focus on refining her own letterforms. She admires work by Thomas Ingmire, Sheila Waters, Julian Waters and Denis Brown, and she recommends books by Maury Nemoy, Gottfried Pott and Julia Cameron.

After her shift in the Emergency Department of a busy hospital, Kelly is happy to return to the home she shares with her boyfriend and two cats, and immerse herself in the pursuit of beautiful letters.

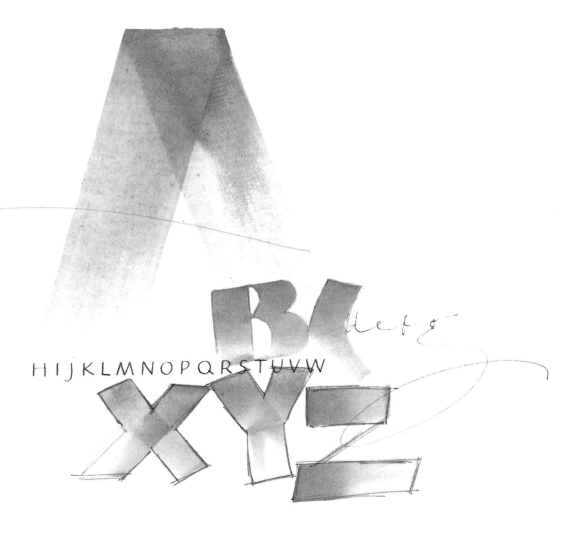

Diluted ink with mat board and wooden stick, Pigma pen and pencil.

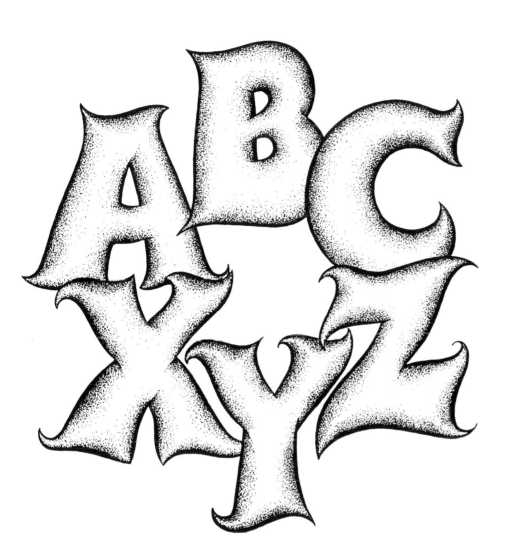

KARLA CUMMINS studied commercial and fine arts at Central Technical School in Toronto, where typography was one of the subjects that greatly interested her. She spent several years working in the printing industry, where her graphic work included paste-up, photography, typesetting, design and illustration.

When she realized that she needed to upgrade her skills from traditional media, Karla enrolled in the digital art and design program at the University College of the Cariboo in Kamloops, British Columbia. Her studies brought her up to date with electronic imagery, and some of her work from that period has been published in computer magazines. She now works in the software industry, creating computer animation for video games and educational entertainment.

Karla has always been interested in the combination of type and graphics, and the possibility of making letters out of a variety of materials. Three-dimensional letters, such as those carved out of stone or sewn with fabric, are as exciting to her as two-dimensional letters on paper.

With the computer, the letters are actually made using light, which changes constantly, just as letters and language are in a constant state of flux. Words are very powerful, and the way in which they are written can alter or enhance their meaning. With film, video and the computer, there is the added possibility of movement, letters changing shape and size, which adds to the excitement!

ELAINE L. MUTH's career as a visual artist comprises a wide range of painting, drawing and calligraphic accomplishments. She has designed and illustrated books for children, including music books and ecology manuals for school use. Her calligraphic skills and her experience in illustration are also evident in her handmade artist's books.

Elaine began experimenting with pen-drawn letters by copying formal alphabets before she was ten years old. She soon discovered that Greek and Hebrew letters offered even more challenge and mystery. As she pursued her studies in painting and drawing, she became more observant about how letters are made calligraphically.

When the Bow Valley Calligraphy Guild began to offer workshops with international instructors in 1985, Elaine was among the first to attend, travelling to Calgary from Saskatoon for classes with Louise Grunewald and Dick Beasley. She made the same journey in later years to study with Martin Jackson, Richard Stumpf and Eliza Schulte, whose bookmaking workshop was uniquely inspiring to Elaine. Meanwhile, Elaine's friends and colleagues, the Saskatoon Lettering Artists, provided enthusiastic support and encouragement.

Elaine's paintings, drawings and calligraphy have been included in group and solo exhibitions across Canada, and she has been active as an art educator since 1975. She also has experience as a teacher of piano and music theory, and as a producer of videos.

Calligraphy at its best is dynamic: akin to other performance art such as music and dance. A main theme in my work is to show that the disciplines of calligraphy, painting and movement are connected. The brush is my favourite tool for expressing these ideas.

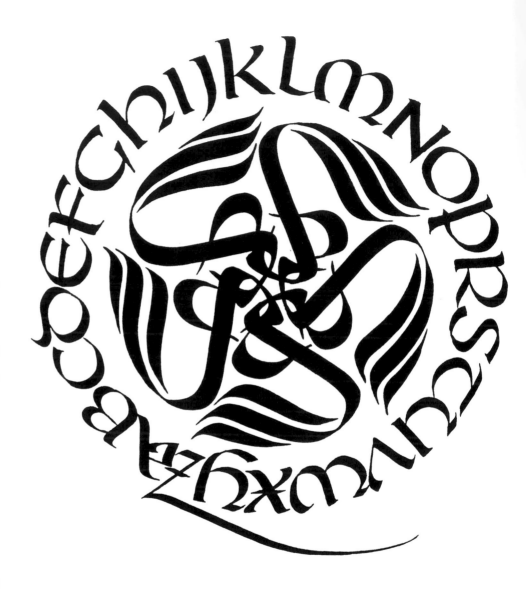

CIRCULAR DESIGN. Based on letters, bird forms and ampersand, brush written. Surrounded by the Uncial alphabet, directly written, unretouched pen letters.

52

LETTERS WORDS
A WRITTEN PAGE
IS VISIBLE SPEECH
TO CHANGE SOUND
A HANDSHAKE
FROM FAR AWAY

ROSEMARIE GIDVANI was born and raised in Austria, where her parents were designers of furniture and interiors. She studied fashion design and illustration in Switzerland before immigrating to Canada.

In Zurich, Rosemarie worked as a fashion designer, and later as a freelance illustrator in fashion advertising. She was often required to include hand lettering in her ads, and she enjoyed experimenting with different styles.

The Calligraphic Arts Guild of Toronto has given Rosemarie the opportunity to learn about letterforms and calligraphic design, and her classes with Carol Ayers have been very inspirational.

Rosemarie admires the work of Hermann Kilian and Karlgeorg Hoefer. She is interested in the interpretive relationship between calligraphy and classical music. She is working to improve her skills and confidence in calligraphy, and she hopes to create a book of selected quotations.

My own words about "letters, words, a written page" using drawing pens .5 and .1.

LINDA PRUSSICK cannot remember a time when she was not intrigued by beautiful letters, and she earnestly tried to master good penmanship as a young child. After completing a commercial art program, she worked as a paste-up artist, and she enjoyed the opportunity to use type as an element of page layout. As her design career progressed, she began to experiment with hand lettering, and to pursue independent studies to develop her understanding of calligraphic process.

In 1985, Linda moved from Ottawa to Toronto and enrolled at the Ontario College of Art. She graduated with awards in design/illustration and calligraphy. After several years working as a graphic designer and art director, Linda started her own business, Black Sheep Artful Enterprises, through which she marketed illustration, calligraphy, hand-painted cards and wearable art.

In 1993, Linda began working at Avenue Road Arts School, where she is responsible for developing and teaching a variety of visual arts programs, including calligraphy, for adults and children. She takes delight in helping students to discover, develop, express and celebrate their creativity.

Linda describes herself as "a born gatherer," who has acquired a huge collection of papers and natural objects which she uses to assemble collages, books, and papier mâché constructions. She concedes that the home that she shares with her husband David Kochberg has become increasingly crowded with her ever-growing assortment of materials.

The Calligraphic Arts Guild of Toronto has provided many opportunities for Linda to learn and develop her skills, and she is a past editor of *The Legible Scribble,* the guild's quarterly publication. She has taken many workshops with international instructors, and with Lynn Lefler and Carol Ayers in their intensive program, *Starting Again From Scratch,* which Linda found to be educational and inspiring!

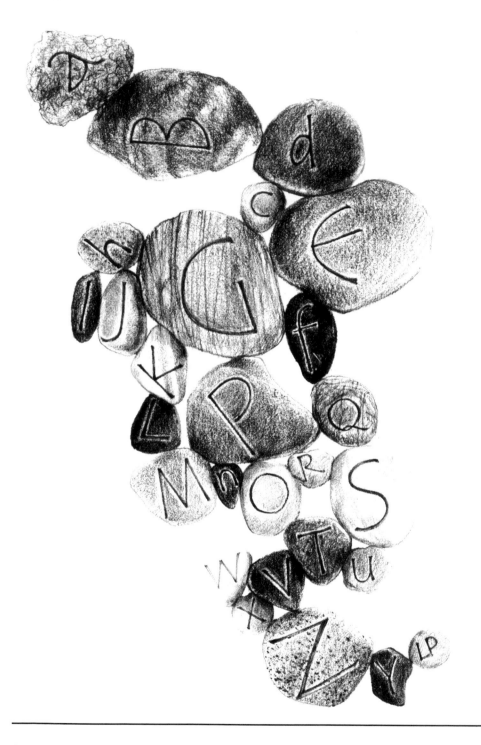

PEBBLES (above). Graphite on Stonehenge paper.
Q (right). Pointed nib and ruling pen, ink on Lana Ripple. Reverse print.

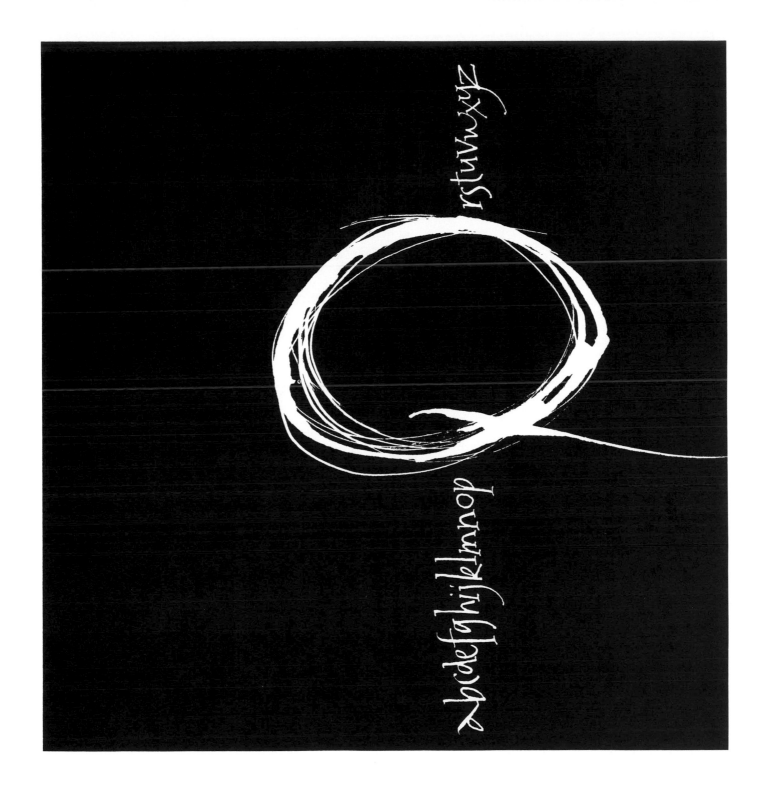

abcdefghijklmnop

qrstuvwxyz

RUTH STERN WARZECHA found herself picking up a calligraphy pen twenty-one years ago, and she says that she has seldom been able to put it down since then. Her interest in calligraphy caused her to set aside her university studies and return to art classes.

Several years later, still largely self-taught, Ruth began teaching calligraphy for the Artcraft Studio at the University of Western Ontario. She also spent a year in Israel studying the art of the classical Hebrew scribe.

After moving to Toronto and joining the Calligraphic Arts Guild of Toronto, Ruth's interest in calligraphy continued to grow. She took advanced classes whenever she could, and she developed an interest in papercuts, intricate designs cut from a single sheet of paper.

Currently, Ruth teaches calligraphy in the adult program for the North York Board of Education. She operates her own studio producing unique Hebrew and English artworks in calligraphy and papercuts, frequently combining these techniques. She also organizes international workshops for the CAGT.

The potential power of the written word, whether drawn, cut or sandblasted, provides the energy behind Ruth's calligraphy. When the words are wise or ancient, they become more meaningful for her when executed with the traditional tools of the scribe: quills, vellum and gold leaf. *But wise and ancient words can become timeless and fresh when they are reinterpreted in modern materials and eclectic styles.*

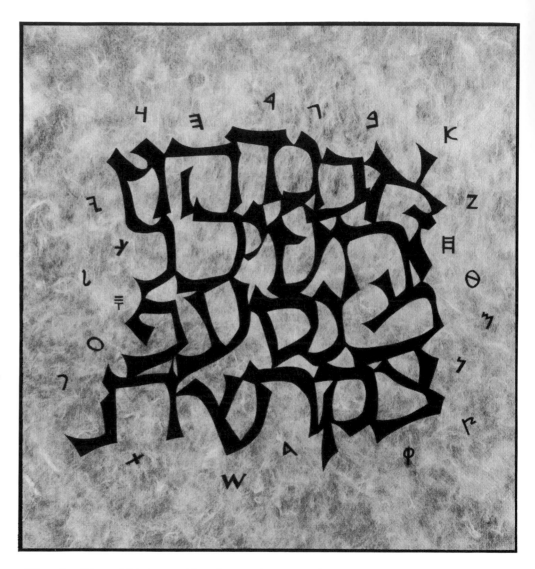

This modern Hebrew alphabet papercut is cut from one sheet of black Canson over a sheet of white gauzy Japanese paper with a second sheet of black Canson beneath it. Individual ancient Hebrew letters are placed near an informal rendition of their more modern Aramaic replacements. Some of the archaic letter shapes show their influence on later Roman letters.

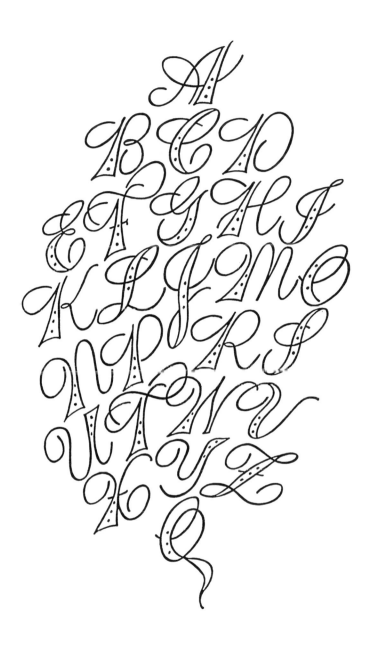

DIANNAH ELIZABETH BENSON took a night class in calligraphy in 1978, and has been furthering her studies ever since, attending conferences and taking courses through the Calligraphic Arts Guild of Toronto. She began learning Copperplate by working through Dick Jackson's *Copperplate Calligraphy,* and she has found that style to be the one most requested by clients and students.

Because she wants to help students use their calligraphy more creatively, Diannah also teaches classes in papermaking and related crafts. Her students have made unique discoveries when combining ideas from different disciplines, and she feels richly rewarded by their success and their insights.

Diannah has had three solo exhibitions in recent years, and her exemplar of Spencerian Script was published in the *Speedball Textbook* (22nd edition). She has presented a four-part television series teaching Copperplate, and she has been featured on *Hands Over Time,* a documentary about Ontario artisans. Her lettering appears at the opening of *Imprints,* TV Ontario's literary talk show.

Now living in Bracebridge, Ontario, Diannah finds herself in an active arts community where she is teaching calligraphy to a new audience. She still serves her clients in Toronto, and she specializes in designing and producing unique wedding invitations on oriental papers. She takes pride in the fact that these invitations become treasured keepsakes, and that her clients and their guests have been delighted with the beauty and originality of her work.

These capital letters are called "Quest." I developed this alphabet in response to numerous requests at courses (of a non-calligraphic nature) to letter the certificates. Often the only tool available was a ballpoint pen, so I came up with this simple set of capitals to dress up the names, and combined Copperplate or Spencerian lowercase letters with them.

EDITH ENGELBERG studied at the Montreal Museum of Fine Arts during her school years, when Arthur Lismer was principal and one of her teachers. Lettering was an integral part of her courses in design, and she acquired a deep and satisfying appreciation of letterforms.

A graduate of McGill University, with a B.Sc. and a diploma in Russian translation, Edith enjoys a teaching career in Laboratory Physics. She always maintained her early interest in art, and she felt that calligraphy would be a pursuit that would "weave into all the other demands" of her life.

Edith was privileged to study with Mr. Bernard Kopland, a calligrapher trained in Holland, who was a generous and inspirational teacher. As a member of La Société des Calligraphes de Montréal, she has attended many workshops, including presentations by Mark Van Stone, Marc Drogin and Barry Morentz.

Excited by many of the new materials and techniques available to calligraphers, Edith plans to keep learning about such innovations. She credits her husband William Engelberg with encouraging her to accept invitations to exhibit and publish her work. He further assists her by taking slides for her submissions.

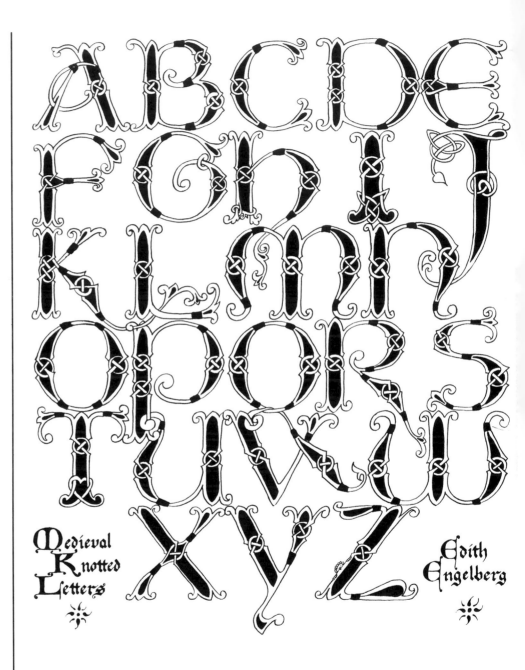

Medieval Knotted Letters

Edith Engelberg

abcdefg
h i jk & love m
nopqrstuv
w x you z

SUZANNE CANNON began to discover the delights of calligraphy at the age of eleven when a neighbour taught her Italic handwriting. Years later, while living in Victoria, Suzanne discovered the Fairbank Calligraphy Society and her life was never the same.

Thanks to the generous sharing of knowledge and the excellent tutelage available through the FCS, Suzanne gained skills and confidence, and she went on to teach in Victoria for several years. She then spent a year in England, at Newcastle-upon-Tyne, where she joined the Society of Scribes and Illuminators, and taught classes through the Tyne and Wear Museum Service.

Now that she is living in British Columbia again, Suzanne teaches in the communities of Surrey, Burnaby and Delta. She is an active member of the Westcoast Calligraphy Society and she has a small freelance design business.

Suzanne has attended workshops too numerous to list, but she says that when that "less-than-perfect letter" leaks, all too often, from her pen, the voice she hears is that of Fred Salmon of the Fairbank Calligraphy Society.

Lᴛɴɴ Hᴏʟʟɪᴡᴇʟʟ Lᴇꜰʟᴇʀ grew up in Willowdale, Ontario. She discovered calligraphy in a *Speedball Textbook,* and began to teach herself from its model alphabets. In 1975, Lynn enrolled in an evening course at Seneca College. Since then, she has taken every calligraphy class that she could.

Although she has now studied with many teachers, in workshops and continuing classes, Lynn credits the late Alf Ebsen with having had a strong influence on her calligraphic development. She also finds inspiration in the work of Charles Pearce and Ann Hechle.

Lynn has attended five international conferences in the United States, and *Kalligraphia 93* in Lethbridge, Alberta. She is an active member of the Calligraphic Arts Guild of Toronto, and has taught many classes and workshops for public arts program and the CAGT.

In 1978, Lynn produced a book for publication. Her sister, Donna Holliwell, did the illustrations and Lynn hand lettered the text for *Pieces of Me,* a collection of her own poems. More recently, Lynn's calligraphy has been exhibited with the Rochester Group, the CAGT, and in *Contemporary Canadian Bookworks,* a juried show that travelled to Japan in 1995.

Lynn often uses graphite and pencil crayon, media which allow her to develop her work outside the studio. She believes that carefully constructed letterforms are essential to good calligraphy: *Through study and practice, one should build the letters into the hand. The letters themselves must speak out of the paper and become an integral part of the message.*

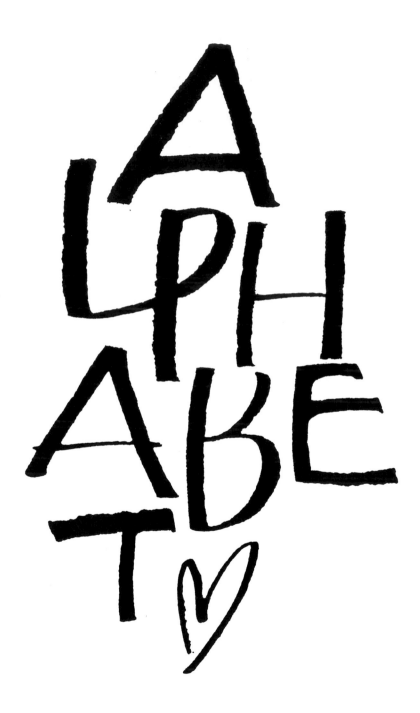

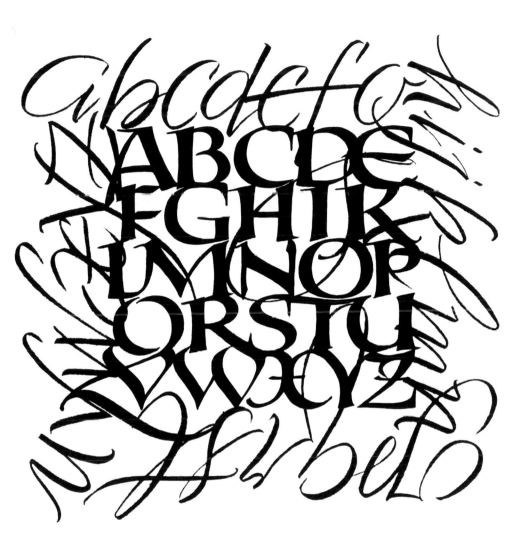

RENÉE ALEXANDER is a full-time freelance calligrapher working out of her home-based studio in North Vancouver. She grew up in an atmosphere of creativity at Alexander Studio. Her father, the late R.S. Alexander, was a well-known Vancouver artist and her mother, Irene Alexander, is a calligrapher whose work also appears in this collection.

After graduating from a two-year diploma program in the applied arts, Renée became a display artist at Eaton's Pacific Centre. While working in display, she spent three consecutive summers pursuing her calligraphic training. A workshop in Britain taught by Ann Hechle was followed by two summers studying with Sheila Waters in Maryland, where Renée received an excellent grounding in the basic letterforms.

Renée is married and has two very energetic children. Although she has a busy home life and a full-time career, she is actively involved with the Westcoast Calligraphy Society. She has arranged many workshops for the society, including presentations by Susan Skarsgard and Julian Waters. Renée also chaired a committee to organize the *East West Exhibition,* Vancouver's first exhibition of Chinese and Western calligraphy.

In the future, Renée plans to create more calligraphic art pieces and to continue to promote calligraphy to the public. She believes that, because so many people have access to computer lettering, hand lettering will become more desirable for its unique qualities.

ALPHABET COMPOSITION. Pentel Color Brush for screened script, broad-edged brush with gouache for black overlay.

LYNDA BOESENKOOL has always loved letters and colour. She is a graduate of the four-year program in Visual Communications at the Alberta College of Art. Her studies there gave her a solid understanding of the principles of design, but barely touched on the art of fine lettering.

After graduation, Lynda worked as a production artist, while further developing her appreciation for precision and her understanding of type. A passion for hand lettering led her to join the Bow Valley Calligraphy Guild, where she has been inspired by the activities and the work of the members, and has attended many classes and workshops.

Visiting instructors to the BVCG have influenced Lynda's outlook on calligraphy. She has admired Susan Skarsgard's unique handmade books; Carl Rohrs's "rebellious approach" to seeing and discovering new lettering styles; and Connie Furgason's sensitivity in combining colour and words.

Lynda's career in graphic arts was interrupted for several years as she devoted her time to caring for her two young children. As she resumes her work in freelance design, she is exploring the use of the computer as a design tool.

Lynda has studied the work of Dutch abstract painter Piet Mondrian, and respects his use of vertical and horizontal structure. She seeks inspiration in the colours and textures of nature, and is strongly attracted to the blue hues of water, sky and mountains. Having recently become interested in quilting, Lynda is excited about working with an infinite variety of textures and colours in a new medium.

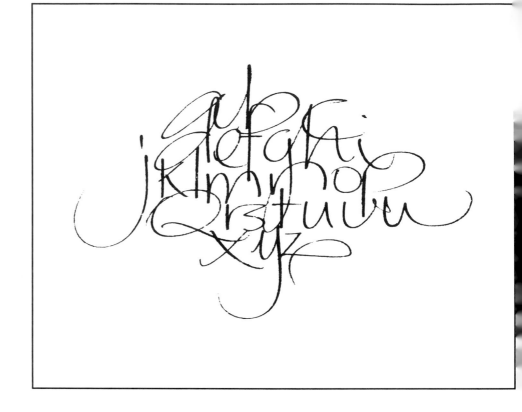

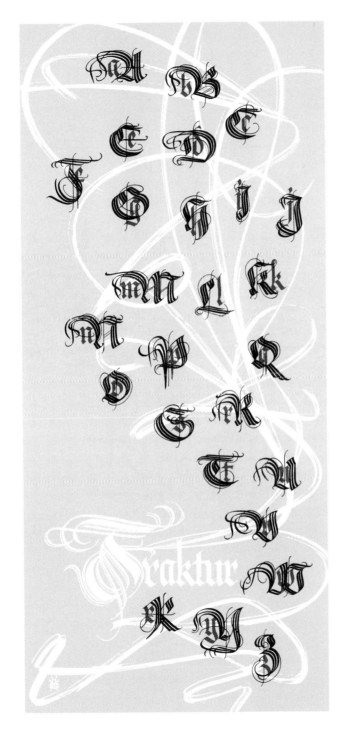

ALPHABET COMPOSITION. Mitchell nibs and quills. *I tried to find alternatives to the traditional "elephant trunks" in the upper case letters.*

MARK LURZ was raised in a small village near the town of Basel, Switzerland. At the age of sixteen, he entered into an apprenticeship as a colour retoucher with a gravure printing company. During those four years of practical training, he also attended the Arts and Craft School of Basel, where he took his first formal classes in calligraphy.

In 1967, Mark immigrated to Canada. He found work in the engraving house where he is still employed, and he met his wife Donna.

As he sought to further his artistic and creative interests, Mark was fortunate enough to find his way into the first classes taught in Toronto by the late Alf Ebsen. Years of classroom studies grew into a lifelong friendship with Alf, whose remarkable insight into the calligraphic arts was very enlightening for Mark.

Mark observes that Alf Ebsen's writing was never without purpose, and that legibility was his prime concern. Mark's own calligraphic work reflects the same approach. In his classes and workshops, he encourages a firm understanding of the basic principles of each calligraphic style. He teaches students of all levels within the greater Toronto area. Although his specialty is Gothic script, he teaches a wide variety of topics related to writing.

As a founding member of the Calligraphic Arts Guild of Toronto, Mark has been actively involved in the group's activities. He has been rewarded with many friendships and many valuable lessons from visiting instructors.

Mark enjoys doing commissioned work for personal customers, friends and relatives; but, as an avid outdoorsman, he sometimes prefers to spend his time windsurfing or cross-country skiing.

WENDY BUCKNER is an Ottawa-based calligraphic artist whose fine hand lettering has flourished over the past decade. In calligraphy, her diverse interests converge: her love of life, language, literature and music find creative expression, often with an unpredictable twist. Recently, she has been combining stained glass with calligraphy, and she often includes her own handmade paper as a distinctive element in her work.

Wendy's signature pieces are "orphan letters," unique items of wearable art. These one-inch squares of paper with single decorated letters are framed between layers of clear glass and worn as calligraphic jewellery. Wendy's work in developing these pieces has been the result of many years of study, and she particularly credits the influence of Heather Mallett and Gottfried Pott, and the enthusiastic atmosphere of the Calligraphy Society of Ottawa.

A former editor of the CSO's newsletter, Wendy remains a regular contributor, and she recently coordinated a mail art celebration of the society's tenth anniversary. Her career has included public relations and print production, and she enjoys doing work for reproduction as well as interpretive lettering. Her broadsides and artist's books have been exhibited locally and internationally, and she recently had her work selected for inclusion in an international brush lettering exhibition held in honour of Karlgeorg Hoefer.

In late 1988, Wendy's life and career took a dramatic turn when she was struck by a hit-and-run driver. This event had a significant effect on her life and work, and she took refuge in her garden and her calligraphy. Wendy has retained both her sense of fun and her sense of wonder, and she hopes that these are reflected in her work. She shares her downtown Ottawa home with a cat, an iguana, some fishes, the odd houseplant and lots of bookshelves.

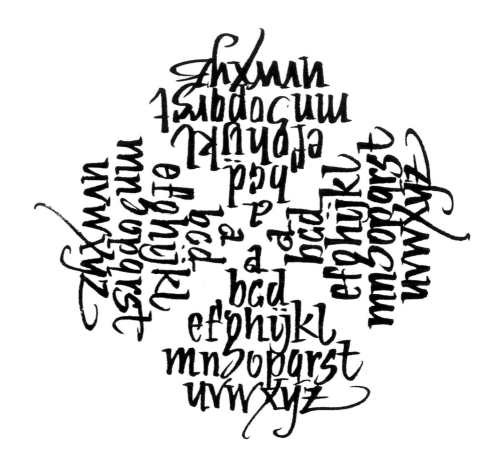

ALPHABET PATTERN. Brush and ink on paper. 15 x 15 cm.

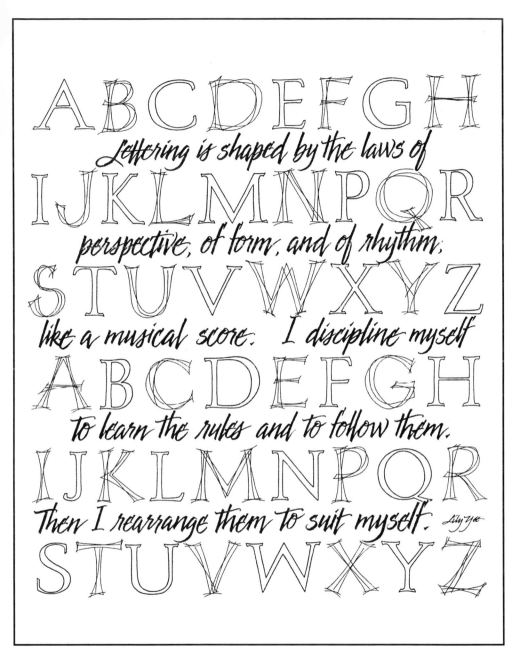

ABCDEFGH

Lettering is shaped by the laws of

IJKLMNPQR

perspective, of form, and of rhythm,

STUVWXYZ

like a musical score. I discipline myself

ABCDEFGH

to learn the rules and to follow them.

IJKLMNPQR

Then I rearrange them to suit myself.

STUVWXYZ

REARRANGING THE RULES. Pigma pen and felt tip pen on bond paper, Kuretake Takara pointed brush on charcoal paper. 24 x 27 cm. *Learning the rules, then rearranging the rules: it is a disciplined hand that understands creative freedom. A free form tri-stroke alphabet design tests the tolerance of the classic Roman hand. The text in pointed brush lettering explains the philosophy while providing a textural counterpoint to the fine line design of the two alphabets.*

LILY YEE has a passion for lettering that stems from her affection for the written word. Well designed calligraphic art attracts a viewer to look and to contemplate. Lily believes that the lettering artist is an interpreter, and that it is necessary to know the author's work and to understand the context of the chosen words.

Lily has been engaged in calligraphy since 1986, and she has studied with instructors from Canada, the United States and Australia. She is indebted to Reggie Ezell for developing intensive courses that have encouraged her to study lettering, to experiment with techniques, and to expand her artistic horizons.

In addition to participating in the ongoing activities of the Calligraphic Arts Guild of Toronto, Lily enjoys meeting regularly with a group of colleagues who provide critique on works-in-progress while exchanging ideas and motivating each other. She delights in poring over publications on the lettering arts, and she attends international conferences to gain a broader perspective on calligraphy.

Lily is a full-time administrator at the University of Toronto. Outside of office hours, she enjoys lettering in her home studio, which overlooks a park and has a spectacular view of the sunset.

To become complacent is to stagnate. Challenging projects and experimentation motivate the artist to stretch. Lily believes that creative achievement is restrained only by two obstacles: limited skill and unfeasible design ideas. Limited expertise compels the artist to study and to practise. Unrealistic design ideas die hard, but spark ingenuity before fizzling. Otherwise, the artistic interpreter knows no limits.

TRUDY NOVACK was trained in New York and California as a teacher of physical education. When she attended a conference on sport and art, she was impressed with the connection between the two, and became more aware of her own artistic inclinations. She discovered calligraphy in 1974, but did not find an opportunity to take a class until four years later in Montreal when she began with Hebrew and Gothic.

As a left-hander, Trudy found calligraphy very challenging, but she applied herself with determination and optimism. She has studied with Sheila Waters, Peter Thornton, Donald Jackson and many others, but she credits Bob Boyajian, also a lefty, for the insight and encouragement that has most influenced her career.

With Marion Zimmer, Trudy was a co-founder of La Société des Calligraphes de Montréal in 1979, and she has devoted much of her energy to its leadership and growth. She has participated in many exhibitions and has promoted calligraphy on television and in print.

Teaching has always been a great pleasure for Trudy, whose love for the artistic expression of letters has led her to further studies in drawing and painting. Through her lettering and design studio, Design 2001, she has created many logos, awards, brochures and posters. As a part-time journalist and radio commentator, she relishes a challenging interview about controversial issues, and she is at work on a book about taking responsibility for one's life.

Now that she has been a Montrealer for more than twenty years, Trudy enjoys the *joie de vivre* of Quebec, and she looks forward to having more time to explore the artistic side of her calligraphy.

Playing with letters is my greatest joy! I hope that some day calligraphy will be as respected worldwide as any other art form.

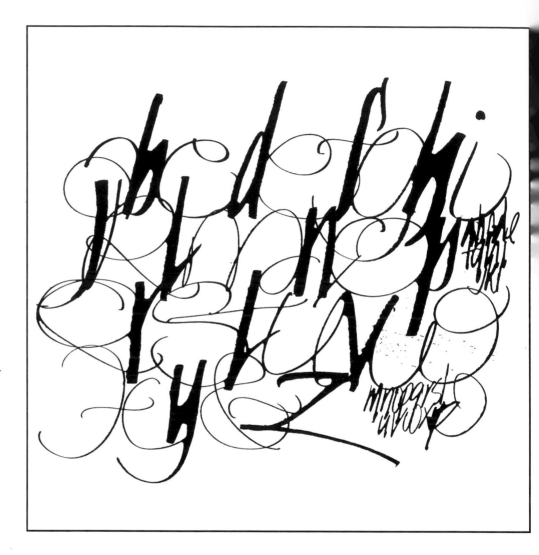

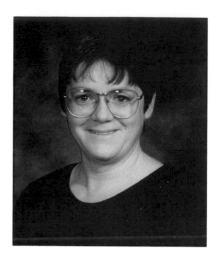

BEANY DOOTJES was born in Haamstede, Netherlands, and came to Canada with her family as a young child. Her mother often made quilts, braided rugs and knitted garments, and Beany began to enjoy sewing and fibre arts while growing up in rural Manitoba.

In 1974, Beany graduated from Red River Community College with a diploma in Advertising Art. During her studies there, she had a short course in calligraphy ... "just a taste!" She continued to develop her interest in textiles, specializing in inkle weaving, making rugs and transparencies on a four-harness floor loom.

Beany began a correspondence course in calligraphy in 1988, working for two and a half years to complete Bookhand and Italic programs supervised by Connie Furgason. She is a continuing student of Betty Locke's annual summer course at Lakeland College in Vermilion, Alberta, and she has attended two Alberta calligraphy conferences.

Beany teaches classes in Neuland, Blackletter, Uncial, Bookhand and Italic, as well as *The Artistry of the Edged Brush,* an introduction to calligraphic and floral brushstrokes. As an artist in residence at a community school, she recently introduced students to basic bookmaking, calligraphy and edged brush techniques.

Living in a rural community in northwestern Alberta, Beany sees her calligraphic isolation as a mixed blessing. Although she sometimes misses the opportunity to attend workshops, she appreciates her independence and is determined to develop her own style and judgment.

ALPHABET SNOWFLAKES. Brause nib, Higgins ink on Mayfair cover. *This was an experiment with the Blackletter hand prior to teaching a class.*

KRISTINA KOMENDANT is a graduate of the University of Guelph and the Kelsey Institute in Saskatoon. She worked as a microbiology research technician from 1980 to 1990 before deciding to pursue a full-time career in the arts.

Through her design business, Kalligraphia by Kristina, she serves commercial and personal clients, creating logos, stationery, certificates, family trees and broadside poetry pieces. Her marbled papers are available to advertising agencies for use in corporate identity packages.

Although largely self-taught, Kristina has attended many workshops in Canada and the United States. She has taken instruction from internationally recognized calligraphers, including Martin Jackson, Susan Skarsgard, Thomas Ingmire, Timothy Botts, Carl Rohrs and Marilyn Reaves; and with well-known bookbinder and marbler Don Guyot.

Kristina's interest in calligraphy and its applications has led her to explore related subjects, including bookbinding, marbling paper and fabric, and the processing and preparation of parchment and vellum, for which she uses deer and sheep skins. She often complements her calligraphic texts with pen and ink drawings and watercolours.

In our fast-paced technological society, Kristina believes that it is important to educate the public about the inherent beauty and spirit of handmade letters. To this end, she teaches calligraphy at the Saskatchewan Craft Council and writes for its publication *The Craft Factor* on calligraphy and related topics. She is preparing forthcoming exhibitions of her work.

In the years to come, Kristina hopes to maintain the delicate balance between the challenge of commercial assignments and the creativity of artistic accomplishment.

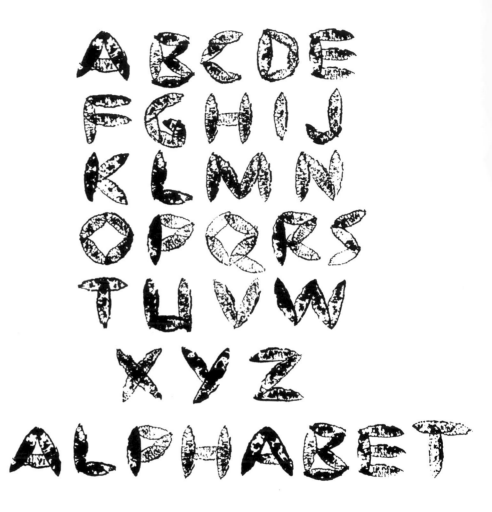

CATTAIL STALK ALPHABET. 22 x 28 cm. *I enjoy finding natural objects and materials to experiment with in letterform construction. The cattail plant, which grows in marshy areas, is quite versatile. A sturdy reed pen can be made from the top of the flower stalk. Further down, the stem becomes more fibrous, and I have used a layer from this section of the plant to create letterforms with an interesting texture.*

I manipulated the torpedo-shaped stalk to form letters similar to Neuland. The movement and density of ink changed as I moved from letter to letter and, as the tool became drier, the detail of the fibre network became clearer. Each letter is different in density of ink and quality of line.

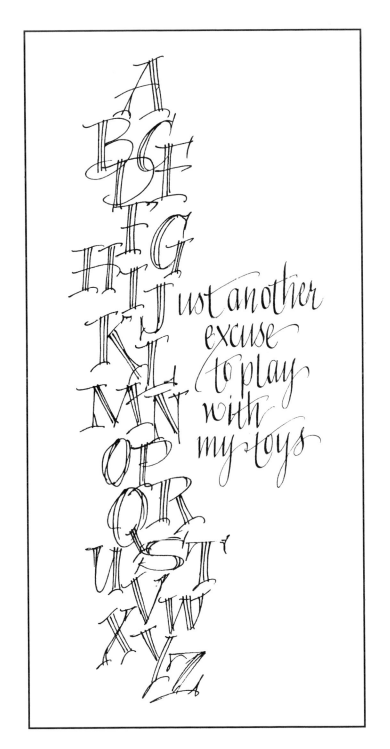

Pigma pen and Hiro #40.

CYNTHIA FOREMAN grew up in southern Ontario, where her father was a sign painter. She began taking calligraphy workshops in 1980 with the late Alf Ebsen, and she knew that she had found a lifelong pursuit.

Although she has learned something new from every workshop, Cynthia continues to respect the influence of Alf Ebsen, who emphasized legibility. She also attended a year-long class with Reggie Ezell, who introduced her to many tools and materials. The continuity of the extended class helped her to raise her skill level.

Cynthia has attended conferences and summer schools in the United States and England. In 1993, she travelled to Austria with three other Canadian calligraphers to take a two-week class at Friedrich Neugebauer's studio. She gained a new awareness of the rhythm of writing, "getting a sense of the letters and doing your own, changing them as the text dictates." She admires the elegance of Neugebauer's work, and his book, *The Mystic Art of Written Forms,* is Cynthia's absolute favourite.

Cynthia has taught workshops on Versals, bookbinding, and design with calligraphic tools. Her chief goal is to execute letters with skill, using style, colour and design to suitably express the meaning of a given text.

Recently retired from Bell Canada, Cynthia now devotes most of her time to lettering and freelance work. Her other interests include reading, learning German, and exploring the potential of the computer. She enjoys the activities of the Hamilton Calligraphy Guild and the camaraderie of other calligraphers.

CAROL AYERS was born and raised in Toronto, "the black sheep of a family of academics and accountants." After obtaining her Bachelor of Arts degree in English at the University of Toronto, she began her self-directed art education, which has led her on an exciting voyage of discovery.

As a potter in the nineteen-sixties, Carol noticed calligraphic marks used in the decoration of pots. She had been reading Nicolete Gray's *Lettering as Drawing,* and she became interested in the possibilities of texture and pattern in letters. These observations led her to investigate calligraphy (which eventually eclipsed her interest in pottery), and she went on to learn about printmaking, drawing, painting, letter carving and bookbinding.

Carol feels fortunate to have studied, as a rank beginner, with Sheila Waters. Other influential instructors have included Mark Van Stone, with whom she has studied many times in many areas of calligraphy; and Tom Perkins, Martin Wenham, Sarah More and John Benson, who have given her instruction in letter carving.

As a member of the Calligraphic Arts Guild of Toronto, Carol teaches beginners and advanced students, and she presents workshops in calligraphy and related subjects for other groups. Teaching is very important to Carol, and she feels that she has learned a great deal about what is really important in an approach to lettering. She places great value on technical skill, and she respects calligraphic traditions combined with innovation.

A calligrapher's work has to be personal in some way or one might as well use type. The quality of the line and the marks of the tools are the things that cause the excitement that hand lettering generates!

COUNTERPLAY. Collage, brush and pen lettering.

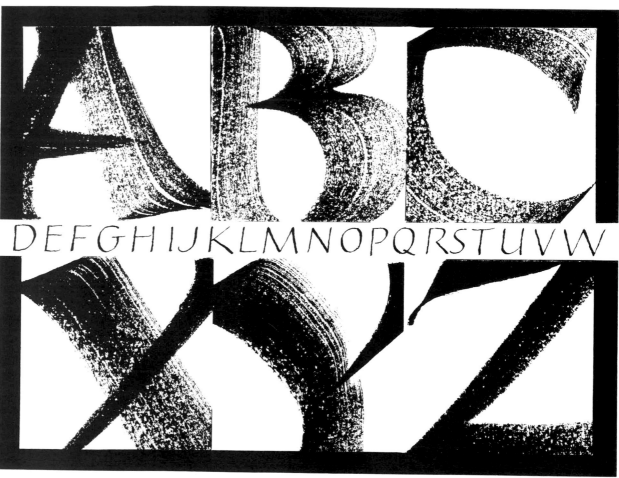

ABCDEF GHIJKL MNOPQ RSTUV WXYZ

Fred Salmon was born in Nelson, British Columbia, in 1922 and spent his childhood on a goat ranch in California. He attended the University of California at Berkeley, but found it boring, and left in 1942 to join the Royal Canadian Air Force. He served as a pilot until 1946, flying to five continents with the RAF Transport Command.

After the war, Fred attended the California College of Arts and Crafts, where he studied lettering and was inspired by teachers Carol Purdy and Wolfgang Lederer. He claims to have failed with the broad-edged pen, and preferred to draw the letters.

Fred's career in graphic design began in San Francisco, where he designed matchbook covers, cookie boxes and manure bags. He then moved to New York, where he began a thirty-year career in lettering, using a crowquill to inscribe greeting card copy ("doggerel") for companies all over the United States.

After moving to Victoria, Fred joined the Fairbank Calligraphy Society in 1980, and began a "belated calligraphic education" in which he at last acquired an affinity for the broad-edged pen. He began teaching in 1983 and has become a respected instructor who appreciates lettering as a disciplined and refined craft. He has served the FCS as librarian and as a collaborator on the quarterly newsletter.

Classic Roman caps are Fred's favourite letters. He claims to be less than enthusiastic about "expressive" cacographic smudges. Fred enjoys classical and jazz guitar, fuji apples, heretical books, cloudy days, late nights, silence, pessimistic wit and red wine. He takes a dim view of physical exertion, tidy studios, neckties, summertime, talk shows and the penalties of growing old.

Drawn classic Roman capitals, based on the forms and proportions of the Trajan inscription. H, J, K, W, Y and Z are made to conform to Trajan letters. Outlined and filled in with pointed pen and brush, ink.

PATRICIA C. DUKE enjoyed a music-filled upbringing in the city of Sheffield, in northern England. Her resourceful family valued originality, which inspired Pat to make her own clothes by hand and to redesign her writing, making each letter different from the way she had been taught. Her teachers discouraged this form of self-expression and required her to conform to traditionally accepted style.

At the age of eighteen, while attending Weymouth Teachers College, Pat was introduced to Edward Johnston's Foundational hand, which was to influence her classroom charts and blackboard inscriptions for many years to come. She relished the opportunity to introduce Foundational to elementary school pupils in Canadian classrooms, and is gratified to know that many of her former students have continued to use and appreciate those beautiful letterforms.

After retiring from teaching, Pat joined the Calligraphic Arts Guild of Toronto and began to appreciate the precision of traditional letterforms. She took a year-long workshop with Lynn Lefler, *Starting Again From Scratch.* With Diannah Elizabeth Benson, she studied the precise forms of Copperplate; and with Lothar Hoffmann, she learned the rudiments of layout and design. She plans to study Uncial and Versal letters and has practised these from such books as Jacqueline Svaren's *Written Letters.*

Pat has served the Calligraphic Arts Guild of Toronto as secretary and vice president, and she considered it a privilege to hold the office of president during the celebration of the guild's twentieth anniversary year.

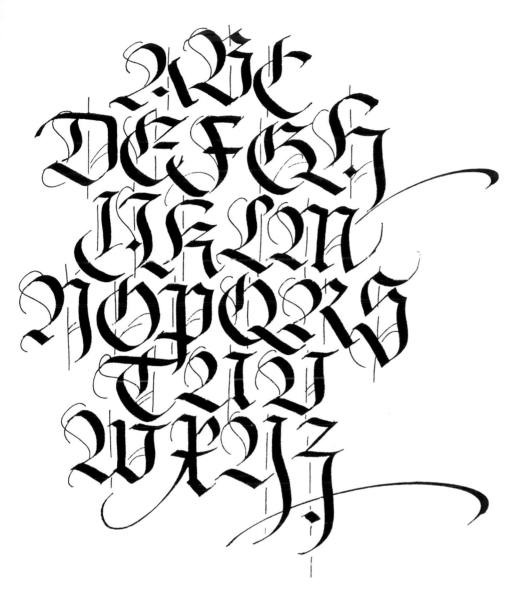

This composition of capital letters is loosely based on the "Wilhelm-Klingspor-Schrift," a typeface designed by Rudolf Koch. I find the flowing structure of the letters and embellishments a refreshing contrast to the lower case letters, which have a strong vertical pattern.

RENATE WORTHINGTON came to Canada from Germany as a young child, and grew up on a farm in northern Alberta. In her home were several hand-lettered plaques in Germanic script, and she was always interested in the variety of letter styles.

After completing her Bachelor of Education degree, Renate taught high school French and Language Arts for seven years. In 1979, she took a calligraphy course in hopes of learning sign lettering. She became aware of many possibilities in lettering styles and began to take workshops from instructors in Calgary and to attend conferences in Canada and the United States.

Renate became a charter member of the Bow Valley Calligraphy Guild in 1981. She has studied with more than thirty instructors, each of whom has made a unique contribution to her search for her own interpretations of calligraphic art. She also teaches children, adults and seniors, and she finds that her students often inspire and motivate her work.

Renate has a bright, efficient studio in the home she shares with her husband Keith and their two daughters. In her commercial work, Renate has fulfilled a wide variety of commissions including banners, church charters and formal and informal certificates. Her posters and store signs can be seen in many of Calgary's malls and boutiques, bringing a touch of colour and elegance wherever they are displayed.

An accomplished photographer, Renate often takes her camera along while hiking, biking or skiing. She has made many beautiful cards combining nature photographs and calligraphy. Her latest work involves decorative painting of floral motifs, using acrylic paints on walls in the homes of private clients and in show homes.

73

ELIZABETH ANN BAILEY TRESIZE was born into an artistic family in Belfast, Northern Ireland. She obtained an Art Teacher's Diploma from Belfast College of Art and taught in high schools from 1950 to 1963, when she immigrated to Canada.

Ann first experimented with the edged pen at the age of thirteen, but it was during her five years in art college that she was taught from Edward Johnston's classic manual *Writing & Illuminating & Lettering.* Her instructors included James Dibble and Miss Mercy Hunter, who had been a student of Johnston's in the 1930's.

Shortly after her arrival in Canada, Ann met Professor Sam Black of the University of British Columbia, and his recommendation resulted in commissions for her work. In 1968, she met Esmé Davis, who had also been a student of Edward Johnston. Ann and Esmé presented demonstrations of calligraphy for several years during events at the Art Gallery of Greater Victoria.

Ann attended a summer school session of the Society of Scribes and Illuminators in England in 1972, and studied with Ann Hechle. She also acquired four original panels of work by Irene Wellington, and these have been a treasured inspiration in her work.

Ann was a founding member of the Fairbank Calligraphy Society in Victoria in 1976, and she has taught classes for the members of the FCS, and for the public at Camosun College. She has now retired from teaching to enjoy travelling with her husband David.

Retaining a strong commitment to support the calligraphic community and to encourage interest in the book arts, Ann hopes to see children being taught to write well, with pleasure and for enjoyment.

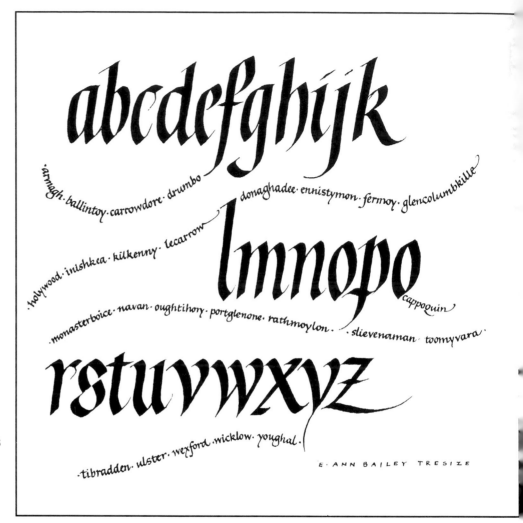

AROUND IRELAND ALPHABETICALLY. Winsor & Newton ink, Brause nibs.

O nuit! O rafraichissantes ✦
ténèbres. Vous êtes pour moi le
signal d'une fête intérieure, vous
êtes la délivrance d'une angoisse
Dans la solitude des
plaines, dans les ✦
labyrinthes pierreux
d'une capitale, scintillement des
étoiles, explosion des lanternes
vous êtes le feu d'artifice de la
déesse Liberté. ✦ Crépuscule, ✦
comme vous êtes doux et tendre
les lueurs roses que trainent ✦
encore à l'horizon, imitent tous
les sentiments compliqués qui
luttent dans le coeur de l'homme
aux heures solennelles de la vie.

From Baudelaire.

MARJORIE HUGHES. An early interest in illustrated verse led Marjorie Hughes into the field of calligraphy. Following art studies in Saint John, New Brunswick, she began a career as a graphic artist. The discipline and skill she had learned in lettering at school would prove valuable in her chosen work and in her practice of beautiful writing.

Marjorie's career began in the advertising department of a Saint John store. Her work then took her to Toronto, where she later joined Coutts Hallmark as a designer of greeting cards. During these years, Marjorie's attraction to illustrated verse grew, and she continued to develop her skill in calligraphy.

Honour scrolls, testimonials and book inscriptions were among Marjorie's first private commissions. In 1939, she was approached by the Loyalist Society of New Brunswick to create an illuminated address for King George VI on the occasion of the Royal Visit to Saint John.

In the 1950's, Marjorie and her husband established a studio specializing in silkscreen printing. Marjorie taught calligraphy classes at the Saint John Craft Centre and continued to produce private works, including family trees and original verse compositions. Exhibitions of her work have been held at the University of New Brunswick and the Saint John Free Public Library.

Now in her eighties, Marjorie reflects with pleasure on the feeling of tranquillity achieved in the midst of creating an intricate piece. *It was rather like being a scribe of old, working in his cell in deep peace, with infinite time to create a manuscript beautifully.*

CONNIE FURGASON admires her mother's talent and initiative, and together they operate a studio and art gallery at Connie's acreage home near Lethbridge, Alberta. While Connie organizes classes, orders calligraphy supplies and fulfills her freelance commissions, her mother creates architectural ceramic murals for public and private clients.

Connie had been experimenting with calligraphy on her own until 1980, when she attended a forum in Vancouver with Thomas Ingmire and Martin Jackson. Since then she has studied with many instructors, attended several Canadian and international gatherings, and worked as a key organizer for the Lethbridge conference, *Kalligraphia 93*.

As a travelling instructor, Connie has visited many guilds in Alberta and British Columbia, and she continues to teach classes through Lethbridge Community College. She has also given instruction by correspondence. An active member of the Bow Valley Calligraphy Guild and the Chinook Calligraphy Guild, Connie believes that such groups provide strong support for calligraphers at all stages of their development.

Having collaborated with other artists and poets to make painterly broadsides in which her calligraphy heightens the expressiveness of the words, Connie is excited about colour and texture in her work, and is making plans to prepare a one-artist show.

In her busy life as a mother of four, Connie makes time to appreciate the process of calligraphy, and finds satisfaction in the experience of pen on paper. *The physical act of working on a piece is as important to me as the end result.*

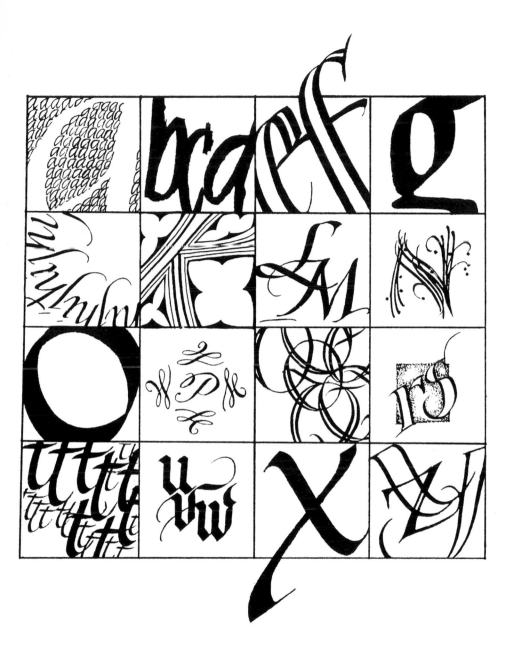

ABC Squared. *Each block in this configuration has been designed as a piece on its own. Numerous tools, styles, ideas and hands were combined to make each block within the framework, which acts to unify the diverse styles.*

Betty Locke remembers her childhood love of colouring, drawing and painting, and she says that art has always been a driving force in her life. At the University of Alberta, she majored in Art Education and Fine Art, and then began a teaching career in secondary schools in Edmonton and Calgary. Marriage and motherhood altered her career pattern, but not her artistic inclinations, and she found that home crafts brought new direction and dimensions to her creative repertoire.

In 1977, Betty attended the University of Oregon, where she earned a Masters degree in Art Education. She then began her study of calligraphy, which ultimately provided her with creative challenges, career opportunities and intellectual stimulation beyond her expectations.

Betty began teaching classes in Calgary in 1979. She has been a visiting instructor to many groups in Canada and the United States, where her work has also appeared in several exhibitions and publications. Her book *Teach Calligraphy? Who? Me?* was self-published in 1993. She is a founding member of the Bow Valley Calligraphy Guild in Calgary, and she has been awarded an honorary life membership by that group.

Betty believes that calligraphy embraces many arts and offers creative opportunities to all who study it ardently; that its practicality, its artistry and its wide appeal make calligraphy a fulfilling, worthy and vital art form. Always a nurturer and supporter of beginners, Betty sees them as the lifeblood of the continuance of calligraphy.

Betty has recently relocated to Duncan, British Columbia, on Vancouver Island. There she resists retirement.

All arts are brothers, each a light to all the others. Voltaire

L YNN S LEVINSKY was born and raised in Edmonton. Her father encouraged her to draw and paint, and she enjoyed art lessons at the Edmonton Art Gallery as a child. At the University of Alberta, she completed a Bachelor of Education degree with a major in Household Economics and a minor in Fine Art.

Piano and singing lessons nurtured her love and appreciation for all kinds of music, and have had a strong influence on her calligraphy, especially her choice of texts. Other interests such as sewing, weaving, quilting and silk painting have also enriched her work.

Many teachers have influenced Lynn's calligraphic style, including Tim Botts, Martin Jackson, Ann Hechle, Jean Formo, Betty Locke and Renate Worthington, who introduced her to the intricacies of Celtic knot designs. The books in the Bow Valley Calligraphy Guild library have also been a source of inspiration to her.

Lynn teaches calligraphy to children and adults, and she also teaches classes that combine calligraphy and the making of handmade greeting cards. She has a love of beautiful papers and rich colours, textures and detail. She enjoys putting these together in her cards. Lynn felt that having her work chosen for publication in *The Spirit of Calligraphy* was an important achievement, and she looks forward to the challenge each year to create calligraphy for display at the BVCG's annual Devonian Gardens Exhibition.

Lynn has great appreciation for the skill and dedication of the calligraphers who produced the illuminated Bibles and books of the past, and she continues to strive to create beautiful letters herself.

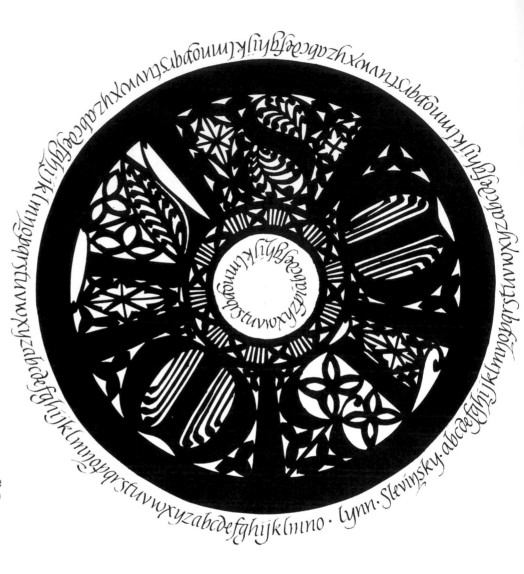

This piece was completed as a homework assignment during a class with Betty Locke at Lakeland College. Because it was designed and executed in just a few hours, there was not a great deal of time for planning. The design was sketched onto white paper, then clipped to black Canson, and both layers were cut at once, using an x-acto. The cut paper was then glued to 140 lb. Arches hot pressed paper and the alphabet letters completed using sumi ink and steel nibs. The letter "S" begins our family surname, while the other letters are the initials of each family member. 39 cm in diameter.

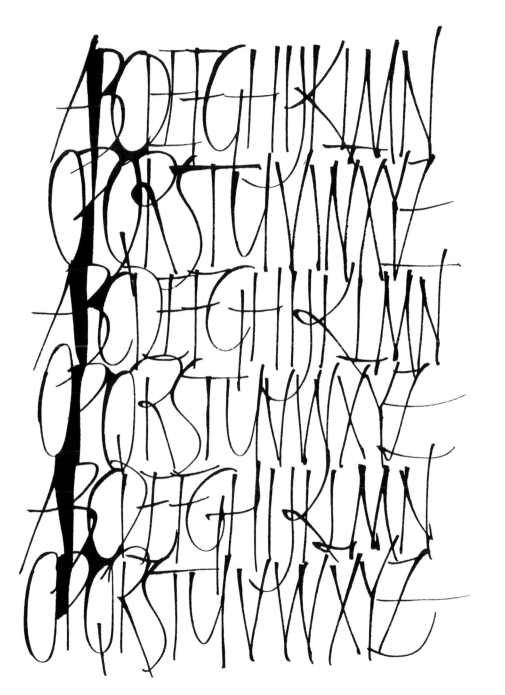

KATHY FEIG was born in Budapest in 1955, and has lived most of her life in the Montreal area. Now she resides with her husband and two children in the farm country just south of the city, where she enjoys horseback riding, T'ai Chi and yoga.

Her lifelong interest in writing led Kathy to begin her study of calligraphy in 1979 at the Saidye Bronfman Centre In Montreal. A visit to the British Museum in 1981 inspired her to begin teaching calligraphy. She has taught at the Saidye Bronfman Centre, the Visual Arts Centre, Miss Edgar's and Miss Cramp's (a private girls' school) and community centres. She feels that the study of calligraphy is of great benefit within schools, and helps students to develop both patience and discipline.

Kathy became involved with La Société des Calligraphes de Montréal in 1980. She has held the positions of newsletter editor and exhibitions coordinator, and now serves as the group's president.

Kathy studies and admires the works of Edward Johnston, Irene Wellington, Rudolf Koch and Father Edward Catich. Her most influential teacher was Friedrich Neugebauer in 1985, but she has also studied with many British and American experts.

A professional calligrapher for more than sixteen years, Kathy has accepted both private and corporate commissions, and has exhibited her work in Canada and the United States. As she raises her young family, she hopes to complete personal goals in her work.

When asked "How does calligraphy fit into your life?" Kathy replies, "How does a tree fit into the earth?"

MARGARET LAMMERTS began her explorations in calligraphy during a high school art course which included Roman Caps. She has taken many courses and workshops in calligraphy and watercolour, and she has wide ranging interests in the visual arts.

A longtime member of the Edmonton Calligraphic Society and the Bow Valley Calligraphy Guild, Margaret has attended summer workshops by Betty Locke at Lakeland College in Vermilion, Alberta. Her studies have been enriched with books such as *Written Letters* by Jacqueline Svaren and *The Creative Artist* by Nita Leland.

Margaret has designed three book covers and numerous logos and letterheads. She takes an exuberant approach to her work by using vibrant colours, and she enjoys "breaking the rules." She teaches calligraphy and papermaking, using recycled materials in innovative ways.

Seeing calligraphy as one part of her volunteer activity, Margaret uses her skills to contribute to her community and to practise "random acts of kindness!"

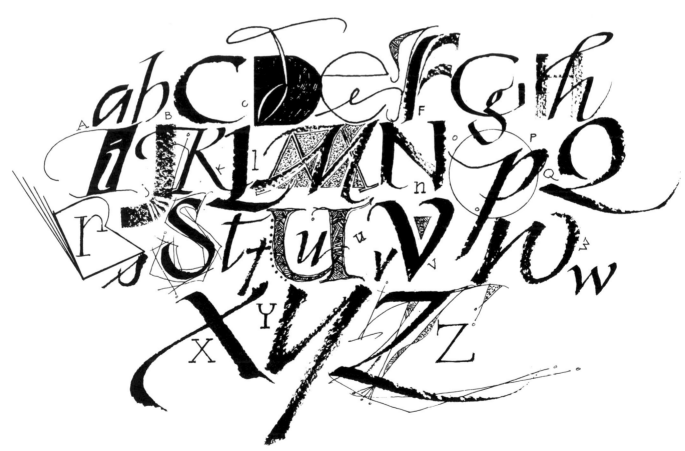

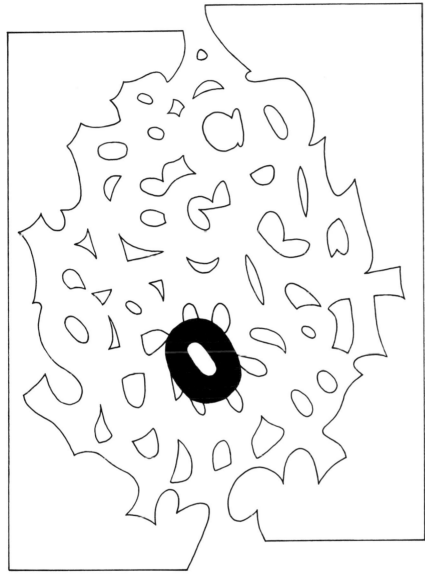

A B C
DEEFGHII
JJKLMNOP
QQRSTUVW
XYZ

Pinball Machine. Pigma pen, ink and brush.
17 x 23 cm.
Rubens. Typeface design.

Susan Nelson was born and raised in the Niagara Peninsula. After graduating in 1967 with a degree in modern languages from the University of Waterloo, she taught high school in Kitchener and later in Toronto. In 1973, Susan and her husband moved to Guelph, and she temporarily retired from teaching to raise their two sons.

Susan took courses in drawing, weaving, pottery, painting and art history before beginning her calligraphy studies in 1979. It was calligraphy that became her passion, and she has taken further instruction in the United States and through the Calligraphic Arts Guild of Toronto. She is a founding member of the Royal City Calligraphy Guild, and she has been an instructor for programs offered by the City of Guelph and Conestoga College.

As a regular participant in annual exhibitions and special shows in the Guelph area, Susan has won a number of awards for her work in recent years. She is represented by Wyget Woods Gallery in Campbellville, and by Collected Works in Toronto. She regularly accepts commissions, and she derives much satisfaction from her work as a freelance calligrapher and artist.

Susan finds expressionistic calligraphy to be an especially stimulating and exciting art form. She enjoys the challenge of transforming traditional letterforms into elements of contemporary composition while maintaining a balance of freedom and discipline.

My goal is to create a visual impression through the placement and manipulation of letterforms ... to visually evoke emotion in accordance with the substance of the text, whether it be dramatic or reflective.

KIRSTEN HOREL was born in California in 1955 and travelled the world, living in Chile and Saudi Arabia before settling in Calgary in 1967. She graduated from the University of Calgary with a degree in Anthropology and Art, and she worked as a technician in landscape architecture.

Kirsten has been learning calligraphy since 1986 and taught her first class in 1990. She teaches a weekly seniors' class and gives workshops in Calgary and elsewhere in Alberta. She finds that it still takes tremendous courage to decide what to teach, and then to go and teach it!

Drawn to rich colours and primitive images, Kirsten believes her best work reflects a fun and funky spirit. Although she admires calligraphers who follow tradition and strive to master fine letterforms, she prefers to break the rules. She enjoys working spontaneously and creating informal letters of her own invention. She often selects "quick" tools: brush felt pens, ruling writer, pencil crayons, graphite and monoline pens. She often incorporates the graphic textural lines and dots that she worked with in landscape architecture.

As Kirsten balances her busy life with her calligraphic pursuits, she draws on the energy of the laughter and silliness that she enjoys with family and friends. Working alone in her studio, she can hear the lively echo of these crazy moments and she delights in getting them onto the page.

I like art that admits to being part of life! Brian Andreas

(right) *I enjoy creating alphabets with a Pentel pointed brush. Curly shapes are made by "following the brush" around in the direction of the stroke. In the title, I used mostly the side of the brush to develop a rhythm. The monoline section was a spontaneous doodle. The last alphabet was developed on the theme of dots and lines - letters with bowls got boxes!*

(far right) *More spontaneous play with the Pentel brush.*

CALLIGRADOODLEBET

83

CRISTIANE DESLAURIERS comes from a creative family. Her father is a professional artist, and her mother enjoys a variety of crafts and visual arts. The family shares a deep appreciation for nature, which remains Cristiane's most enduring source of inspiration.

While studying typography as part of her curriculum in Graphic Design at Algonquin College, Cristiane became interested in letterforms, and she decided to try various styles in hand lettering and sign making. Later she studied with Leo W. de Wit, who encouraged her to develop her skills and to join the Calligraphy Society of Ottawa.

In addition to calligraphy classes sponsored by the CSO, Cristiane attends workshops in bookbinding, folk art and papermaking. She has also been inspired by publications of the Bow Valley Calligraphy Guild and by *The Encyclopedia of Calligraphy Techniques* by Diana Hardy Wilson, and *Illuminated Alphabets* by Patricia Carter.

Cristiane enjoys a growing proficiency with brush calligraphy and she seeks opportunities for freedom and "whimsy" in her work. She plans to improve her bookbinding skills, and one of her long term goals is to create a calligraphic botanical abecedary, complete with illustrations.

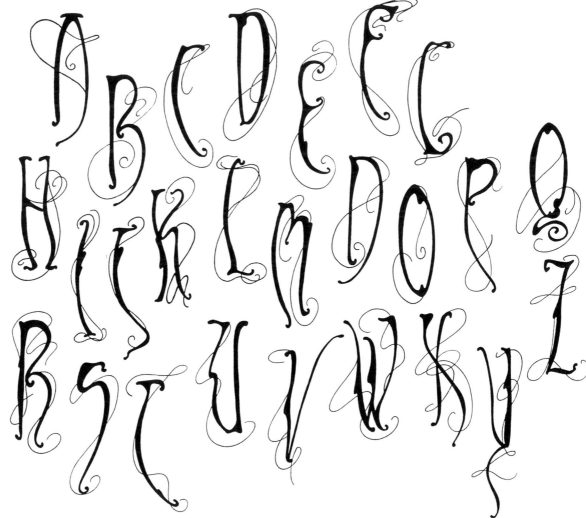

AN ART NOUVEAU ALPHABET: STRINGS.

84

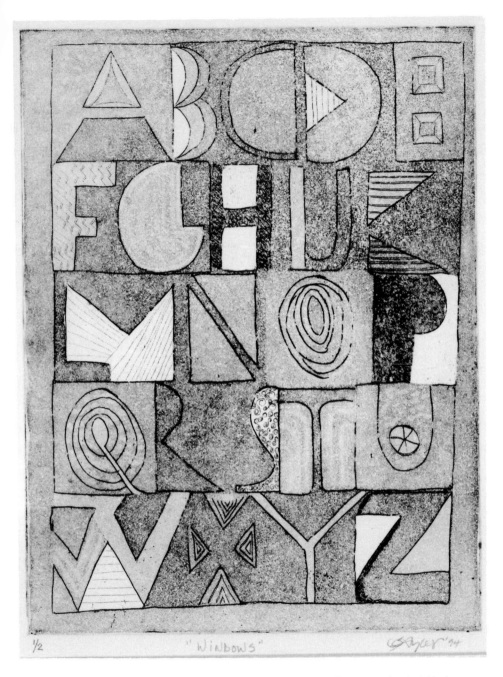

1/2 "Windows" Ayles '94

WINDOWS. Etching on zinc plate. 15 x 20 cm. *Letters were drawn in reverse using dental tools and steel nibs. The plate was then dipped in acid baths.*

SHEONA AYLES grew up in Rosemere, Quebec, and was active in music, dance and theatre. She earned Bachelor of Arts and Bachelor of Education degrees at St. Francis Xavier University in Nova Scotia. During her university years, she began to teach calligraphy through evening classes.

Sheona had experimented with calligraphy after observing various letter styles and imitating them by drawing. Her discovery of the broad-edged pen led to classes in calligraphy, then to a four-day course with Sheila Waters, whose ideas and techniques still form a cornerstone of Sheona's approach to her work. She has also taken classes with Betty Locke, who made her aware of the "lighter side" and the "humanity" of calligraphy.

As a member of La Société des Calligraphes de Montréal, the Bow Valley Calligraphy Guild and the Edmonton Calligraphic Society, Sheona has been influenced and encouraged by friends and by visiting instructors. After a recent workshop with Jean Formo, Sheona has begun to explore creative processes with calligraphic books.

Now living in Hinton, Alberta, Sheona has taught both adult and children's classes in her community. She has had her work accepted into several province-wide art exhibitions, and she rejoices to see the inclusion of calligraphy in such a setting, alongside contemporary painting and drawing.

In her calligraphic design business, Sheona enjoys creating custom work for her clients. She also plans to increase her involvement with the making of books.

ARLENE YAWORSKY has worked as a naturalist, an editor and a public relations representative, but now makes her living as a writer.

Arlene does commercial calligraphy and design work part time. While her typical commissions include poems, certificates and wedding invitations, she is always ready for the unexpected, and has made ceremonial presentations, a design for a door plate, a champagne label and some unusual books. She does many pieces for personal reasons, perhaps to capture a special moment in words and drawings, or to mark a significant event. Arlene also teaches classes that introduce calligraphers to the principles of design.

During her school years, Arlene studied oil painting and later took evening courses in various arts and crafts. She focused on calligraphy after moving to Victoria and meeting Fred Salmon, who became her teacher and mentor for many years. She is an active member of the Fairbank Calligraphy Society, and has served as newsletter editor, workshop coordinator and co-chairperson.

In calligraphy, Arlene seeks out the qualities that make it "handmade" rather than slickly produced as graphic art. *I do calligraphy because it can be irregular. I love surfaces with depth, and marks with surprising changes: textured surfaces, ragged edges, letters of imaginative variety and subtle colour contrasts.*

When not in her studio or at her computer, Arlene can be found outdoors where she enjoys sketching birds, puttering in a kayak or gardening.

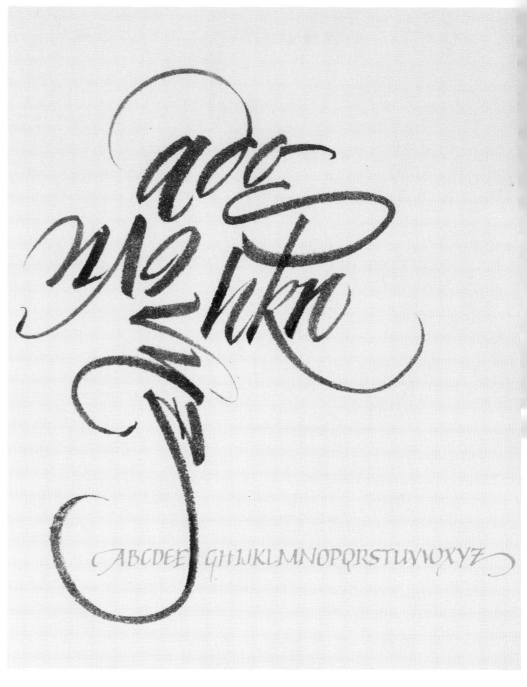

ALPHABET COMPOSITION. Gouache, pointed brush, broad-edged pen on Arches Text Wove. 25 x 21 cm. *My intent was to make a brush "character" using every fourth letter of the alphabet and Z.*

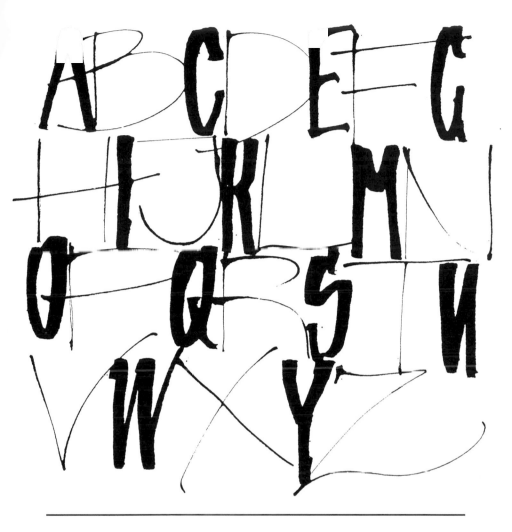

The freedom of the ruling pen excites me, as one can create textures and patterns with such a simple tool!

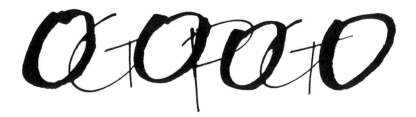

SANDY SOMMERFELD was born in Ontario and raised on the prairies in a small town near Edmonton. Within a close family environment, she was influenced by the creative talents of her mother and grandmother. Sandy later went on to study sign writing and interior design, and the works of Canadian artists.

In 1979, Sandy discovered another outlet for her abundant creative energy when she began the study and practice of calligraphy. While exploring the versatility of lettering arts, Sandy has taken many courses and workshops, and she has been actively involved with several societies, particularly the Kelowna Calligraphers Guild.

Sandy has been a student of Julian Waters, Betty Locke, Martin Jackson and Judith Bain Dampier, and she continues to draw inspiration from her calligraphic friends Jacquie Myers and Kathy Guthrie. She has expanded her skills to include teaching, specializing in Neuland and Foundational alphabets.

It is Sandy's observation that calligraphy as a visual art form has yet to be discovered by connoisseurs of art, and she would like to see the public become more aware of the value and power of calligraphic expression.

Sandy's work has been shown in exhibitions throughout British Columbia and Alberta, and was included in *The Spirit of Calligraphy*, published by the Bow Valley Calligraphy Guild.

Sandy and Boyd Sommerfeld reside in Kelowna, British Columbia, with their two American cocker spaniels. Currently employed as a kitchen designer, Sandy continues to develop and promote her own graphic design business, Sommer Images.

Bev Allen has been studying lettering and related subjects for more than seventeen years. She teaches calligraphy and paper craft classes and does freelance work.

Bev has enjoyed workshops with many renowned instructors. She has attended two international calligraphy conferences, summer programs sponsored by the Fairbank Calligraphy Society in Victoria, and the calligraphy symposium in Calgary in 1986. She regularly attends *Letters of Joy,* the annual festival of letters in Edmonds, Washington.

Because she loves to read calligraphic newsletters, Bev is a member of seven guilds and is a founding member of the Alpha-beas Calligraphy Guild. She is currently coordinator of *The Broad Edge,* the entirely calligraphic quarterly publication of the Alpha-beas. By promoting a hand lettered, hand sewn newsletter, Bev hopes to reach beginners and seasoned calligraphers alike and to remind them of their roots.

After spending more than a year starting the new guild, Bev hopes to focus more time on her personal goals which include: learning classical Romans; improving her presentation skills; mastering pop-ups; and exploring colour in calligraphy.

Bev and her husband Martin live in Langley, British Columbia, with their two teenagers, two bulldogs and one cat.

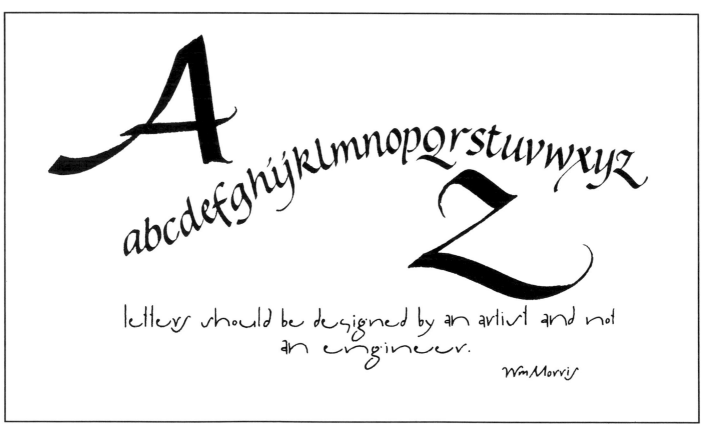

ALPHABET COMPOSITION. Higgins Eternal ink, Tape nib, Techniquill pen and bowl pointed nib. *I use Italic letterforms most of all. The William Morris quotation reflects how I feel about letters. It is written in Akim cursive.*

Cabernet Sauvignon
Burgundy Chardonnay
Zinfandel Madeira Claret
Gewurztraminer Port
Tokay Pinotage
Riesling Sauternes
Beaujolais
Champagne Hock
Frascati Chablis
Port Shiraz
Rioja

SARAH WIDDOWSON. As a high school student in Oxford, England, Sarah was given two calligraphy books which stimulated her curiosity about lettering, but it was several years before she had the opportunity to develop her interest. She worked as a geologist in Britain, South Africa and Australia before coming to Canada in 1989.

While working in Melbourne, Australia, Sarah began to take evening courses in calligraphy, and she resumed her studies five years later, after moving to Calgary. She joined the Bow Valley Calligraphy Guild, which provided opportunities to take workshops from local and visiting instructors. She admires Martin Jackson's precise letterforms and attention to detail, and Lindley McDougall's literary knowledge and quest for new ideas.

In addition to many calligraphic courses, Sarah has attended workshops in papermaking and silkscreen printing. She has been teaching classes in calligraphy and card making for several years, and she welcomes opportunities to exhibit her work and to contribute to publications.

Sarah leads a busy life as a full-time mother and volunteer worker, but she makes time to share her skills within her community, and she seeks to develop her teaching abilities and widen her repertoire of commercial work. She finds it broadening to respond to challenging assignments in calligraphy because they encourage her to grow and mature as an artist.

Copperplate nib and black gouache on Paper for Pens.

SHANNON READ always loved the ornate lettering that adorned the books and enhanced the certificates and awards that she received as a child. After her sister studied calligraphy in a high school art class, Shannon began to acquire instructional books. When she eventually took her first workshop, she was delighted to realize how many other resources were available.

While living in Fort McMurray, Alberta, Shannon had the opportunity to meet and study with other calligraphers, especially Jan Slaughter, who inspired and encouraged her.

After moving to Amherst, Nova Scotia, Shannon enjoyed collaborating with other artists, and she has gained new skills and changed her perceptions about practicality and art. She has noticed that there is very little calligraphic awareness in Nova Scotia, but that the oral traditions of song and storytelling are very rich and colourful, as is the visual art environment.

Now living on Cape Breton Island and directing much of her energy to university studies, Shannon is exploring new ideas which she feels will influence her work in the future. Her calligraphic commissions have allowed her to work from her home studio while caring for her family. *I have appreciated the opportunity to muck around with the children, taking advantage of having a studio and art materials in the house. They've enjoyed it as much as I have!*

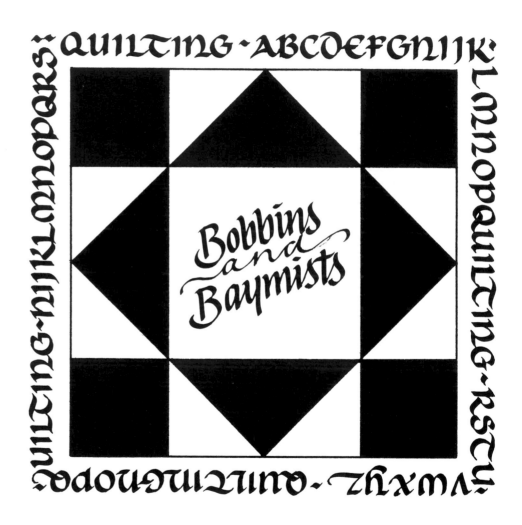

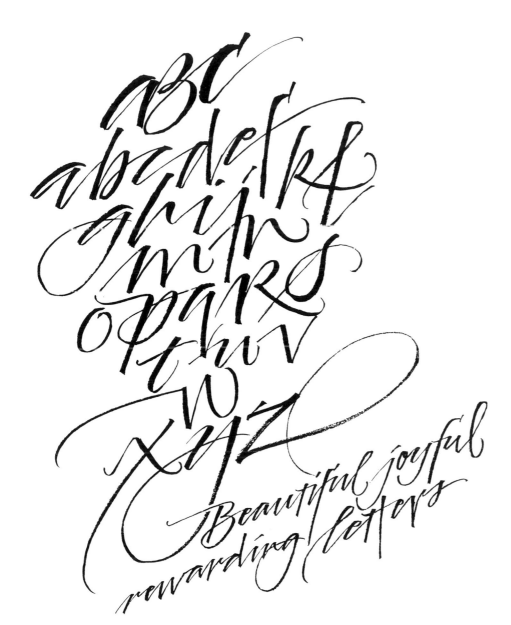

Beautiful joyful rewarding letters

GAIL STEVENS has been doing calligraphy since 1979. She finds this surprising and insists that there is a notable lack of artistic bent revealed in any investigation of her background. On the other hand, her lifelong interest in words, books and literary matters finds a natural affinity in a medium that draws attention to words and meanings.

She began her journey into calligraphy in a class taught by Betty Locke in the basement of a Calgary craft store. Gail soon became an instructor herself, and pursued a knowledge of letters with vigour and enthusiasm.

With the Bow Valley Calligraphy Guild, Gail took classes from Ewan Clayton, Ann Hechle, Fran Strom and Denys Taipale, who was particularly influential because of her insistence on correct form and spacing. When she became workshop director for the BVCG, Gail found herself in a position to fulfil her every learning wish, and she invited many excellent instructors, including Martin Jackson, Eliza Schulte, Peter Thornton and Richard and Teri Stumpf. She also attended international conferences and studied with John Stevens, Leana Fay, Julian Waters, Marilyn Reaves and others.

At first, Gail believed that good calligraphy should be read, and easily read at that; but later, she came to appreciate colour, design and other artistic qualities within the work. She likes a piece to appeal in two ways: from a distance there should be strong design that attracts the viewer visually; closer inspection should reward with the message of the words. "Either part of that equation can be emphasized without loss to the other side."

After spending several years working full time in calligraphy, Gail has resumed her career as a teacher of high school English. She still loves the dance of letters, especially Italic and brush alphabets, and she still teaches weekend workshops in pointed brush.

TYLER LANE was born in 1966 and grew up in Winnipeg. He first tried calligraphy at the age of sixteen when his little sister brought home a calligraphy book from school. He soon bought a boxed pen set and began to practise on his own.

A course in basic Italic, taught by Nancy Flook, was soon followed by courses in Bookhand and Blackletter. Gaye Mackie came from Calgary as a visiting instructor, and she introduced Tyler to Copperplate and Compressed Italic.

Tyler began instructing seniors' groups while living in Winnipeg, and he continued to teach classes after moving to Calgary and joining the Bow Valley Calligraphy Guild.

Tyler's calligraphy has been influenced by several of his instructors. Betty Locke has inspired and encouraged him with her exceptional teaching ability, and Gaye Mackie's beautiful letters continue to impress him. Timothy Botts's approach to expressive design; Ivan Angelic's graceful flourishes and versatility; and Ike Derksen's precisely made letters have all contributed to Tyler's motivation to improve and refine his own work.

Along with his love of hand lettering, Tyler has found creative satisfaction with *Pagemaker* and *CorelDRAW!* as he seeks new ways to enhance his work. He speculates that there is a special message that someone at some time will want the world to know; and that, by doing calligraphy, he is preparing to deliver that message for the generations to come.

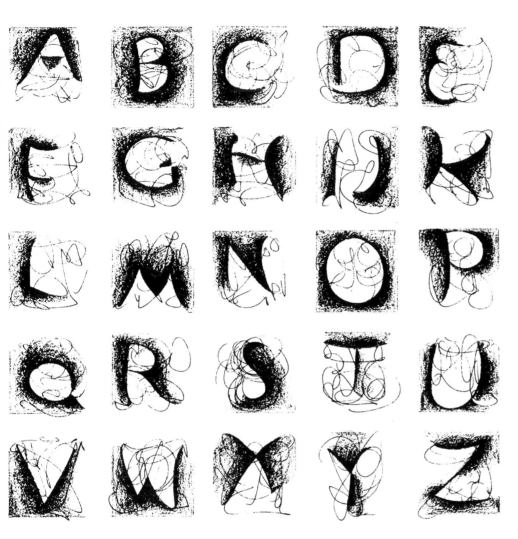

SCRIBBLE ALPHABET. *When I was asked to teach a one-day lettering workshop to high school students, I was looking for ways to make everyone successful - and everyone can scribble!*

HEATHER MALLETT has been a freelance lettering artist since 1980. Her enchantment with the visual arts began in childhood as she observed her artist father at work.

Heather graduated from the University of Toronto in 1958 and taught both elementary and secondary school. As a high school art teacher, she introduced her students to beautiful letters made with a Speedball pen, and she became so enthralled with the process that she began to pursue calligraphic knowledge in earnest.

After attending seven international conferences, making pilgrimages to Sheila Waters' summer school, and bringing many international instructors to Ottawa, Heather has clocked almost one thousand hours of classroom study in the calligraphic arts since 1980. Many fine books have also been important sources of knowledge and inspiration.

Heather's work has been published in *Floraison* and in *Calligraphy Review* (now *Letter Arts Review*), and has been included in juried exhibitions since 1977. More recently, she has participated in numerous group shows and a month-long solo exhibition featuring thirty pieces of her work. As one of four collaborators who made the *The Merchant Navy Book of Remembrance* for the Canadian Merchant Navy, Heather painted more than one hundred illustrations and lettered five folios.

Heather feels that her best work is colourful and expressive, and she enjoys using coloured pencils, pastels and paste paper. Fascinated by the link between creativity and spirituality, she is exploring ways of using lettering and creative expression as both a gift and a ministry to others.

All art is holy. Not that it is all long-faced and miserable; it can be wild and woolly. But if it transforms you, it is art. And it is holy. Robertson Davies

Dirk Van Wyk. During his year of study at the Rietveld Academy in Amsterdam, Dirk was required to take a course in lettering, and he grew to love the formal relationships of positive and negative space that co-exist within letters. He discovered that his experience in drawing could bring the liveliness of response and gesture to the predetermined forms.

Dirk sometimes includes letters or text in his mixed media drawings, paintings and artist's books, and he designs logos as part of his commercial work, but he does not consider himself a calligrapher. He believes that the distinctions between fine and applied art, and the differences between letter form and representational form, are social and cultural constructions. They are upheld for the apparent need to categorize and classify value experiences. For the artist, these distinctions do not really exist.

All work is received as a commission, even if it is self-generated. All work is done for profit, but not necessarily money.

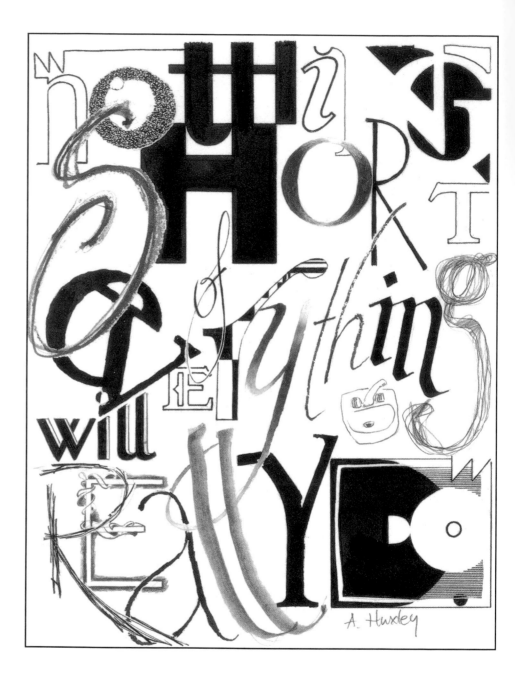

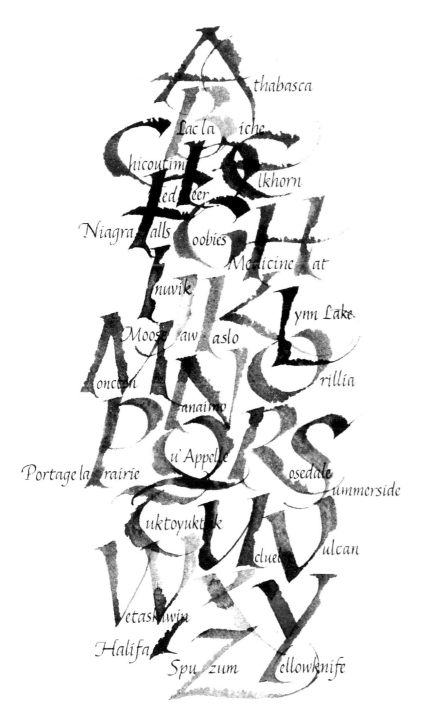

Diana Haines grew up in England in a family of jewellers and watchmakers who sold "wearable art" in the form of precious jewels set in gold and silver. They repaired clocks and watches, deft fingers delicately removing springs and wheels with tiny instruments. Diana's mother was forever sewing costumes or painting scenery for her theatre group, upholstering furniture or hanging wallpaper.

Diana's inherited appreciation for colour, texture and form led her to art college and a diploma in Dressmaking and Design. She came to Canada as a new bride in 1965, arriving in Fort Saskatchewan, Alberta, dressed in a mini skirt and black leather; but she found that the sixties revolution had not yet reached The Fort.

In 1980, while living in Calgary, Diana took her first calligraphy course from Noreen Guzie. She then studied with Betty Locke and became a founding member of the Bow Valley Calligraphy Guild. On moving to Langley, British Columbia, she joined the Westcoast Calligraphy Society, and she has been teaching calligraphy across the Fraser Valley for ten years. In 1994, she helped to found the Alpha-beas Calligraphy Guild.

Diana's trips back to England always include a calligraphy retreat where she can wallow in a bit of history, although she is really more attracted to contemporary expressions in calligraphy. She has studied with many renowned instructors, but she has never forgotten the encouragement she received early on from Noreen Guzie and Betty Locke. Diana plans to continue exploring the endless possibilities of letter design and the visual expression of the written word.

ABC CANADA. *I was influenced by Jacqueline Svaren's Bone alphabet, as I love to play with letterforms. The pen manipulations with an automatic pen, watercolours and Arches 500 paper helped to create this ragged look. The variety of names of places in this country reflect its rich heritage.*

ELYSE PROULX is a versatile artist with many years of education and practice in various disciplines of the visual arts. She studied printmaking at l'Ecole des beaux-arts de Québec and in Geneva, Switzerland, and then earned a certificate to teach at the high school and college level. She has taught life drawing, illustration, colour theory and printmaking at colleges in Rivière-du-Loup, Sherbrooke and Trois-Rivières.

Elyse has been studying bookbinding since 1981 with Simone B. Roy and with Lise Dubois, and she has been a member of La Société des Calligraphes de Montréal since 1986. Her artist's books, which initially included etchings and fine binding, now contain calligraphic text as well. In 1993, Elyse received a grant from the Quebec Ministry of Culture to complete a sculptural book in which she combined engraving, drawing, calligraphy and binding.

Elyse has taken calligraphy instruction from Stan Smith, Peter Thornton, Donald Jackson and Julian Waters, and she has travelled to New York to study marbling with Don Guyot.

Since 1967, when her work was first displayed at Terre des Hommes (Expo 67), Elyse has participated in exhibitions in Canada, Switzerland and France. Since she began developing her calligraphic work, she has won awards for her decorated envelopes and has had her artist's books acquired by the National Libraries of Canada and Quebec.

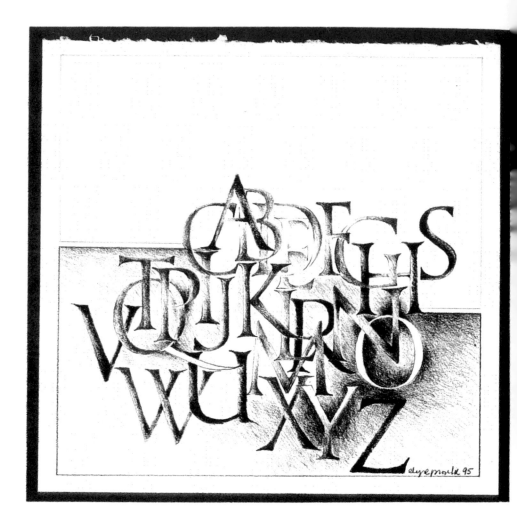

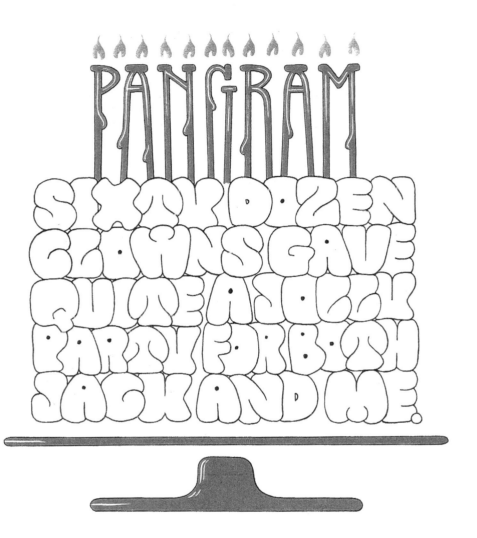

This is a celebration of the pangram, a sentence containing all the letters of the alphabet. The "cake" is made up of marshmallow letters.

MARY CONLEY was born and brought up in a small fishing village in New Brunswick. She took art lessons as a young student and later considered a career in fine arts, but she was encouraged to study science and math at university instead. She moved to Vancouver to attend medical school at the University of British Columbia. During the summers, she went to art school and took drawing, painting, silkscreen printing and pottery.

Mary took a year out of medical school to study at the Honolulu Academy of Arts, where she painted many nudes. She then returned to British Columbia, completed her medical degree and moved to Victoria. Before launching her full-time practice, she attended the Bank Street School of Art.

In 1978, after going to a fascinating lecture by Sheila Waters, Mary bought a calligraphy book and spent the next year struggling to learn the basics. She then began taking lessons and joined the Fairbank Calligraphy Society. She was fortunate to have a gifted teacher, Fred Salmon, with whom she took semi-private lessons for more than three years. She has attended international conferences and summer schools with Martin Jackson and Judith Dampier. Mary sees calligraphy as a very important part of her life, both socially and artistically.

Mary's work was selected for inclusion in the 1995 *Letter Arts Review* annual, and also for the tenth anniversary edition of that prestigious journal. She has been a regular contributor to the *Heart to Heart* calendar in San Francisco, and she designed its cover in 1994.

Mary gives workshops in women's health issues and is an active spokesperson for women's reproductive rights; sometimes her political concerns inspire her calligraphy. In future, she hopes to develop her calligraphic interests as an artist and a teacher. She plans to explore innovative techniques and designs that amuse and delight the viewer.

LORRAINE DOUGLAS is involved with calligraphy, paper marbling and the creation of books. She strives to express the dynamic nature and contemporary potential of each of these traditional crafts.

Focusing on personal response to poetry and its imagery, Lorraine is interested in the lives and works of poets such as Mary Oliver, Anne Sexton, Pablo Neruda and Denise Levertov. She has created unique painted and calligraphed books about Neruda, Paul Klee and Henri Matisse, and she is researching the work of Franz Kline and the Abstract Expressionists.

A graduate of the University of Manitoba and the University of Alberta, Lorraine is a librarian interested in contemporary writing and illustration, and in programs which encourage family literacy. As well as writing reviews and articles, Lorraine is involved with community groups which promote children's literature and reading.

Encouraged in calligraphy by Daryl Redekopp, Lorraine has taken workshops with Lindley McDougall, Betty Locke, Martin Jackson, Gottfried Pott, Nancy Culmone and Thomas Ingmire. She teaches classes in the book arts for the Winnipeg Art Gallery and the Calligraphers' Guild of Manitoba.

Lorraine's work has been exhibited in *The Art of the Book 93*, *Harbourfront 1993*, Leonard Marcoe Studio Gallery, *Contemporary Canadian Bookworks* in Japan, and in a number of juried exhibitions of the Manitoba Crafts Council. She was granted a purchase award by the MCC in 1993 for her book on Emily Dickinson. In 1995, a solo exhibition of her artwork was held at Heaven in Winnipeg. Her work has been published in *The Spirit of Calligraphy* and *The Letterforum Calendar*.

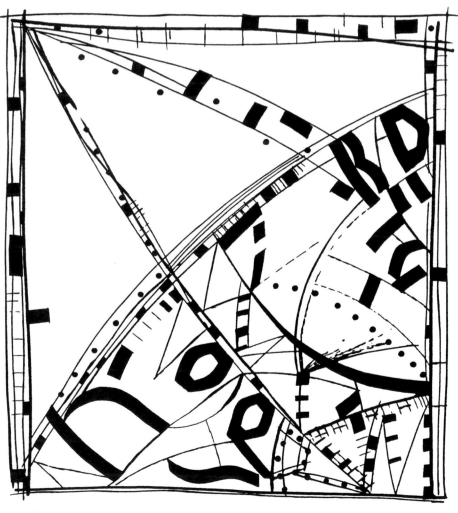

WHERE'S WALDO (far left). *This alphabet has hidden letters - see if you can find them all! I wanted to create an alphabet composition that used the space in a different way.*

MONOLINE ADVENTURE (left). *Done with a Pigma marker on paper towel at 1 a.m. after Lindley McDougall's workshop here in Winnipeg.*

PINKY (above). *This alphabet was cut out of black paper using my mother's old and dull pinking shears. I wanted to create an alphabet which could be used in headlines for holidays in Mexico, to attract cold Winnipeggers!*

NOREEN MONROE GUZIE began making greeting cards and place cards for family celebrations soon after learning the alphabet at the age of four. Her early adulthood in Edmonton was spent spinning, weaving, painting and raising five children.

When Noreen moved to Calgary in 1978, she began taking calligraphy lessons from Betty Locke, who encouraged her to teach beginner classes and to become a charter member of the Bow Valley Calligraphy Guild. For many years, Noreen taught evening classes and travelled throughout western Canada presenting her greeting card workshop, *Sincerely Yours.*

Noreen admires the work of Thomas Ingmire and Carl Rohrs. She has also received instruction and inspiration from other guild members, guild workshops, art courses at the University of Calgary, and books such as *Contemporary Calligraphy* and *Calligraphy Masterclass.*

Since 1980, Noreen has been teaching calligraphy at a seniors' centre in Calgary; and since 1990, she has been giving monthly workshops to inmates at the Drumheller Penitentiary. She is a regular instructor in the summer program at Loyola University in Chicago. Her calligraphy, logo designs and book jacket covers have been published in Canada and the United States.

Noreen has a keen interest in Jungian thought and is the co-author of *About Men and Women: How Your Masculine and Feminine Archetypes Shape Your Destiny* and *Journey to Self-Awareness: A Spiritual Notebook for Everyday Life,* both published by Paulist Press (New York). She and her husband Tad have travelled throughout North America presenting workshops related to personal growth.

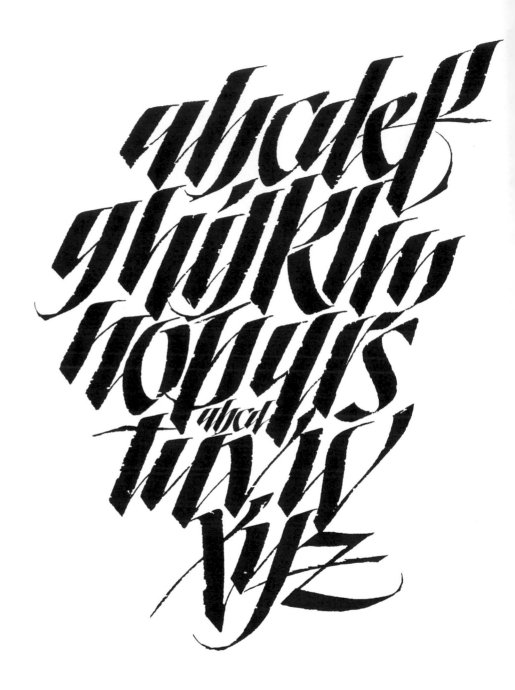

My goal is to develop the skills I need to become an image-maker, combining what I experience with what I see. I long to recapture the spontaneous, confident creativity I knew as an eleven-year-old. In the meantime, to unwind, I put on New Orleans jazz or Viveza, pick up a popsicle stick or a Lozada pen, and play with variations of the Alfred Linz alphabet.

Argos Blue Jays C.N. Tower Deli Eatons Film Festival Globe & Mail Hotels Island Jams King Edward Lakeshore Mirvish Newsworthy Ontario Place Queen's Park Royal Winter Fair Spadina T.T.C. Universities Valley Waterfront The X Yonge Street Zoo

Toronto Abecedary. Hiro #50, Copperplate nib, ruling writer with Pebeo Designers Gouache on Ledger paper and Lana Papier Spéciale. 15 x 16 cm. *Over several years, I developed this style, which I call Liberation Font. It has its roots in pointed brush lettering, but has been modified so that any tool can be used to create the letterforms. This style of writing lends itself to daily applications and is especially effective on envelopes and cards.*

CHERRYL MOOTE recalls the "dark and stormy night" when it all began. She was reshelving books in a library at the University of Western Ontario when an old copy of Edward Johnston's book *Writing & Illuminating & Lettering* fell to the floor. She dusted it off and was amazed to see that it was about calligraphy, a subject about which she had considerable curiosity. She signed out the book and did not return it until just before her graduation in 1974.

For the next ten years, Cherryl was completely self-taught, and, she says, "it showed!" In 1985, she discovered the Calligraphic Arts Guild of Toronto. Weekend workshops offered by the guild helped her to become aware of different styles and tools, and gave her the chance to develop an eye for good calligraphy. When Reggie Ezell offered his year-long class in Toronto, she began to devote much of her time to practice and study.

As an active member of the CAGT, Cherryl has served as the guild's president, and she continues to work on its quarterly magazine, *The Legible Scribble*. Because interaction with her calligraphic colleagues is very important to Cherryl, she participates in a monthly study group composed of graduates from Reggie Ezell's courses, and she uses the Internet to communicate with calligraphers around the world.

Cherryl teaches calligraphy and rubber stamp design. She lives in North York with her husband, two children and a poodle puppy. She has been involved with many other crafts, but her special interest in fabric and quilting has inspired many of her pieces of calligraphic work. Cherryl enjoys travel and she loves to read, "even when it isn't written in calligraphy!"

LINDLEY McDOUGALL grew up in Pointe-Claire, Quebec. She is a graduate of Trent University and she has lived in Alberta since 1969. For fifteen years, her main work was designing and building stained glass windows.

Having always been interested in language and literature, Lindley became intrigued by calligraphy after enrolling in a class with Gail Stevens, who emphasized the importance of verbal content and the integration of message and design. Since joining the Bow Valley Calligraphy Guild in 1986, Lindley has taken many classes and workshops with Betty Locke and with numerous international instructors.

As editor of the BVCG newsletter, Lindley gained experience in compiling the work of contributors from the guild's far-flung membership, and she enjoyed the process of preparing the quarterly publication. In 1991, she curated a collection of members' work for the manuscript book, *A Celebration of Life*, and wrote about that undertaking for *Calligraphy Review* (now *Letter Arts Review*). In 1994, she served as advisor to the editorial committee for *The Spirit of Calligraphy*, published by the BVCG.

As a visiting instructor, Lindley has travelled from British Columbia to Ontario presenting workshops in calligraphic design, and she has been a resident artist in programs at Red Deer College and the Okanagan Summer School of the Arts. Her calligraphic books and broadsides have been exhibited across Canada and in Japan in juried exhibitions.

Lindley enjoys meeting and corresponding with calligraphers, and she plans to direct a continuing program to publish the work of Canadian artists involved in calligraphy and related book arts.

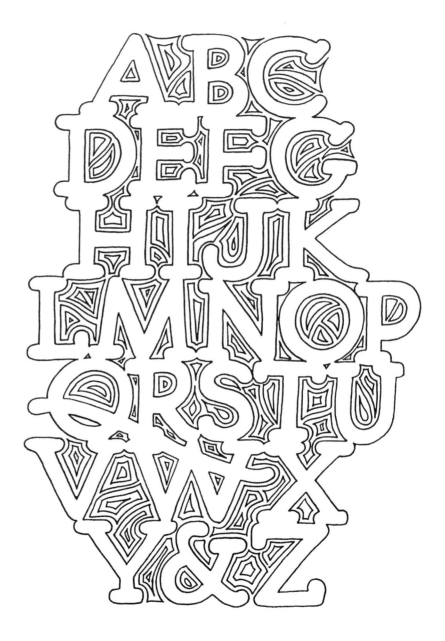

AMAZING SPACES. *I made this alphabet with a Q-tip dipped into yellow ink, then drew around the continuous mass of the letters with a Pigma pen. When photocopied, the yellow disappears, leaving the outline. I played around in the counterspaces, building on the shapes and looking for a pleasing balance between the empty letters and the maze-like spaces between them.*

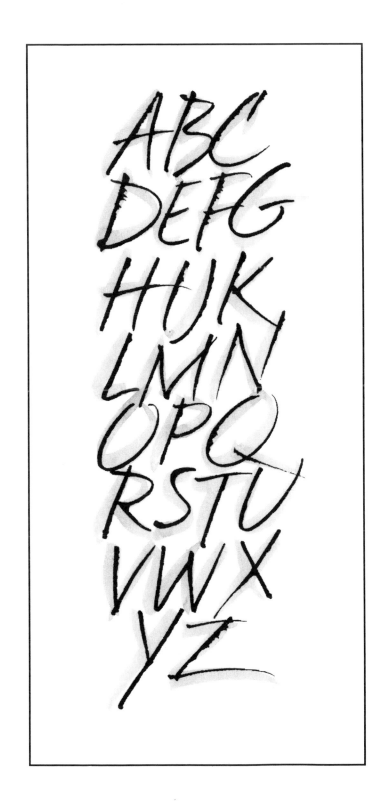

GINETTE MORIN has been involved with calligraphy since 1983. Having always had a passion for good lettering, her first experience with a calligraphy workshop, offered by La Société des Calligraphes de Montréal, was a definite *coup de foudre* which gave her life a new direction. She became involved with the society as workshop chairman and later as president while actively pursuing her calligraphic education through many books, workshops and international conferences. Design, as well as lettering, became an important part of her study.

Ginette has benefited from excellent instruction, and she gives credit to Thomas Ingmire, Nancy Culmone and Dick Beasley for teaching about creativity; Jovica Veljovic, Julian Waters and Peter Thornton for researched, informal lettering; Sheila Waters and Stan Knight for structured lettering; and Donald Jackson, Reggie Ezell and Mark Van Stone for information about materials and techniques.

Today, her business, Le Scribouillard inc., is celebrating its eleventh anniversary, and continues to offer services in design and lettering to many prestigious clients. Ginette's work ranges from very structured, traditional documents with gilding and illumination, to more researched and freely executed lettering for specific uses in advertising. Having entered the computer world, Ginette continues her study of lettering through typography. She especially admires typefaces designed by experienced calligraphers, and one of her goals is to create a typeface based on her own lettering.

KATHY GUTHRIE grew up in North Bay, Ontario, and studied Graphic Design at Sheridan College in Oakville. She discovered calligraphy in 1985 after moving to Calgary, and she joined the Bow Valley Calligraphy Guild in 1989. Since then, she has been working continuously to develop her skills and meet the challenges of an active career in calligraphy.

Since moving to Kelowna, British Columbia, Kathy has served as editor of the Kelowna Calligraphers' Guild newsletter and as the guild's president. She has lettered the text for two children's books and has designed many signs, ads and logos. She often participates in exhibitions in Alberta and British Columbia.

Kathy's calligraphy has been influenced by many instructors whose workshops she has attended: Leana Fay, Benny McAdams, Susan Skarsgard, Gottfried Pott, Julian Waters, Betty Locke, Judith Dampier, Lindley McDougall, Martin Jackson and Alan Blackman. The Bow Valley Calligraphy Guild has inspired Kathy to continue her calligraphic studies, and *Letter Arts Review* keeps her up to date with international trends.

Kathy enjoys hiking and skiing with her husband and two children, but she spends most of her time immersed in her calligraphic work. She hopes to increase public awareness of calligraphy as an art form as well as a commercial application. Kathy and her family have recently relocated to Victoria, where she plans to be active in the Fairbank Calligraphy Society.

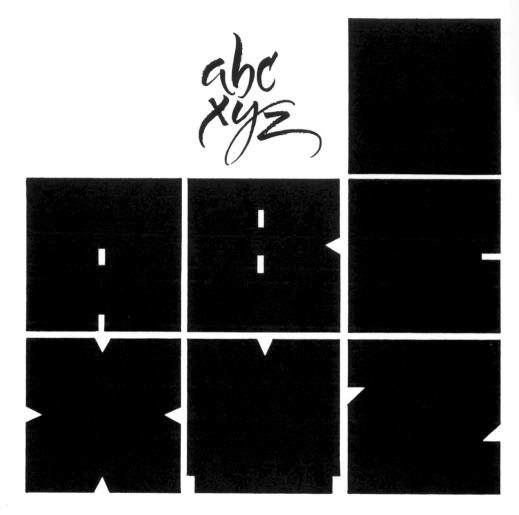

This black and white composition was created for a workshop assignment with Alan Blackman using squares of cut paper. The point of the exercise was to cut as little as possible from the square to create legible letters of the alphabet. The brush letters are freely written with a Pentel Color Brush in direct contrast to the architectural graphic qualities of the letters created from the square blocks.

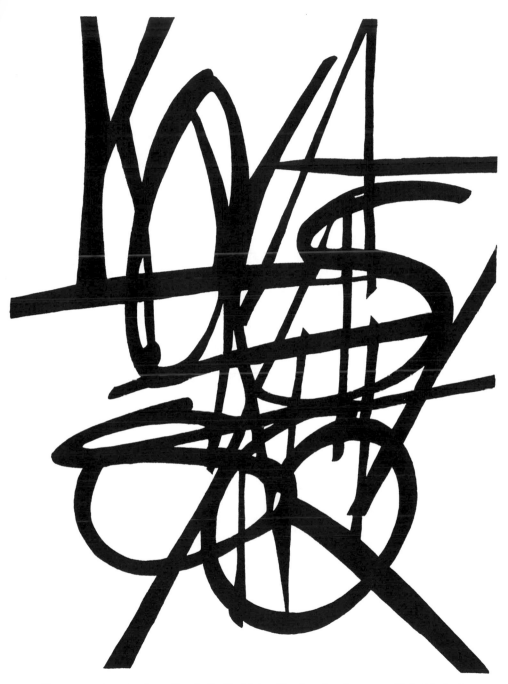

Koyaniskatsi (meaning "crazy like a fox"). Black ink and brush, watercolour paper. *While listening to a piece of music with this title, I created this experimental black and white composition.*

BEVERLY BUNKER first attempted calligraphy as a high school art student in Edmonton in 1968, but she was frustrated by poor materials and inadequate exemplars. A few years later, she discovered better resources and has been working continuously since 1973 to refine and hone her skills.

Thomas Ingmire opened the door to the creative possibilities of calligraphy. He also taught Bev several gilding procedures and introduced her to vellum and illumination.

Sheila Waters was an influential instructor who shared her finely tuned vision of calligraphy and design. She encouraged Bev to develop her own personal style.

Gaynor Goffe continues to be a guiding force in Bev's work, having been her tutor for more than ten years. She generously offers critique and commentary as Bev progresses on the long and complex task of preparing a portfolio as a candidate for fellowship in the Society of Scribes and Illuminators.

A large library of calligraphy books and *Letter Arts Review* have given Bev much inspiration, as have her artist friends who have little knowledge of letterforms but share her appreciation for design, colour and craftsmanship. She also acknowledges the members of the Edmonton Calligraphic Society for their support and encouragement.

Beverly sees each finished piece of work as being an accomplishment that leads to success in her larger pursuits. She takes pride in the perseverance that is the result of her genuine love for the path she has chosen to follow, and she takes special pleasure in nurturing those who are just beginning to study calligraphy.

CINDY ROMO has been a graphic and lettering artist for more than twenty years. She studied art at the University of Montana, where one of her classes was *Layout and Lettering* with Walter Hook. She went on to study, practise and exhibit calligraphy in Montana, Oregon and Saskatchewan.

Cindy has lived in Saskatoon since 1986. For six years, she was employed as a graphic artist by the University of Saskatchewan, and she did many calligraphic pieces for the university during that time.

The Saskatchewan Craft Council consulted Cindy with the request that she research and write a list of criteria for the jurying of calligraphy, which they wished to include in their retail craft markets. The resulting guidelines, composed with co-author Kristina Komendant, are designed to promote good quality in calligraphic work shown to the public, and Saskatchewan calligraphers have gained access to new and profitable venues for their work.

International calligraphy conferences and guild memberships have provided camaraderie and encouragement for Cindy, who has also been inspired by the published work of many professionals, especially Hermann Zapf. She admires "spirit, vitality, integrity and sound letterforms, bound together with excellent craftsmanship," and she is committed to seeking these qualities in her own work.

The process of lettering challenges me and brings me joy; because it is so enriching, the product that results can always be considered a success!

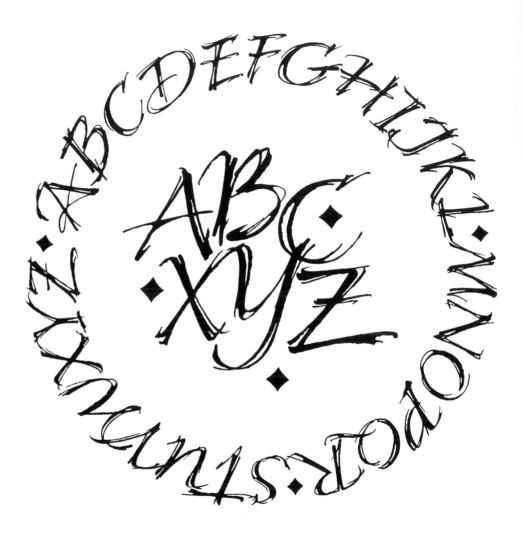

CIRCLED CAPS. Experiment in lettering design with the ruling pen, inspired by the work of Gottfried Pott, Werner Schneider and Friedrich Poppl.

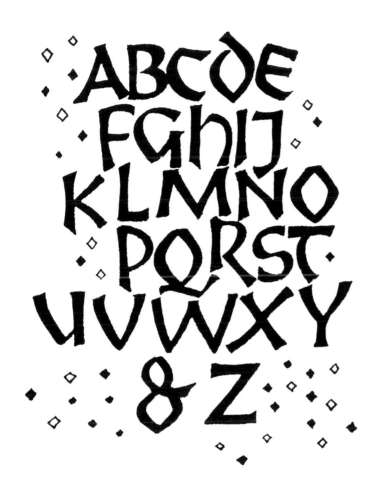

MARGARET VAN DIEST began her calligraphic studies in 1984 through the Leisure Learning program in Calgary. Since then, she has taken many courses from Canadian and American instructors, and she attended the *Kalligraphia 93* conference in Lethbridge, Alberta. She hopes to continue to study and develop her love of letters for many years to come.

As an active member of the Bow Valley Calligraphy Guild, Margaret has served as the coordinator for the guild's annual exhibition in Devonian Gardens, and she spent three years as the workshop director.

Margaret's work has been exhibited in Calgary and at the Medicine Hat Museum and Art Gallery, and her calligraphy has been included in three of the BVCG's publications. She teaches classes in calligraphic arts, and she also does freelance commissions.

Although she works full time at Air Canada, Margaret is continuing her studies at the Alberta College of Art and Design. She also serves as a volunteer at the Triangle Gallery, Calgary's civic art gallery. Margaret plans to teach more classes in the future, and she is committed to finding new and original ideas for her artwork.

JEAN WEGERHOFF, who was born in Port Elizabeth, South Africa, has lived in Namibia and Scotland as well as Canada, and has moved more than forty times in her life. Upon her arrival in Calgary in 1981, Jean was presented with a calligraphic welcome certificate, which whetted her interest and led her to begin her study of calligraphy.

Jean has taken classes in watercolour painting, batik, papermaking and bookbinding, and she has always enjoyed sewing and knitting. These varied pursuits have enriched her understanding of colour, texture and design, and she is enthusiastic about the creative process and the possibilities of combining materials and techniques.

A faithful contributor to the Bow Valley Calligraphy Guild's annual exhibition in Devonian Gardens, Jean has also had her work selected for juried shows and publications. Her first calligraphic book was included in an exhibition organized by the Society of Scribes and Illuminators in London, England. Her submissions have been accepted for both of the calligraphic exhibitions at the Medicine Hat Museum and Art Gallery. She was a committee member and juror for *The Spirit of Calligraphy,* published by the BVCG in 1994, and three pieces of her work were included.

Among the many calligraphy instructors with whom Jean has studied, she has been most influenced by Gottfried Pott, Martin Jackson and Jean Formo, whose exotic and sculptural book structures have been particularly inspiring.

In addition to her teaching and freelance calligraphic work, Jean continues to be very active athletically and is a champion tennis player. She resolves to "keep fit and healthy and enjoy what life has to offer*!"*

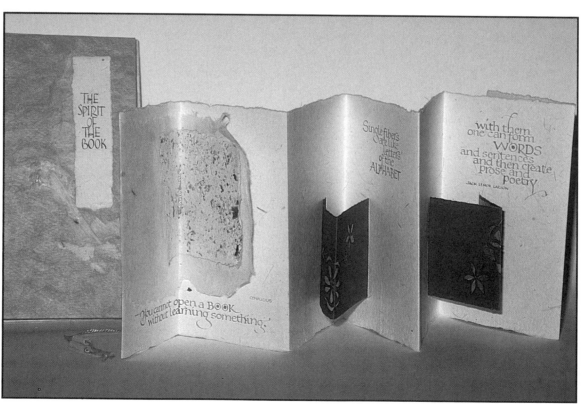

THE SPIRIT OF THE BOOK. Brause nib, crowquill, gouache on Indian rag paper, Thai handmade paper, Rose paper handmade by the artist, Canson Mi-Teintes. 22 x 13 x 2 cm. Quotes: Confucius and Jack Lenor Larson.

MEDIEVAL STUDIES

MEDIEVAL STUDIES POSTER (detail).
Main heading, printed in black on
Aged Parchtone card. 28 x 43 cm.

M. JOYCE MacKINNON received a calligraphic pen kit in the early 1980's, and she began an independent exploration of letters that involved hundreds of hours of practice and study. She sought out old family Bibles and reproductions of medieval manuscripts such as the *Book of Kells* as sources of inspiration.

Today, Joyce is employed by the Memorial University of Newfoundland, where she is a publications officer. In addition to her other duties, she does calligraphy for the special awards and documents generated by the university. In her freelance work, she provides calligraphic services to the Protocol Office of the provincial government of Newfoundland, and she accepts private commissions which include book inscriptions, invitations and scrolls.

Joyce acknowledges that the proliferation of computers has made a huge variety of type styles available to the public, but she feels that hand lettered documents are more personal and more genuine.

While her favourite tools are flexible steel nibs and brushes, Joyce sometimes makes pens from balsa wood and mixes her own inks. In addition to traditional and handmade papers, she has put calligraphy on some unusual items, including champagne glasses and silk scarves. She feels that each job is a challenge, and that her greatest reward is the genuine appreciation of clients whose messages are transformed into detailed works of art.

Joyce intends to keep developing her skills, "refining, expanding and experimenting, as long as I can hold a pen." She looks forward to the experience of learning and working with others in the newly formed Newfoundland Calligraphers' Guild.

RONALD MARSHALL. When a grade four classmate showed some of his grandmother's calligraphy at school, Ron knew that he had discovered an art that he wished to master. With the help of friends, he sought out a complete Blackletter alphabet, gathering a variety of letters from signs, Bibles, newspapers and magazine headings.

For many years, Ron continued on the path of self-instruction, experimenting with the broad-edged pen and combing libraries and bookstores for examples of manuscripts, illumination and gilding. He acquired copies of writing manuals by Alfred Fairbank and Edward Johnston, and copied out long passages of scripture.

Ron spent six years at the Prairie Bible Institute in Three Hills, Alberta, first as a student and later as a cook. In 1986, he joined the Bow Valley Calligraphy Guild, which provided challenge and enrichment through its shows, newsletter and pen friendships. After returning to Ontario, Ron joined the newly-formed Hamilton Calligraphy Guild and began to participate in its meetings and workshops.

A serious bicycle accident in 1989 severely damaged Ron's right arm, and it was feared that his dexterity had been destroyed; but, in spite of lingering physical limitations, his calligraphic ability had returned to its previous standard eight months after the accident. His work has been exhibited in Alberta and southern Ontario, and has been published in *The Spirit of Calligraphy* and the *1995 Calligraphers' Engagement Calendar*.

Ron works with Reach Forth, a sports outreach ministry. He coaches sports, gives chapel messages, and designs T-shirts, flyers and posters. He lives in his hometown of Dundas, Ontario, with his wife and two young sons, to whom he hopes to convey his love of letters.

BLACKLETTER ALPHABET WITH JOHN 1:14. *The original was written with an automatic pen on St. Armand's Constitution paper to achieve a broken textural effect. After playing with different letter styles, I settled on Blackletter, which gives a good, dense outline. I like that the Latin has fewer ascenders and descenders, and the small, light translation line acts like a hairline under the cross.*

abc
def
et verbum caro ghi factum est, et
habitavit jkl in nobis
and the word became flesh and dwelt among us: John 1:14
mn
opq
rst
uvw
xy
z

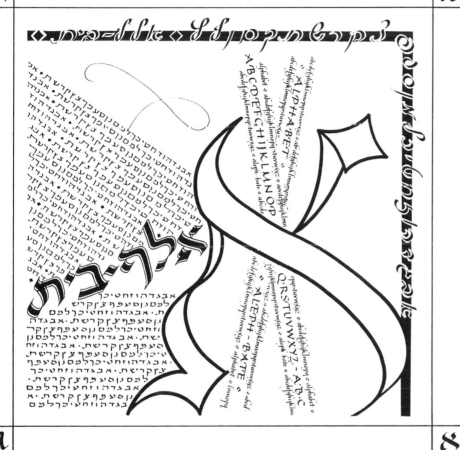

Marion Zimmer has always enjoyed looking at letters and practising writing. When she began to take lessons from an elderly calligrapher in Montreal, she was required to use a Mitchell nib without a reservoir. This experience made for a challenging introduction to calligraphy!

With Trudy Novack, Marion was a co-founder of La Société des Calligraphes de Montréal. The society sponsored classes with visiting instructors from England and the United States, and Marion was able to study with many outstanding teachers. She began to teach calligraphy, and she attended classes in Fine Arts at Concordia University where she found the exposure to various media and processes to be a very liberating experience.

After her freelance work became more demanding, Marion gave up her regular teaching. She began to concentrate on her creative calligraphy, and she has had several one-artist shows. She attends the society's workshops and international conferences, and she has travelled to Camp Cheerio in North Carolina to study with Peter Thornton.

Marion is working full time in calligraphy, and is pursuing her own artwork and her interest in ketubot, decorated Jewish marriage contracts. She finds it very fulfilling to be working in an area that reflects her Judaic roots. Her clients often make specific requests, which Marion incorporates into original designs based on traditional ketubot.

Marion lives in Montreal with her husband Shelly and their two grown children, Jonathan and Lisa.

My objective was to create a dynamic piece incorporating both the Hebrew and the traditional Italic alphabets. I decided to start with the first letter of the Hebrew alphabet, the aleph. This is my favourite letter and I felt that the beautiful curves of the letter would create lots of movement and a sense of life on the page. To contrast this, I used straight lines of text going through the aleph and large areas of text beside it. I added one line of heavier text to add more interest to the piece, and decided to tie it together with a border. The piece still needed more definition, so I added weight to the outline of the large aleph and filled in the spaces between the letters in the border.

The most fun element for me was experimenting with both alphabets to decide which was best suited for a specific area, but ultimately I found, much to my delight, that both alphabets were interchangeable.

IRENE ALEXANDER won a scholarship to the Vancouver School of Art (now the Emily Carr Institute of Art and Design), where she studied Applied Arts and Design. She specialized in lettering, illuminating and heraldry under Grace Melvin from the Glasgow School of Art.

Irene worked in advertising, commercial lettering and display after leaving art school, and she co-founded the Alexander Studio with her husband, Robert S. Alexander. He taught painting and drawing while she taught lettering arts. Since her husband's death in 1974, Irene has continued to work in the studio, which is in her home. She has taught calligraphy classes at Langara College and the University of British Columbia, and has presented workshops throughout B.C. She became a founding member of the Westcoast Calligraphy Society in 1976, and is now a Life Member.

Over the years, Irene has accepted many commissions of a rather formal nature, including memorial books for churches, presentations scrolls and family trees. She has also undertaken work for reproduction, including decorative or focus maps, and heraldic work for book publishers. She was made a Fellow of the Heraldry Society of Canada in 1986.

Irene has developed a particular interest in bilingual work, projects that require documents to be carried out in English and another language, especially French. She has collaborated with other calligraphers whose first language is Chinese, Japanese, Ukrainian or Russian, and she has incorporated the Cyrillic alphabet into her own repertoire.

In recent years, Irene has been experimenting with the characteristics of the Arabic/Persian alphabet, interpreting its rhythms, shapes and gestures into an English counterpart. Working with quotations from Persian poetry, or a Surah from the Qur'an, Irene seeks to transcribe the look and feeling of Islamic writing.

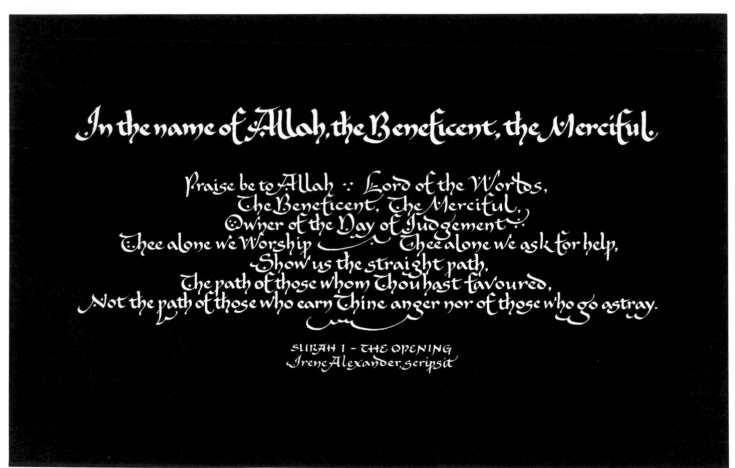

In the name of Allah, the Beneficent, the Merciful.

Praise be to Allah ·: Lord of the Worlds,
The Beneficent, The Merciful,
Owner of the Day of Judgement ·:
Thee alone we Worship ·: Thee alone we ask for help,
Show us the straight path,
The path of those whom Thou hast favoured,
Not the path of those who earn Thine anger nor of those who go astray.

SURAH 1 – THE OPENING
Irene Alexander, scripsit

They do not have set capital letters with accompanying small letters. Ligatures are free and variable. They write from right to left - fluid and very expressive! Slashes and diamond-shaped dots in singles, pairs or more, which are an integral part of the letterforms, can be used decoratively in transliteration.

Listen to the exhortation
 of the Dawn!
 Look to the day!
For it is life — the very life of
In it's brief course lie all the
varieties and realities of your
 existence:
 The bliss of growth
 The glory of action
 The splendour of beauty
For yesterday is but a dream
And tomorrow is but a vision
But today well lived makes
 every yesterday a dream of
 happiness.
 And every tomorrow
 a vision of hope
Look well therefore to this!
Such is the Salutation of the
 Dawn

from the Sanskrit
circa 1200 B.C.

Irene Alexander
Scripsit 1990

113

Leo W. de Wit was born in Amsterdam in 1943 and came to Canada at the age of fourteen. While living in Ottawa in 1983, he took his first calligraphy class from Nancy Drennan. Since then, he has attended courses with Sheila Waters, Michael Harvey, Ewan Clayton and Charles Pearce, but he acknowledges Heather Mallett as having been his most influential instructor.

An active member of the Calligraphy Society of Ottawa, Leo served as treasurer for the group. He has completed many prestigious freelance commissions for former Prime Minister Brian Mulroney and for the Speaker of the House of Commons, the Senate, and many of the embassies in Ottawa.

Now living in the Halifax area, Leo has been working on interpretive calligraphic pieces inspired by poetry or text quotations. He teaches adult evening courses through the Halifax and District Community Education Centre, and he says that his most important goal in calligraphy is "to improve constantly."

abcdeeffgg
helenkmhopi
sqjeffreytuw
vxzzlee-annr
half-uncial

Speedball C2 nib, Sumi ink, Paper for Pens.

114

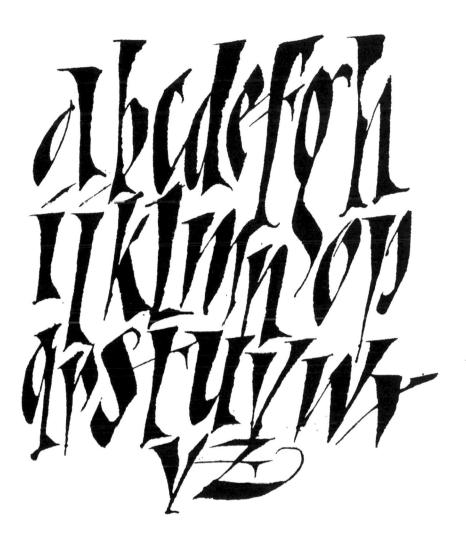

Techniquill and brown ink. Derived from Gothicized Italic, with lots of pen twisting.

MARGARET CHALLENGER was born in England and came to Canada in 1959. She began her discovery of calligraphy in 1978, when she learned the "Canadian System" developed by Alf Ebsen of Toronto. Margaret says that she then "entered the door to the garden of scripts" and took every opportunity she could find to learn more, studying in Canada, the United States and England. In 1984, she started her own business, Design Calligraphy.

Through the Calligraphic Arts Guild of Toronto, Margaret has enjoyed many classes with visiting teachers and has made many friends who provide encouragement. She has served as the guild's president and has worked as an organizer and advisor within the group.

Don Taylor, of the Canadian Bookbinders and Book Artists Guild, was a major influence on Margaret's work as she began to incorporate her calligraphy into handmade artist's books. Two of her books have been acquired by the National Library in Ottawa for their permanent collection. She has explored many crafts related to the book arts, including decorated paper, embossing, box making and sign writing. Margaret enjoys "writing *on* everything and *with* everything!"

Margaret teaches calligraphy for public arts programs and for the CAGT. She enjoys entering book arts exhibitions and experimenting with new ways of using fine lettering in the book form.

Every place you go, there is writing to look at ... from historic inscriptions ... to documents and personal lettering on paper and fabric. From Pompeii to Toronto, the writing is on the wall!

INGE KERN was born in 1937 in Greifswald, Germany, where she was raised and educated. While she was taking private art lessons at the age of nine, her teacher recognized her talent and commitment to the study of lettering. In her teens, thanks to her mother's encouragement, Inge was able to enter into a three-year apprenticeship as a calligrapher with a renowned East German graphic artist, Helmut Maletzke.

In 1958, Inge immigrated to Canada. She had been employed as a draftswoman, and had learned to work with discipline and accuracy. When she began her freelance career as an artist, graphic designer and calligrapher, she brought this same care and precision to her studio.

Inge has completed many private and public commissions, and she has exhibited her work in Brockville, Ontario, and the surrounding area, since 1970. She taught calligraphy at St. Lawrence College in Brockville from 1982-1987. Inge is a member of the Calligraphy Society of Ottawa.

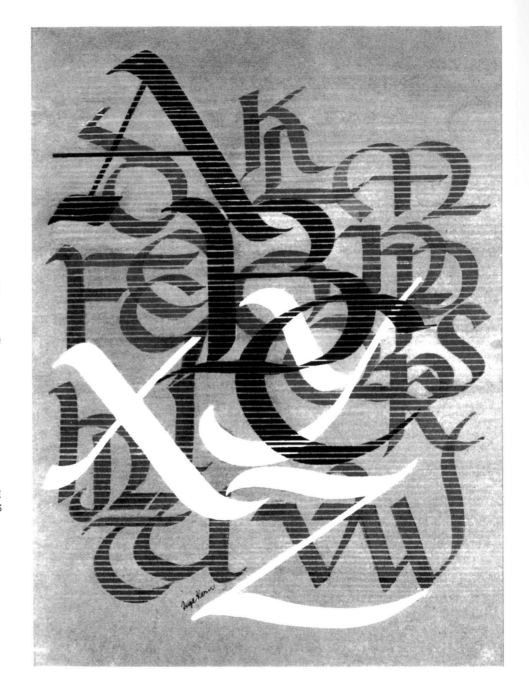

Waterproof ink, diluted ink, printing paper, resist. Ruling pen used with resist to draw thin lines, lettering done with flat edged fibre brushes. 23 x 33 cm.

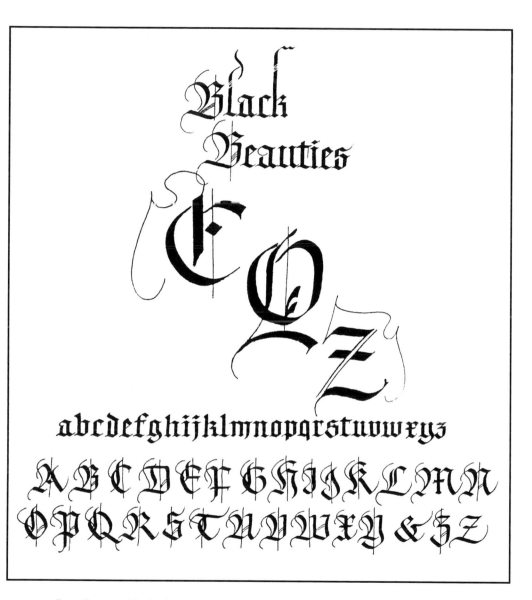

Black Beauties

EOQZ

abcdefghijklmnopqrstuvwxyz

ABCDEFGHIJKLMN
OPQRSTUVWXY&ZZ

BLACK BEAUTIES. Higgins Eternal
ink on paper, techniquill, crowquill
and Brause nibs.

GAYE MACKIE, a native Calgarian and a charter member of the Bow Valley Calligraphy Guild, is married and the mother of three children. After completing her education and a five-year career as a receptionist and secretary for a major pipeline company, her interests became focused on her family. Volunteer work consumed her time, and as Chairperson of the Education Committee for Deaf and Hard of Hearing Services, she was involved with the Special Education programs in the Calgary school system.

Gaye's study of calligraphy began in 1979, when she enrolled in a class with instructor Betty Locke. She began teaching in 1981 for Continuing Education programs, senior citizens' classes, Girl Guide groups and community centres. She enjoys many alphabets, but has concentrated mainly on the Blackletter, Copperplate and Compressed Italic hands. She has travelled throughout Western Canada teaching workshops in these alphabets. She has been fortunate to have had the opportunity to attend many workshops and classes with a variety of calligraphy instructors, all of whom have had an influence on her work.

In addition to her calligraphy and related commercial contract work, Gaye's interests include golf and a variety of crafts. She has recently completed a course in floral design. She enjoys combining floral arrangements with dry embossing and cast paper techniques to enhance her calligraphic greetings to friends and relatives.

117

CHERYL TASAKA was born in Winnipeg, raised in British Columbia, and takes pride in her Japanese heritage. Having earned her Bachelor of Education degree at the University of British Columbia and her Masters degree in Early Childhood Education at Western Washington University, Cheryl is now an elementary school teacher in Delta, B.C.

Cheryl has always been interested in handwriting and lettering styles. She took her first calligraphy course in 1979, and she has continued to pursue her studies of calligraphic techniques by attending workshops and lectures. Her most influential instructors have been Canadian calligraphers, including Irene Alexander, Martin Jackson, Irene Poskitt, Stan Manson, Judith Dampier and the late Wendy Wilson.

Her approach to design and lettering reflects the understated simplicity of Oriental art, and Cheryl's studies have also included Japanese brush calligraphy and Sumi-e painting.

Cheryl does calligraphic volunteer work for friends, conferences, workshops and charities, and she has made cards, invitations, exhibition pieces and donations to the Westcoast Calligraphy Society's fundraising events. She has recently become interested in lettering on fabric.

Cheryl appreciates her calligraphic friends who have kept her involved in meetings, workshops and projects. She finds that the intangible rewards of learning and sharing have encouraged her to develop her skills and her interest in calligraphy and design.

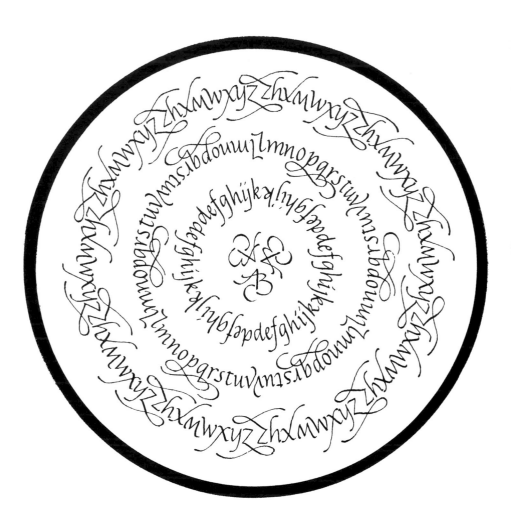

ALPHABET SOUP.
Gouache with Mitchell nibs
on Fabriano-Roma paper.
18 cm diameter.

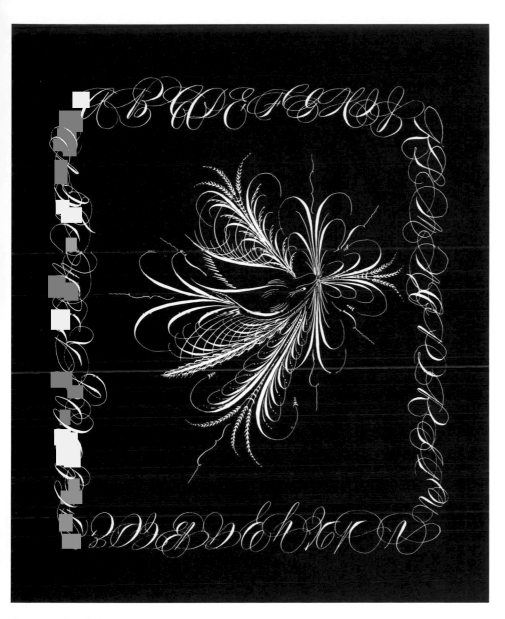

FLOURISHED BIRD & SPENCERIAN ALPHABET.
Japanese stick ink on cotton bond paper.
Reverse print. 22 x 28 cm.

JOAN GOODERHAM is the mother of nine children, grandmother of fourteen, wife of a minister, and a practising lettering and design artist. As a child, she was fascinated by her grandfather's skill in applying lettering and striping to commercial vehicles at his auto body and paint shop.

Years later, Joan bought a calligraphic fountain pen and a book of "ten easy lessons." She began to practise on her own, but she resolved to seek further knowledge and understanding of letterforms. After she was introduced to the Niagara Calligraphic Guild, Joan began to take workshops and to enjoy the association with others who freely shared their knowledge and expertise. A year-long course with Reggie Ezell provided her with an ideal opportunity to hone her skills.

Joan's personal hand of choice is Spencerian, and she admires the work of Michael Sull, which has heightened her appreciation for these graceful letters. She also finds inspiration in medieval illuminated manuscripts.

Much of Joan's work is of a spiritual nature, and her texts include scriptural quotations and hymns. Her husband, although still teaching and preaching full time, is her greatest supporter, and he constructs the frames for her broadside work.

Joan operates a studio called The Golden Quill in Ridgeway, Ontario, and her work has been displayed at a number of exhibitions and summer shows. Joan feels that her calligraphic work, which began as a hobby, has become a strong expression of her faith.

119

ROBERTA HUEBENER is an Ottawa artist and high school visual arts teacher. While at university, she had her first encounter with lead type in the printmaking studio, and she took a calligraphy course that included some book design. In the mid-eighties, Roberta's interest in calligraphy was rekindled by her friend Heather Mallett, who urged her to attend a workshop with Ewan Clayton.

Since then, Roberta has studied with more than twenty instructors in calligraphy and the book arts, and she has organized and taught workshops for the Calligraphy Society of Ottawa. She has exhibited her work with various groups, including The Ottawa Women's Credit Union Arts Committee, the annual Art Credo Exhibition at St. John's Church, The Papertrail, Black History Ottawa and the CSO.

Roberta enjoys the roots of calligraphic traditions, and she appreciates the opportunity for new personal expression through calligraphy, paper making and decoration, and book design. Although she enjoys the interpretation of favourite quotations from literature, Roberta feels that it is equally important to write her own words for her calligraphic works. She has designed, lettered and bound three small editions of her own short poems and prose.

Roberta attempts to find the point where words and images merge and work together visually and symbolically. She uses a variety of approaches to lettering, including spontaneous brush and pen techniques, and stencil-cut letters combined with watercolour and collage. She wishes to transcend false barriers that have arisen between the craft traditions of lettering, papermaking and book arts, and the so-called "fine arts."

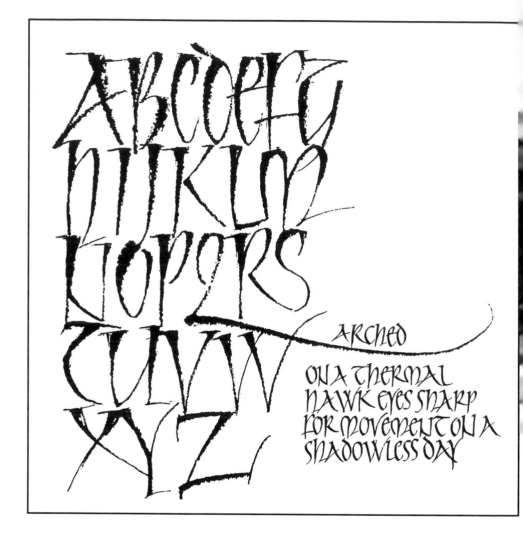

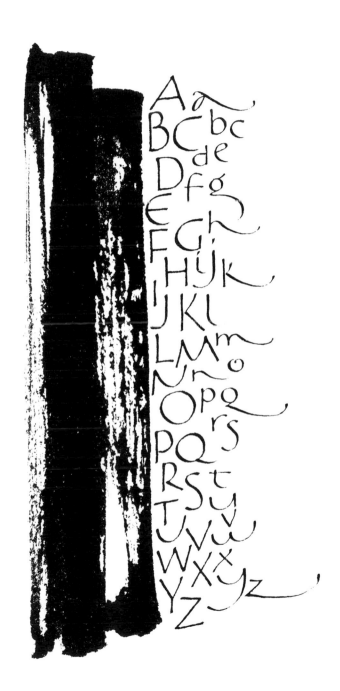

NICOLE GUYOT COULSON is a Winnipeg calligrapher and book artist with a background in photography and botany. She is currently employed as a graphic artist in educational and curatorial work in visual arts for Le Centre culturel franco-manitobain. Her calligraphic work consists mostly of commissions and commercial assignments as well as gallery signage.

Nicole has taught calligraphy and bookbinding in Winnipeg and southern Manitoba, including a week-long summer workshop, together with Lorraine Douglas, at the Winnipeg Art Gallery. She has received most of her training through workshops sponsored by the Calligraphers' Guild of Manitoba and at conferences in Minnesota and Alberta. She has taken classes with Ann Hechle, Thomas Ingmire, Carl Rohrs, Annie Cicale, Martin Jackson, Betty Locke, Lindley McDougall and others.

While she appreciates the craft of fine lettering, Nicole believes that calligraphy can be an expressive visual art. Line, form, texture and colour can be combined to give a visual voice to the written word. The significance of the words and her reaction to them are prime motivators in Nicole's work. She especially enjoys the richness and imagery of French poetry.

Nicole's work has been exhibited in a juried show of Manitoba artists and a group show of Canadian artists' books at Le Centre culturel franco-manitobain, and has been published in *The Spirit of Calligraphy*. She has also participated in numerous group shows in Manitoba and Alberta.

Letterforms can be interesting design elements in themselves, but, culturally, they are powerful symbols of expression.

LUC SAUCIER was born in Ottawa and has lived in Montreal since 1982. A member of La Société des Calligraphes de Montréal, Luc fell in love with calligraphy twelve years ago during his classical voice training. Today he is an aspiring opera singer and a self-taught freelance scribe. Since 1991, he has been a full-time calligrapher and poster designer at La Chapelle historique du Bon-Pasteur in Montreal.

Lorsque les hommes commencèrent d'être nombreux sur la terre et que des filles leur furent nées, les fils de Dieu trouvèrent que les filles des hommes leur convenaient et ils prirent pour femmes toute celles qu'il leur plut.

GENÈSE CH. VI 1-4

Yahvé dit: Que mon esprit ne soit pas indéfiniment responsable de l'homme, puisqu'il est chair: sa vie ne sera que de cent vingt ans."

Les Nephilim étaient sur la terre en ces jours-là, et aussi dans la suite, quand les fils de Dieu s'unissaient aux filles des hommes et qu' elles leur donnaient des enfants. Ce sont les héros du temps jadis, ces hommes fameux.

Osmiroid fountain pen, B4 nib on Daler parchment paper. *These mysterious verses from Genesis are here rendered in variants of Carolingian and Gothic scripts.*

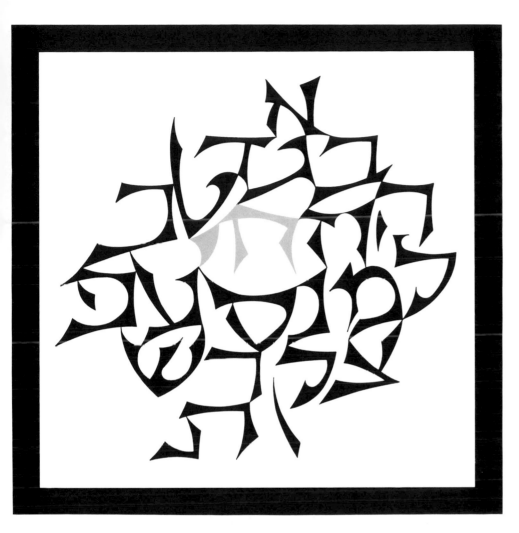

ALEPH-BET. *The natural form of the printed Hebrew alphabet is square. In this design, the letters are based on curved lines. Each letter is connected to one or more letters at one or more points, thereby emphasizing not only the shapes of the letters but also giving attention to the negative spaces. The completed alphabet creates an oval which symbolizes the "Circle of Life" - not having a beginning or an end. All the letters are black with the exception of two which have been left grey. These two letters form the Hebrew word LIFE - Chai.*

KARNY RIVLIN VORONA was born and raised in Israel. As a descendant of a rabbinical family, her ancestral love of the Hebrew language and literature has had a strong influence on her choice of calligraphic subjects.

Karny's artistic career began in the field of architectural design and drafting in Israel, where her presentations to clients required the use of artistic lettering. She later spent several years on the Caribbean island of Curaçao, and began to use warm tropical colours in her artwork.

After moving to Toronto, Karny took calligraphy courses with many instructors, including Reggie Ezell, Donald Jackson, Mark Van Stone, Lothar Hoffmann and Timothy Botts. She joined the Calligraphic Arts Guild of Toronto in 1986. She has served a year as its president and has earned a CAGT teaching certificate.

Her work has been widely exhibited. *Song of Songs - The Book* received honorable mention in a juried exhibition, and she has been commissioned to design covers for Hebrew magazines.

Karny specializes in making original illuminated ketubot (Jewish marriage contracts) and other artworks which emphasize milestones in Jewish life. Her goal is to share her love of her Judaic background and her passion for the written letter. Her work can be found in private collections in Canada, the United States and Israel.

Karny is a member of the Watercolour Society of Toronto, the Israeli Artists Group of Toronto, and the Jewish Artists Group of Ottawa. As a reporter for the arts, she contributes to several Hebrew publications.

FRANCIE ALBERTS BREDESON'S first effort at calligraphy was the writing of a poem for her high school yearbook, an attempt that she now refers to as "total cacography!" She moved from St. Albert, Alberta, to Calgary to attend the Alberta College of Art, and was later employed as a layout artist.

In 1980, Francie and her family relocated to Wetaskiwin, Alberta, where she found, to her delight, that calligraphy classes were offered by the local recreation facility. Vi Pratt, an instructor from Calgary, introduced her to this new "hobby," which became Francie's favourite pursuit and, eventually, her career.

Having joined the Edmonton Calligraphic Society and the Bow Valley Calligraphy Guild, Francie has continued her studies while teaching classes for children and adults, and developing her freelance business. Her commissions include unique cards and handmade books, letterhead and business card designs, invitations and certificates. She takes great pleasure in creating broadsides of quotations and poems, and is particularly excited about the use of watercolours, pointed pen variations and hand-carved stamps.

Francie has been inspired by the works of Sheila Waters, and she has had strong encouragement from Margaret Lammerts and from Betty Locke, whose "vibrant, fanciful works" she especially admires. Francie's published works include pages in the *Habitat for Humanity Reminder Calendar* and *The Spirit of Calligraphy*.

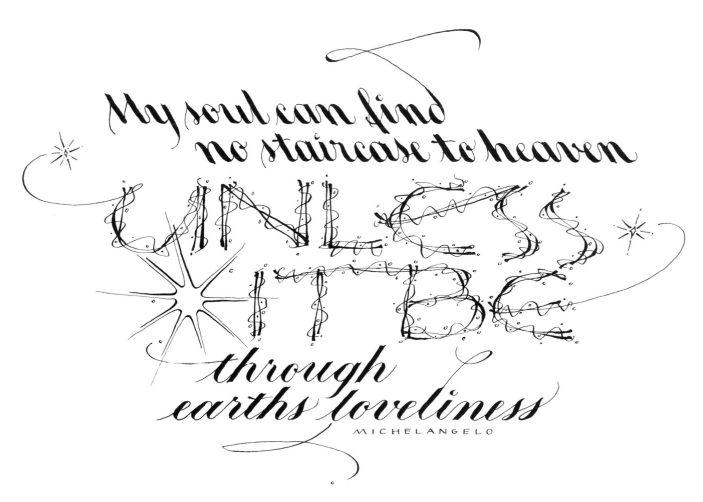

My soul can find no staircase to heaven UNLESS IT BE through earths loveliness

MICHELANGELO

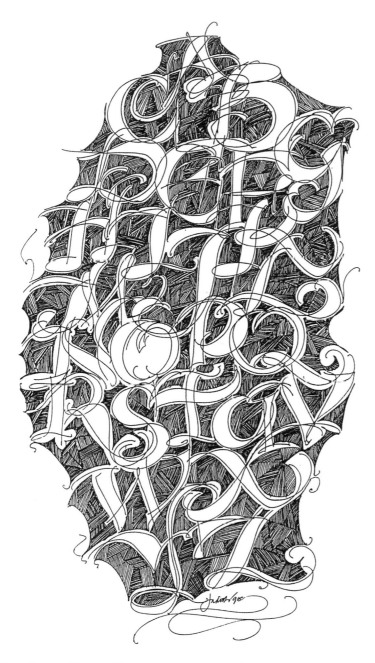

JUDITH BAIN DAMPIER lives with her family and their animals in the Peace River country, at Dawson Creek in northern British Columbia. Her interest in lettering and graphic design dates back to her early school days, and she began to study calligraphy in 1977. In 1980, she went to England on a Calligraphy Study Tour during which she discovered a "glorious panorama of history and letters!"

The tour included a workshop with Ann Hechle, whose vision and enthusiasm were to prove an enduring influence for Judith, inspiring her and the late Wendy Wilson to begin a collaborative relationship that continued for ten years. While living in Vancouver, Judith was actively involved in the calligraphic life of the city, teaching, organizing workshops and exhibitions, and doing private commissions. Her teachers included Martin Jackson, Fred Salmon and Irene Alexander, and she also acknowledges the influence of Mark Van Stone and Thomas Ingmire.

Since moving to Dawson Creek in 1991, Judith's approach to her work has changed dramatically. Although she works "in calligraphic isolation," she welcomes the opportunity to take new directions and to collaborate with other artists in the Peace River region. Supplies and services are often scarce, and the stimulation of calligraphic colleagues is sorely missed, but Judith finds satisfaction in her independence and has found that "the need to reach within for inspiration" has resulted in some of her best work.

Judith admires *Sabine's Notebook* by Nick Bantock and *In and Out of the Garden* by Sara Midda. Her long-term goal is to compose an artist's book about the Peace River country that would be influenced by the fantasy and the painterly beauty of such books as these.

BLIND CONTOUR VERSALS. *The letters presented here are intuitive and immediate. They are not reworked for the purpose of this piece although each letter was done separately and then transferred to the final alphabetic design. In use, these letters are not normally grouped together - as in this alphabet - but most often used individually. The pleasure in working with blind contour forms is in the discovery of the energy of the letter and in the exploration of the kinesthetics of a given calligraphic form. These started out as being merely exercises for accessing the Right Brain and sort of grew from there - perhaps because they are so fascinating.*

GALLERY II

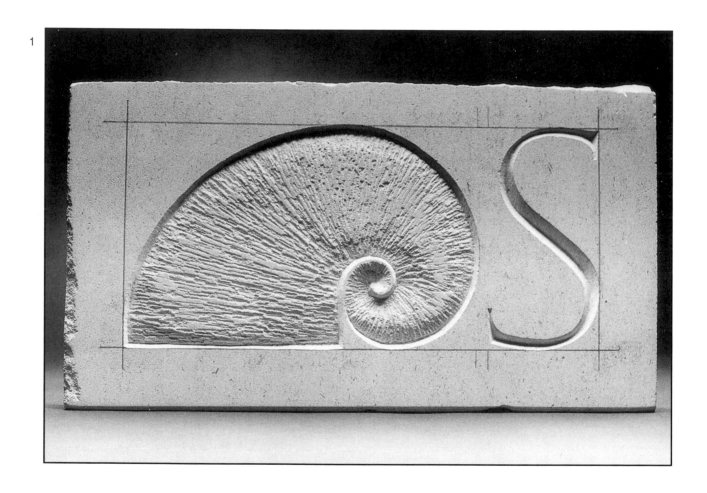

1

2

3

1
CAROL AYERS. *S IS FOR SYMMETRY.* Carved in Portland stone. 35 x 19 cm.

2
FRED SALMON. *NO-L ALPHABET.* Crowquill pen and ink.

3
SANDY SOMMERFELD. *The Okanagan Valley beckons a calligrapher to explore and experiment with the earthy textures and patterns that nature presents. I find the curled, twisted, crooked grapevines of the local vineyards appealing; I seem to gravitate to my "Grapevine Gesturals."*

4
WENDY BUCKNER. *IN THE SPIRIT OF WILLIAM MORRIS.* Technical pen on illustration board. 38 x 6 cm.

4

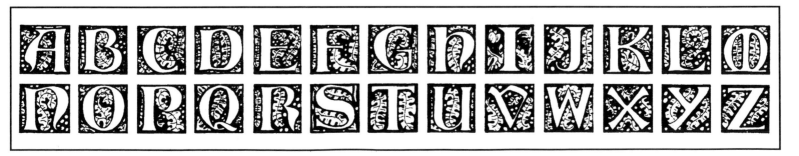

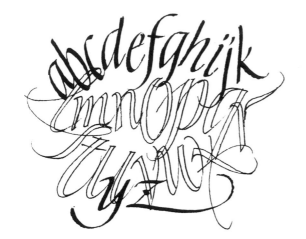

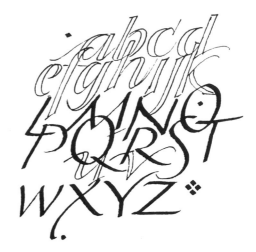

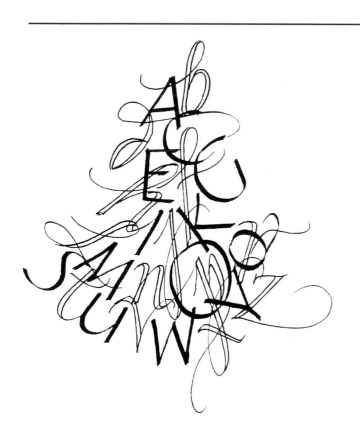

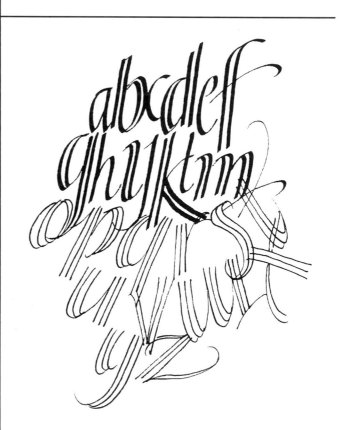

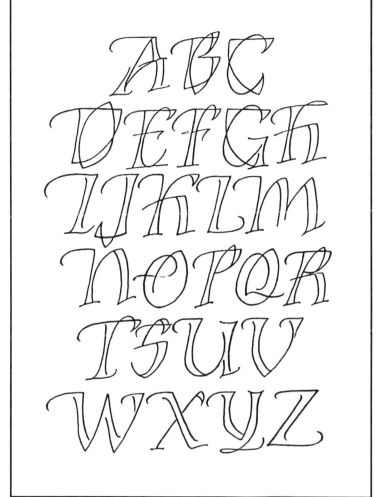

BETTY LOCKE. Detail of a series of eight alphabet explorations, all done within one hour. Brause nib and Pigma pen.

2, 4
VALERIE ELLIOTT. *ALPHABET EXPERIMENTS.* Steel nibs and ink.

3
RUTH BOOTH. *STYLIZED MODERN CAPS.* These are intended for use individually as eye catchers at the beginning of text, but are designed to have continuity as a family where a series of initial caps might be used (e.g., to mark the beginning of sections or chapters in a longer text). Colour or gold strokes could be added to these letters to further accent them or to tie in with other characteristics of a layout.

1

1
IVAN ANGELIC. Mars Graphic 3000 on coated stock.
2
HOLLY DEAN. *YSZ*
3
LINDLEY McDOUGALL. Poster title for exhibition of
artists' books. Notched nylon nib on Mayfair cover.
4
MARGARET LAMMERTS.

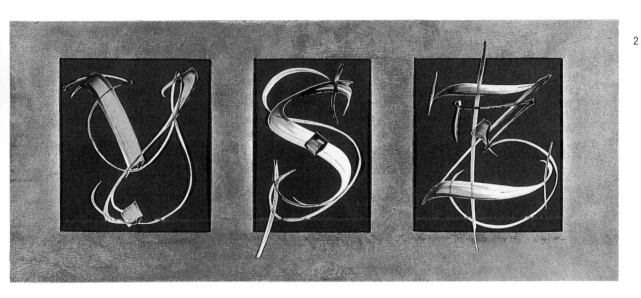

THE OPEN & CLOSED BOOK

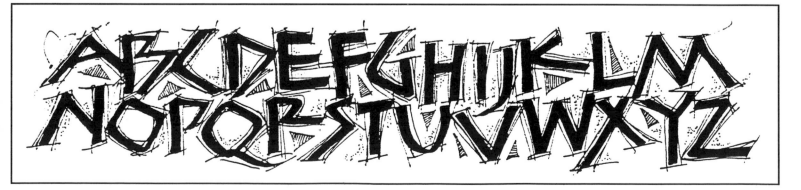

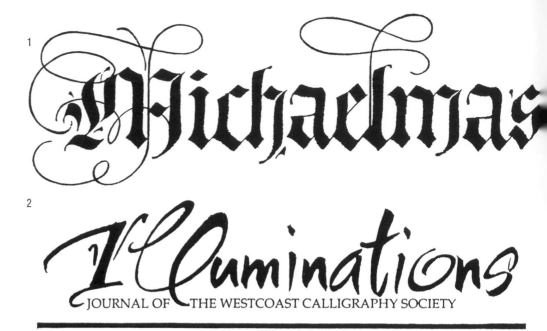

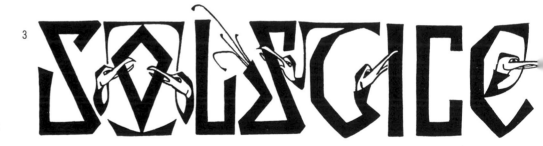

JOURNAL OF THE WESTCOAST CALLIGRAPHY SOCIETY

1
RENÉE ALEXANDER. *MICHAELMAS.* Broad-edged brush and gouache, small Mitchell nib and ink for flourishes.
2
RENÉE ALEXANDER. *ILLUMINATIONS* (masthead). Bamboo brush and Chinese ink.
3
ARLENE YAWORSKY. *SOLSTICE.*
4
LYNN SLEVINSKY. *SING* (detail of title and border). Black Canson paper, cut with an x-acto knife, mounted on 140 lb. Arches hot pressed paper. 59 cm wide.
5
LILY YEE. *TRI-STROKE ROMANS.* Pencil and Pigma pen on bond paper. Reverse print. 33 x 38 cm.

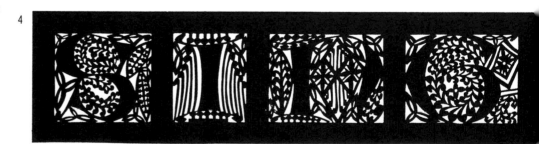

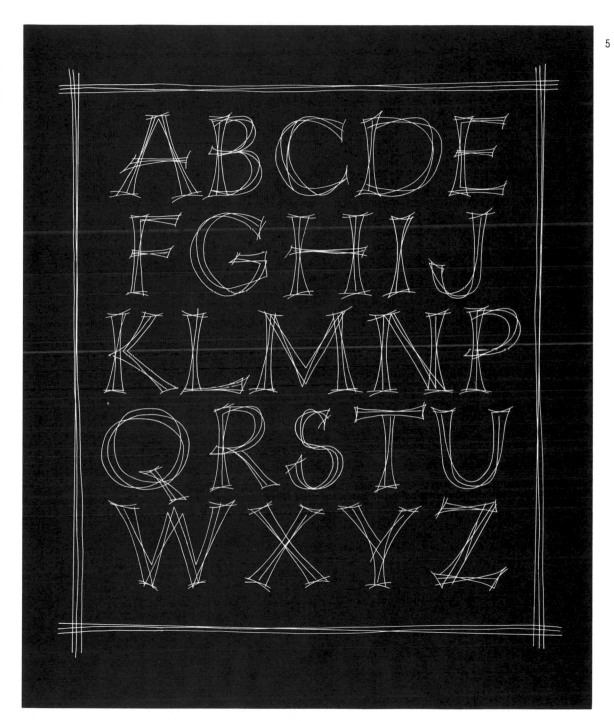

1

2

3

4

Just Right!

MERRY CHRISTMAS

1 WHAT IS IT?

alphabets

START

ALPHABET TO TRY

GET WELL SOON!

Goodbye!

GREETINGS

Bow Valley Calligraphy Guild
Bow Valley Calligraphy Guild

Merci

BEST WISHES

Newsletter

LOGO ASSEMBLAGE:
1 KIRSTEN HOREL. 2, 6, 7 SUZANNE CANNON. 3 MARK LURZ. 4, 8 IVAN ANGELIC. 5, 9, 10, 12 TRUDY NOVACK. 11 CHERRYL MOOTE.
13
JUDITH BAIN DAMPIER. Logo designed for the Fairbank Calligraphy Society, Victoria.
14
JUDITH BAIN DAMPIER. Logo designed for the Dawson Creek Art Society/Art Gallery. *This is used on invitations, brochures, certificates, etc. The gallery is housed in a converted grain elevator.*

4

Another Masterpiece

8

Jamboree

12

Papyrus d'Argent
calligraphie · cadeaux — cartes de souhaits · cadeaux

13

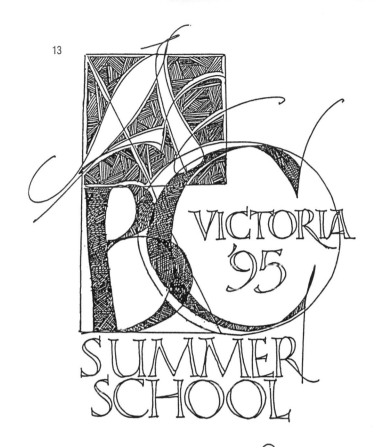
ABC VICTORIA '95 SUMMER SCHOOL

14

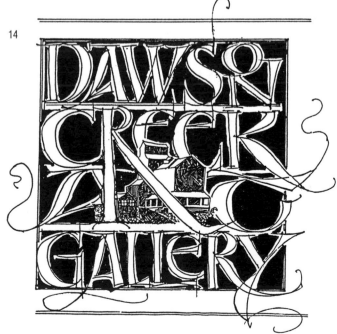
DAWSON CREEK B.C. GALLERY

FAIR DAYS

diet

Peace on Earth

FLASH AND DAZZLE

Ghost

CATHY AND GEORGE ARE TYING THE KNOT

Homeless

Halloween

Kiss High Prices Goodbye

Win Money and Prizes

Kids LUV Peace

You Won't Believe The Savings

Eye to Eye

Celebrate

SCREAM

Summer Sensations

Christmas Classics

HOLIDAY

RAZZ

Gracias

12

SANTA SAYS:

Lifes most treasured moments

Pasta à la Carte

Shopper Stoppers

LIFE STYLE

WOOD ROASTED

13

Hong Kong Bank Mutual Funds

BUY ONE GET ONE FREE

Christmas is Blooming at Crossroads

Building Our Strength ...Today!

Rites of Spring

Beauty Mark

Sandcastle CLUB

It's a Bargain

© IVAN ANGELIC 1996

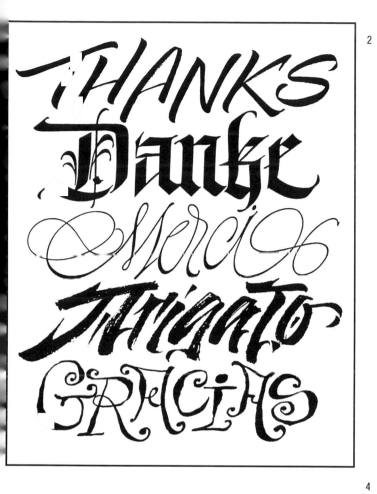

2

3

1
Ivan Angelic. Compilation of commercial lettering.
2
Ivan Angelic. Lettering for thank-you notes. Various tools on various papers.
3
Shannon Read. Logo for Kirby Chan Memorial Fund.
4
Mary Conley. *Heart to Heart Thanks*. Cover for calendar published in San Francisco.
5
Judith Jaimet Bainbridge. *CMD Monogram*. Pigma pens. 20 x 10 cm.

4

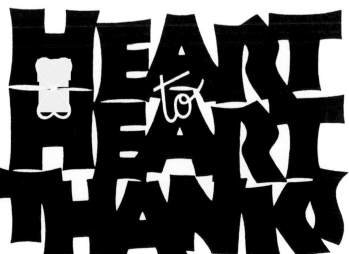

5

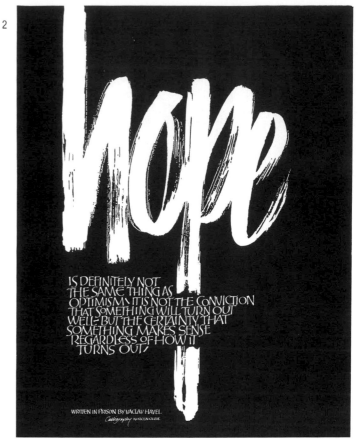

1

THANK YOU... (thank you repeated throughout design)

2

hope

IS DEFINITELY NOT
THE SAME THING AS
OPTIMISM: IT IS NOT THE CONVICTION
THAT SOMETHING WILL TURN OUT
WELL, BUT THE CERTAINTY THAT
SOMETHING MAKES SENSE
REGARDLESS OF HOW IT
TURNS OUT.

WRITTEN IN PRISON BY VACLAV HAVEL.
Calligraphy NANCEN OUZIE

3

HAL
LE
LU
JAH

(HALLELUJAH repeated throughout design)

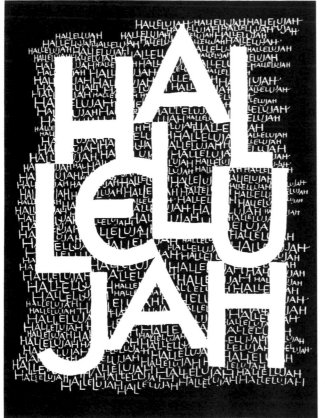

4

All hail to the days
That merit more praise
Than all the rest of the year
And welcome the nights
That double delights
As well for the poor as the peer

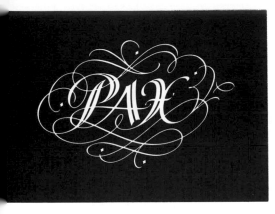

5

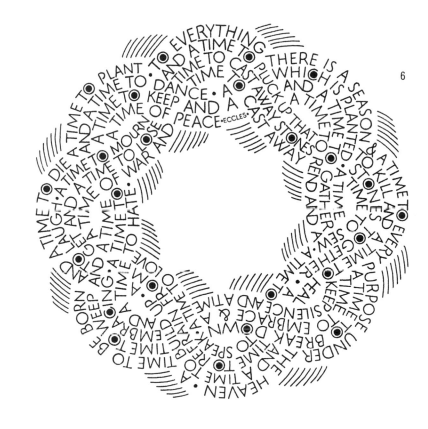

6

7

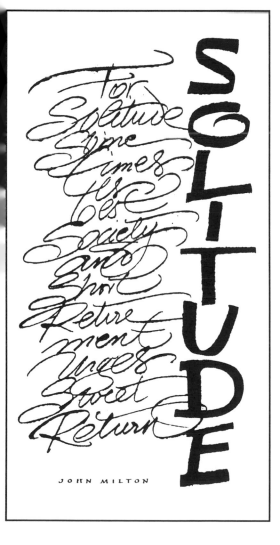

1
BETTY LOCKE. Thank-you card.

2
NOREEN GUZIE. *HOPE.* Brush, pen and sumi ink on Arches paper. Reverse print. Author: Vaclav Havel.

3
E. ANN BAILEY TRESIZE. *HALLELUJAH.* Christmas card.

4
RENÉE ALEXANDER. Christmas card. Mitchell nib and Chinese ink.

5
FRED SALMON. *PAX.* Drawn with pointed pen and ink. Reverse print.

6
MARY CONLEY. *TO EVERYTHING THERE IS A SEASON.* *This is a familiar quote from Ecclesiastes. It was designed to take the form of a Celtic knot. From a distance, it looks like a wreath of berries. The design was silkscreened in raised gold on a maroon background.*

7
TANJA BOLENZ. *SOLITUDE.* Ruling pen. 12 x 22 cm. Author: John Milton.

1

THE HUMAN SOUL
MANNSSÁLIN

The human soul
MANNLEG SÁL

is neither morn nor eve,
Á EI MORGUN NÉ KVÖLD,

nor beginning
UPPHAF NÉ

nor ending.
ENDI.

It is eternal,
HÚN ER EILÍF,

unbounded
ÓTAKMÖRKUÐ

as space itself
SEM ALGEIMSRÚMIÐ

neither guilty
HVORKI SAKLAUS

nor innocent,
NÉ SEK,

but is itself god.
HÚN ER SJÁLFUR GUÐ.

GUTTORMUR J. GUTTORMSSON
Translated by Paul A. Sigurdson · SW '95

2

A mighty fortress is our God, a bulwark never failing; our helper He amid the flood of mortal ills prevailing. For still our ancient foe doth seek to work us woe; his craft and power are great, and armed with cruel hate, on earth is not his equal. Did we in our own strength confide our striving would be losing, were not the right man on our side the man of God's own choosing. Dost ask who that may be? Christ Jesus it is he, Lord Sabaoth His name, from age to age the same, and he must win the battle. And though this world, with devils filled, should threaten to undo us, we will not fear, for God hath willed his truth to triumph through us. The prince of darkness grim—we tremble not for him; his rage we can endure, for lo! his doom is sure; one little word shall fell him. That word above all earthly powers—no thanks to them—abideth, the Spirit & the gifts are ours through him who with us sideth. Let goods & kindred go, this mortal life also; the body they may kill: God's truth abideth still, His Kingdom is forever.

3

OH THAT I WERE
WHERE I WOULD BE
THEN WOULD I BE
WHERE I AM NOT
BUT WHERE I AM
THERE I MUST BE
AND WHERE I WOULD BE
I CAN NOT

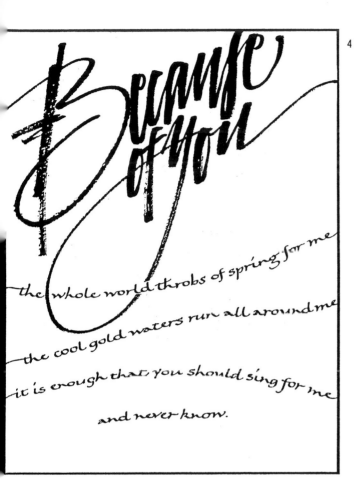

the whole world throbs of spring for me

the cool gold waters run all around me

it is enough that you should sing for me

and never know.

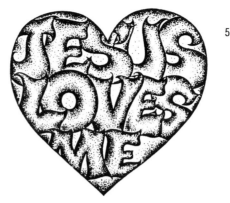

1
SUZZANN ANDERSON WRIGHT. *THE HUMAN SOUL/MANNSSÁLIN.* Author: Guttormur J. Guttormsson. *Ever since I was a young child, I have heard references to Guttormur Guttormsson's poetry. Despite being a third generation Icelandic-Canadian, I could not read my grandparents' mother tongue. I did not discover his poems until much later in life, when I read them in English translation.*

2
RONALD MARSHALL. *A MIGHTY FORTRESS.* Mitchell nib on Arches hot press watercolour paper. Author: Martin Luther, translated by Fredrick H. Hedge.

3
CAROL AYERS. Traditional nursery rhyme. Pen and ink.

4
GAIL STEVENS. Pointed brush and steel nib. Author: Roberta Barker.

5
KARLA CUMMINS. T-shirt design. *An idea in the back of my mind is to make this into a raised appliqué pillow.*

6
HOLLY DEAN. *AND IF OTHERS CAN SEE IT.* Author: William Morris.

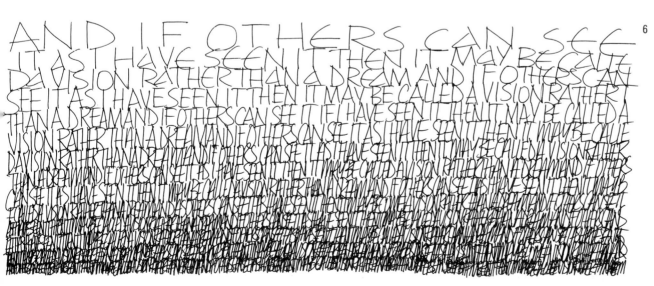

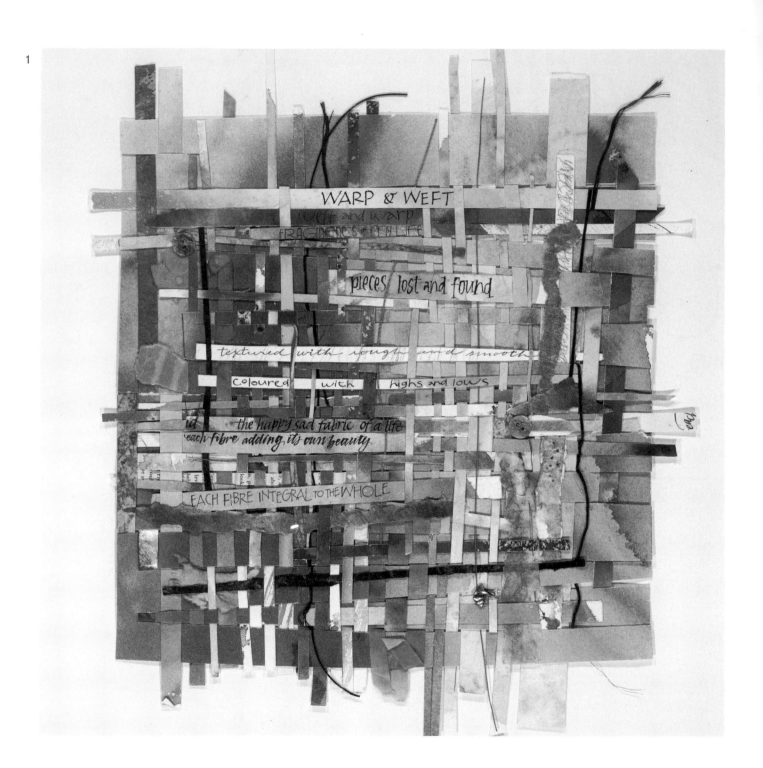

The woven artwork contains the following handwritten text:

WARP & WEFT
weft and warp
fragments of my life

pieces lost and found

textured with rough and smooth

coloured with highs and lows

the happy sad fabric of a life
each fibre adding its own beauty

EACH FIBRE INTEGRAL TO THE WHOLE

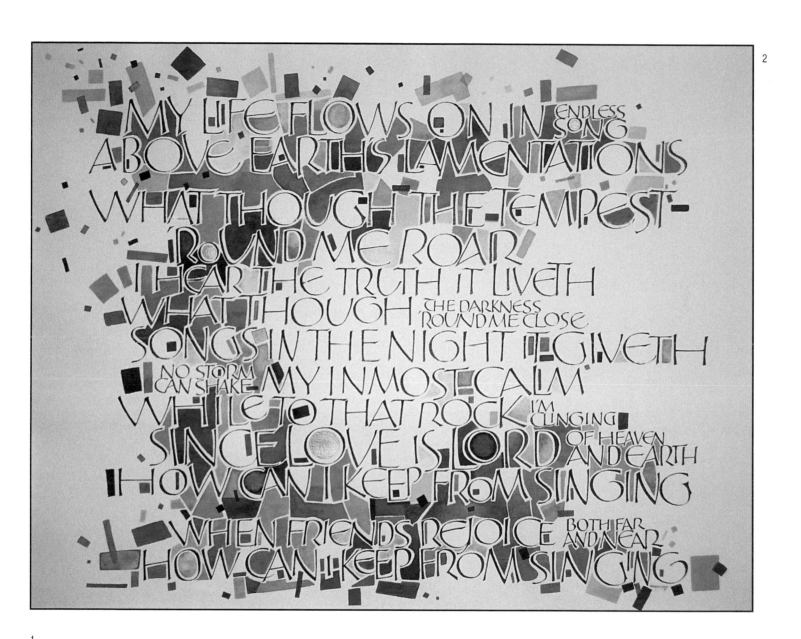

MY LIFE FLOWS ON IN ENDLESS SONG
ABOVE EARTHS LAMENTATIONS
WHAT THOUGH THE TEMPEST
ROUND ME ROAR
I HEAR THE TRUTH IT LIVETH
WHAT THOUGH THE DARKNESS
ROUND ME CLOSE
SONGS IN THE NIGHT IT GIVETH
NO STORM CAN SHAKE MY INMOST CALM
WHILE TO THAT ROCK I'M CLINGING
SINCE LOVE IS LORD OF HEAVEN AND EARTH
HOW CAN I KEEP FROM SINGING
WHEN FRIENDS REJOICE BOTH FAR AND NEAR
HOW CAN I KEEP FROM SINGING

1
LINDA PRUSSICK. *WORDWEAVE.* Mixed papers, thread and found objects. Artist's own words.
2
NOREEN GUZIE. *MY LIFE FLOWS ON IN ENDLESS SONG.* Quills, Higgins Eternal ink, gouache and watercolour on Arches paper. 60 x 44 cm. Traditional hymn.

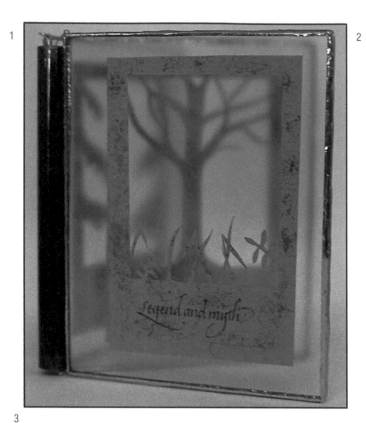

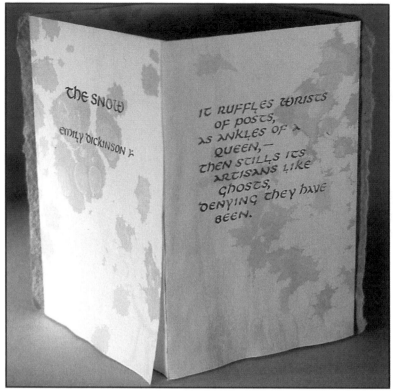

THE SNOW

EMILY DICKINSON Jr.

IT RUFFLES WRISTS
OF POSTS,
AS ANKLES OF A
QUEEN, —
THEN STILLS ITS
ARTISANS LIKE
GHOSTS,
DENYING THEY HAVE
BEEN.

IT SIFTS FROM
LEADEN SIEVES,
IT POWDERS ALL THE
WOOD,
IT FILLS WITH
ALABASTER WOOL
THE WRINKLES OF
THE ROAD.

IT MAKES AN EVEN
FACE
OF MOUNTAIN AND
OF PLAIN, —
UNBROKEN FOREHEAD
FROM THE EAST
UNTO THE EAST
AGAIN.

IT REACHES TO THE
FENCE,
IT WRAPS IT, RAIL BY
RAIL,
TILL IT IS LOST IN
FLEECES;
IT FLINGS A CRYSTAL
VEIL

ON STUMP AND STACK
AND STEM, —
THE SUMMER'S
EMPTY ROOM,
ACRES OF SEAMS
WHERE HARVESTS
WERE,
RECORDLESS, BUT
FOR THEM.

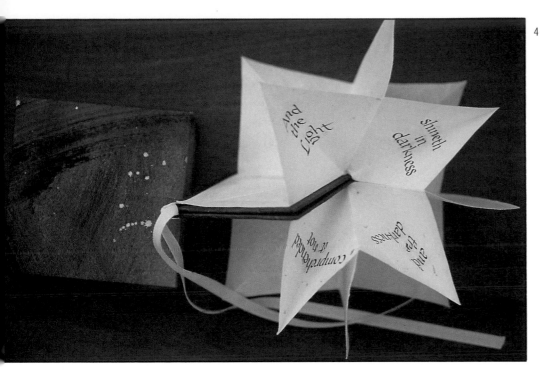

4

1
WENDY BUCKNER. *LEGEND AND MYTH: THE GLASS BOOK.* Glass, metal, cut paper. Author: Charles de Lint, *Spiritwalk.*

2, 3
SUSAN PINARD. *THE SNOW.* Watercolour on marbled Ingres paper and the artist's handmade paper. 10 x 13 cm. Author: Emily Dickinson.

4
AMANDA LEWIS. *STAR BOOK.* Gouache on Japanese paper. 16 x 16 x 9 cm. *Box.* Paste paper. 9 x 9 x 5 cm.

5
JUDITH JAIMET BAINBRIDGE. *RIGHTEOUSNESS: A CHINESE PROVERB.* Mitchell nibs, gouache on Lana laid paper, Japanese stencil paper over mat board. 9 x 13 cm.

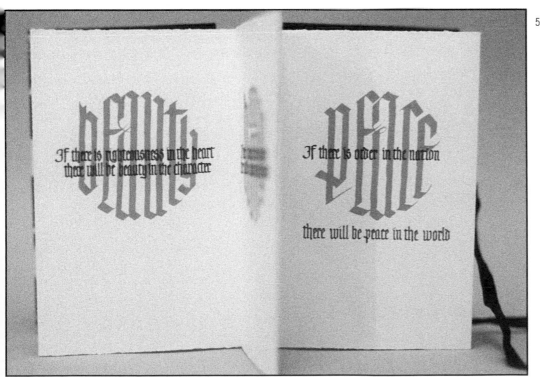

5

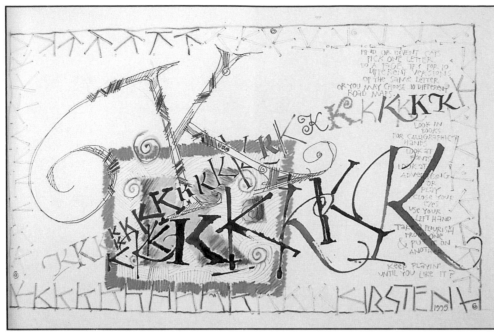

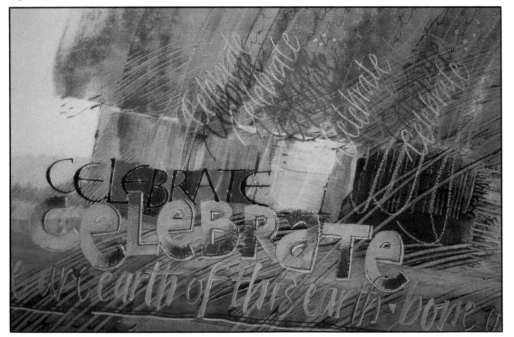

3

1, 2, 3
KIRSTEN HOREL. *TEXT AND TEXTURE BOUND.* Acrylic inks, coloured pencil, gouache, paste paper, graphite and ink on Arches Text Wove paper. 40 x 30 cm. *This book was created during a class I co-taught with Margaret Van Diest. The culmination of a series of assignments was to bind them together and make a unified book.*

4, 5
ROBERTA HUEBENER. *ODAWA BLUES 2.* Details of two page spreads. Acrylic paint, coloured pencil and Prismacolor Color Stix on black Canson paper. 26 x 9 cm.

6, 7
ROBERTA HUEBENER. *UNTITLED BOOK.* Inside front cover and inside back cover showing page details. Xerography and Color Tag foil on 100% rag tracing vellum. 22 x 28 cm.

8
ROBERTA HUEBENER. *ODAWA BLUES 1.* Detail of first page spread, showing overlapping fold-out pages. Paste paper, gouache and acrylic inks on Arches paper. 50 x 13 cm. *These books were produced as a result of a long-term project with Nancy Culmone and Paul Maurer. I developed several book formats for a chosen text, using a variety of calligraphic media. I used my own words, a series of five narrative poems that call up imagined spirits of Ottawa's past.*

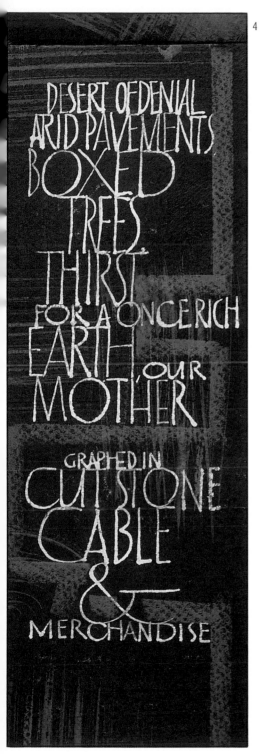

4

DESERT OF DENIAL
ARID PAVEMENTS
BOXED
TREES
THIRST
FOR A ONCE RICH
EARTH, OUR
MOTHER

GRAPHED IN
CUT STONE
CABLE
&
MERCHANDISE

5

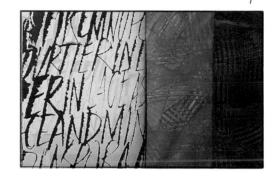

the vision sought

THE LOCKS THE BRIDGE NOT YET BUILT THE YOUNG
MEN HUNTING LOVE IN THE PARKS THE SKINHEADS
HUNTING THE BLOOD IN FACE THE FLAILING ARMS TIE
CRIES THE FALLING BODY SMASHED DOWN TO THE
ROCKS BELOW A GREAT LONG HOUSE OF STONE

6

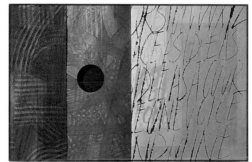

7

8

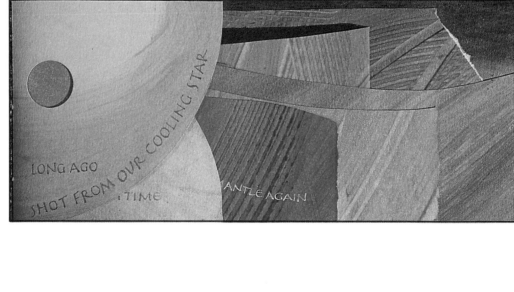

LONG AGO
SHOT FROM OUR COOLING STAR
TIME
MANTLE AGAIN

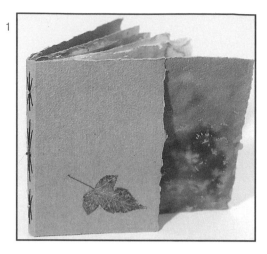

1

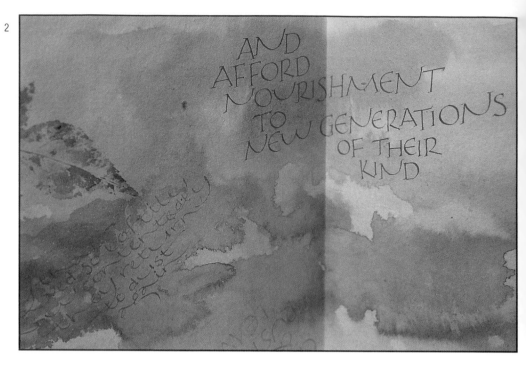

2

1,2
NICOLE GUYOT COULSON. *THOREAU'S AUTUMN*.
Watercolour and walnut ink on St. Armand handmade
papers. Author: Henry David Thoreau.

3
CONNIE FURGASON. *UNTITLED BOOK*. Bark paper and found
objects. Artist's own words.

4
LORRAINE DOUGLAS. *ALPHABET BUNDLE BOOK*. Painted and
cut paper.

5
LORRAINE DOUGLAS. *CHARLES*. Artist's own words. *This
is about my grandfather Charles Queau and the dish of
seashells from France that he kept in his living room.*

6
LORRAINE DOUGLAS. *PAUL KLEE BOOK*. Pointed pen, ink,
watercolour; gilding on gum ammoniac; Arches Text
Wove, Japanese paper interleaving, metallic cords and
thread. 33 x 25 cm. Artist's own words. *This is a
personal book about Paul Klee's life, works and thoughts
on art.*

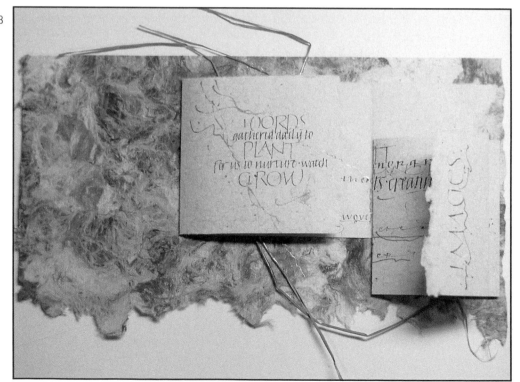

3

4

5

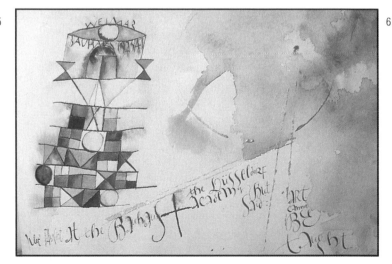

6

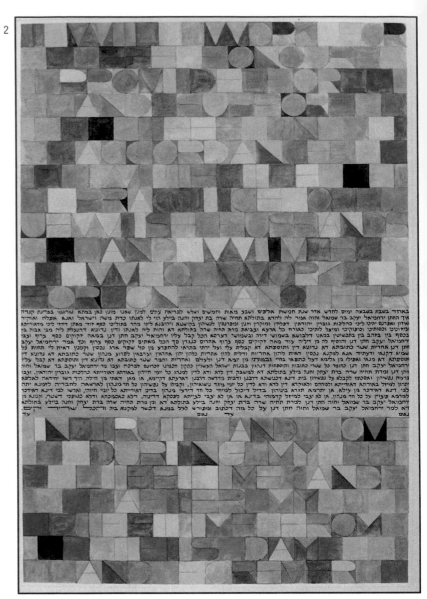

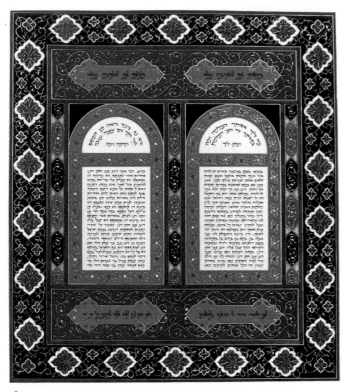

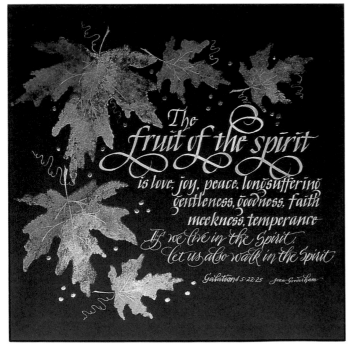

1
LAYA CRUST. *ARABESQUE*. Gouache, Pelikan ink, shell gold on Arches cold pressed watercolour paper. 50 x 55 cm.

2
LAYA CRUST. *GEOMETRIC*. Watercolour, pencil, Pelikan ink on Arches hot pressed watercolour paper. 43 x 65 cm.

3
JOAN GOODERHAM. *FRUIT OF THE SPIRIT*. Mitchell nibs, pointed pen, gouache, acrylic paint; gold leaf on gum ammoniac; Arches Text black. 45 x 45 cm. Text: Galatians 5:22-25.

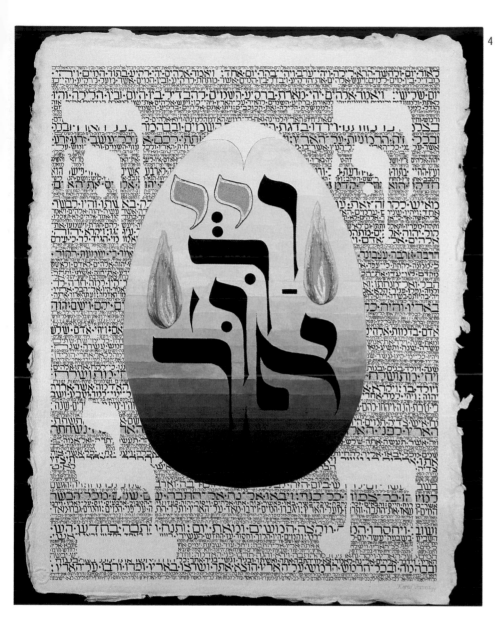

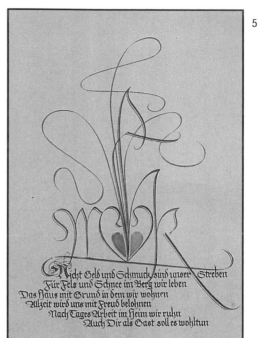

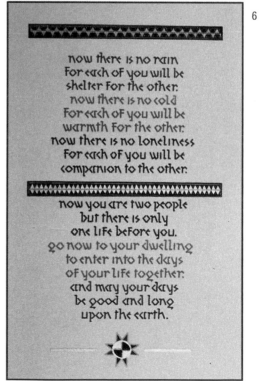

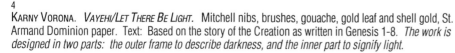

4
KARNY VORONA. *VAYEHI/LET THERE BE LIGHT.* Mitchell nibs, brushes, gouache, gold leaf and shell gold, St. Armand Dominion paper. Text: Based on the story of the Creation as written in Genesis 1-8. *The work is designed in two parts: the outer frame to describe darkness, and the inner part to signify light.*

5
MARK LURZ. *MONOGRAM, MRHL.* Steel nibs and quills on hand tinted Arches paper. *This was a wedding gift to my sister and her husband.*

6
BEVERLY BUNKER. *NOW THERE IS NO RAIN.* Gouache, shell gold, leaf gold, gum ammoniac, on Arches hot pressed watercolour paper.

153

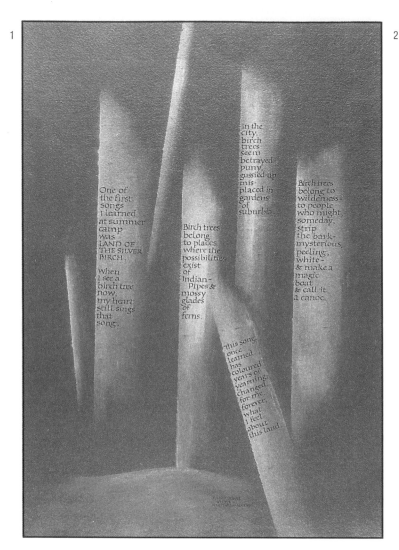

1

One of the first songs I learned at summer camp was LAND OF THE SILVER BIRCH.

When I see a birch tree now, my heart still sings that song.

Birch trees belong to places where the possibilities exist of Indian-Pipes & mossy glades of ferns.

In the city, birch trees seem betrayed puny, gussied-up mis-placed in gardens of suburbia.

Birch trees belong to wilderness-to people who might someday, strip the bark-mysterious peeling, white-& make a magic boat & call it a canoe.

this song once learned has coloured years of yearnings, changed for me, forever, what I feel about this land.

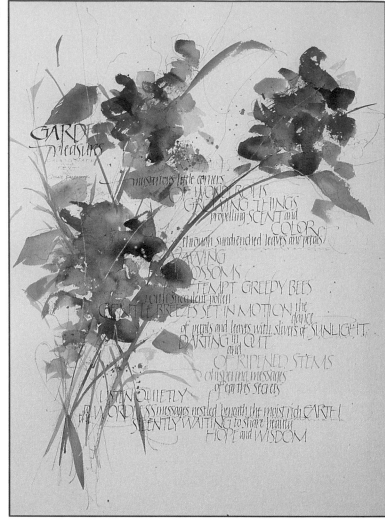

1
HEATHER MALLETT. *BIRCH TREES.* 36 x 57 cm. Artist's own words.

2
CONNIE FURGASON. *GARDEN PLEASURES.* Gouache, pencil on Arches cold pressed watercolour paper. 53 x 60 cm. Artist's own words.

3
KIRSTEN HOREL. *FIREFLIES.* Rotring ink, gouache, resist, graphite, coloured pencil on Arches Text Wove paper. 36 x 23 cm. Author: Margaret Holmes.

4
LINDA PRUSSICK. *AUGUST.* Rotring acrylic inks on hand-coloured Lana Papier Spéciale. Artist's own words.

154

FIREFLIES

With their little lights
THEY HERALD IN THE SUMMER NIGHTS
like diamonds twinkling in the grass
THEY HAVE DESCENDED TO EARTH AT LAST
and with their glowing light they sit as bait
TO CATCH A WANDERING MALE AS MATE

But if we continue to destroy God's gift
TO THE CHILDREN IT WILL BECOME A MYTH
For they would not know the joy they bring
THE GLOWING TAIL LIGHT BLINKING AS THEY WING
over the fields as they pass by

A LITTLE BUG KNOWN AS
THE FIREFLY

MARGARET ELSIE HOLMES JULY 1971 SPIRIT HOPE

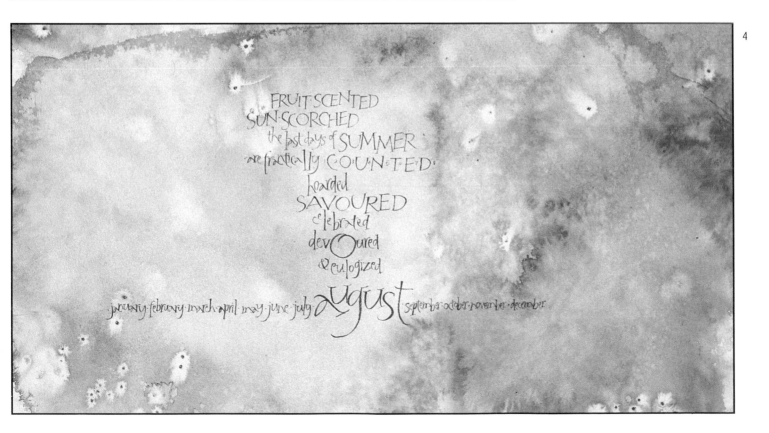

FRUIT·SCENTED
SUN·SCORCHED
the last days of SUMMER
are practically C·O·U·N·T·E·D
hoarded
SAVOURED
celebrated
devOured
eulogized

january·february·march·april·may·june·july AUGUST september·october·november·december

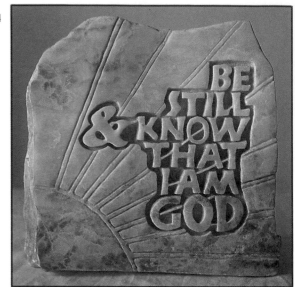

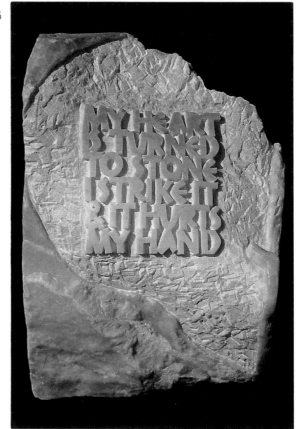

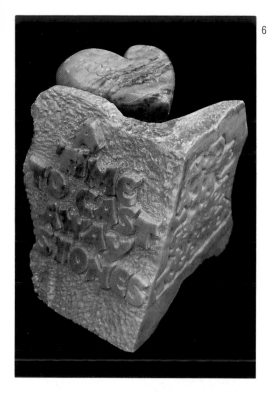

6

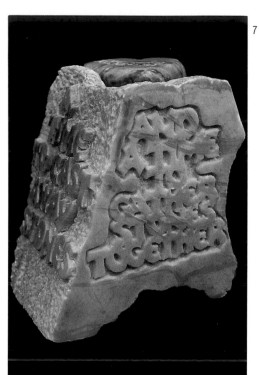

7

1, 2, 3
LAURIE E.R. BROADHURST. *CERAMIC BOX.* Hand-carved lettering stamps impressed into high-fire grey clay. 20 x 17 x 27 cm.

4
DIANNAH ELIZABETH BENSON. *BE STILL.* Carved alabaster. 22 x 24 x 12 cm. Text: Psalm 46.

5
LILY YEE. *MY HEART IS TURNED TO STONE.* Alabaster, carved with chisel, mallet, motorized hand-held tools, x-acto knives and dental tools. 22 x 28 x 12 cm. Author: William Shakespeare, *Othello. The natural shape of the stone lends itself to the text. Neuland letters emerge from the front face of the stone, where the outline of half a heart is defined. The right lateral face shows the outline of a flat hand; a carved thumb reaches around to touch the front face.*

6,7
SUSAN NELSON. *TOGETHER.* Power tools and x-acto knife, alabaster. 22 x 25 x 30 cm.

8
RUTH BOOTH. *THIS END/THAT END: BOOKENDS.* Dremmel tool and x-acto knives on alabaster. 11 x 17 x 11 cm.

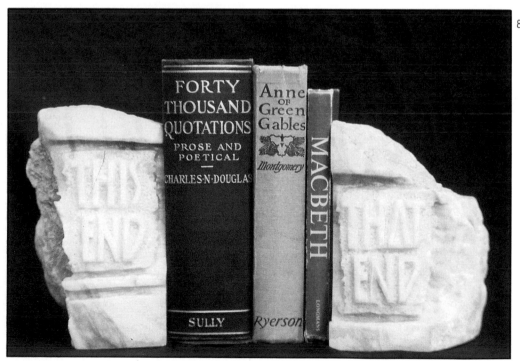

8

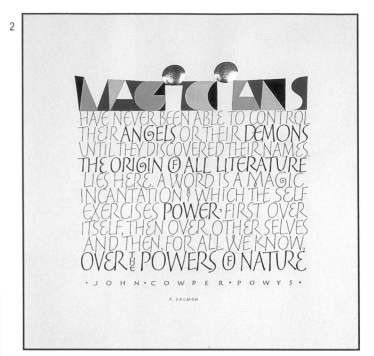

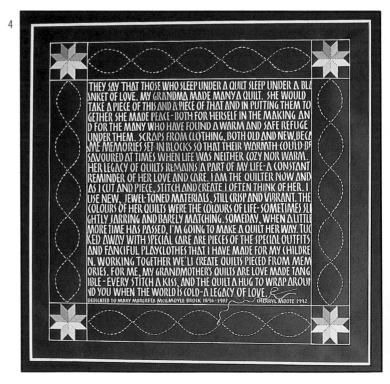

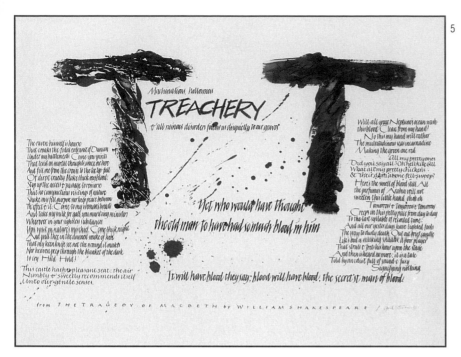

1
KATHIE MCILVRIDE. *I LOVE THESE LITTLE PEOPLE.* Rotring ink on watercolour paper.
Author: Charles Dickens.

2
FRED SALMON. *MAGICIANS.* Ink, gouache, xerography and Color Tag foils.
Author: John Cowper Powys.

3
MYKEN WOODS. *CONVERSATIONS WITH A FRIEND.* Mixed media. 90 x 76 cm.

4
CHERRYL MOOTE. *THOSE WHO SLEEP UNDER A QUILT.* Mitchell nibs, gouache on black Arches paper.
40 x 40 cm. Artist's own words. *One of my grandmother's quilting needles and a piece of thread are
framed into this piece. The quilt pattern in the Lemoyne Star.*

5
GAIL STEVENS. *TREACHERY.* Ink, gouache, monoprint on Saunders paper. 40 x 30 cm.
Author: William Shakespeare, *Macbeth* and *King Lear.*

6
BETTY LOCKE. *OUT, OUT DAMNED SPOT!* Graphite on paper. Author: William Shakespeare, *Macbeth.*

7
LEO W. DE WIT. *CANDLE IN THE DARK.* Ink and gouache. Author: Rolanda Kane.

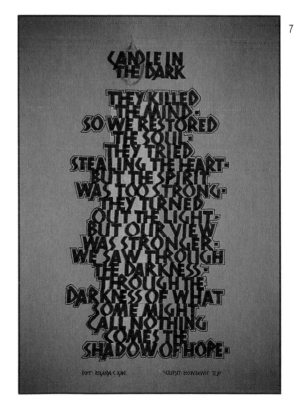

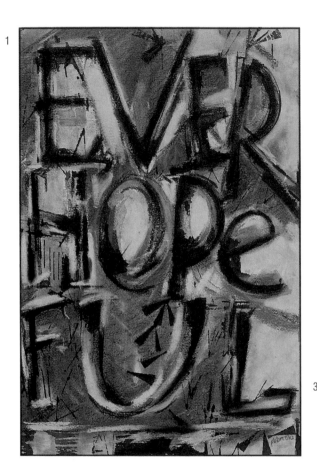

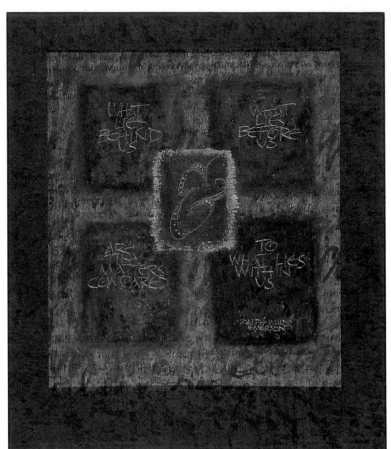

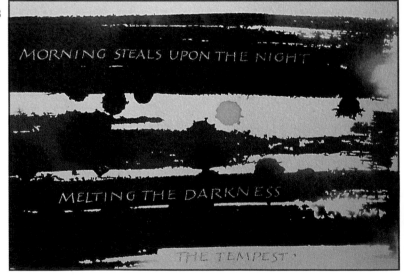

1
PAMELA BARLOW BROOKS. *EVER HOPEFUL.* Chalk pastel.
35 x 65 cm.

2
HOLLY DEAN. *WHAT LIES BEHIND US.* Nibs, ruling pen, sticks; ink,
oil pastels, acrylic paints, metallic gold, varnish. 28 x 33 cm.
Author: Ralph Waldo Emerson.

3
CAROL AYERS. *MORNING.* Dr. Martin's watercolours, gouache.
23 x 14 cm. Author: William Shakespeare, *The Tempest.*

4
TANJA BOLENZ. *NORWEGIAN FOLK TRADITION.* Manuscript book.
Steel nibs, gouache. Tissue paper overlay.

BIBLIOGRAPHY

This listing is a selection of the books and periodicals recommended by, or written by, contributors to *ABC Canada*.

Bantock, Nick. *Sabine's Notebook.* Raincoast Books, Vancouver, 1992.

Botts, Timothy. *Doorposts.* Tyndale House Publishers, Inc., Illinois, 1986.

Brown, Peter. *The Book of Kells.* Thames and Hudson, London, 1980.

Cameron, Julia. *The Artist's Way.* G.P. Putnam's Sons, 1992.

Camp, Ann. *Pen Lettering.* Taplinger Publishing Co., Inc., New York, 1984.

Catich, Edward M. *The Origin of the Serif: brush writing and Roman letters.* 2nd ed. Iowa, 1991.

Elliott, Valerie. *Val's "I Hate to Wait" Vegetarian Cookbook.* Valerie Elliott, Victoria, 1992. *Written entirely in calligraphy.*

Emery, Richard. *The Creative Stroke 2.* Rockport Publishers Inc., Massachusetts, 1994.

Fink, Joanne and Kastin, Judy (eds.). *The Speedball Textbook.* 22nd ed. Hunt Mfg. Co., North Carolina, 1991.

Fink, Joanne and Kastin, Judy. *Lettering Arts.* PBC International Inc., New York, 1993.

Folsom, Rose. *The Calligrapher's Dictionary.* Thames and Hudson Ltd., London, 1990.

Gilman, Karyn Lynn (ed.). *Letter Arts Review,* quarterly publication, Oklahoma, 1982-ongoing.

Gray, Nicolete. *Lettering as Drawing.* Taplinger Publishing Co., New York, 1982.

Guzie, Noreen Monroe and Guzie, Tad. *About Men and Women: how your masculine and feminine archetypes shape your destiny.* Paulist Press, New York, 1986. *Calligraphic illustrations for each chapter.*

Guzie, Noreen Monroe and Guzie, Tad. *Journey to Self-Awareness: a spiritual notebook for everyday life.* Paulist Press, New Jersey, 1994. *Calligraphic illustrations for each chapter.*

Hoefer, Karlgeorg. *Kalligraphie.* ECON Taschenbuch Verlag, Dusseldorf, 1986.

Johnston, Edward. *Writing & Illuminating & Lettering.* Taplinger Publishing Co., Inc., New York, 1983.

Knight, Stan. *Historical Scripts.* Taplinger Publishing Co., Inc., New York, 1986.

Lefler, Lynn. *Pieces of Me.* Lynn Lefler, Ontario, 1981.

Lewis, Amanda. *Writing: a fact and fun book.* Kids Can Press , Toronto, 1992.

Lewis, Amanda. *Lettering.* Kids Can Press, Toronto, 1996.

Locke, Betty. *Teach Calligraphy? Who? Me?* Betty J. Locke, Calgary, 1993.

Lueck, Mavis (ed.). *The Spirit of Calligraphy.* Bow Valley Calligraphy Guild, Calgary, 1994.

Midda, Sara. *In and Out of the Garden.* Workman Publishing Co. Inc., New York, 1981.

Neugebauer, Freidrich. *The Mystic Art of Written Forms.* Verlag Neugebauer Press, Salzburg, 1979.

Pearce, Charles. *The Anatomy of Letters.* Taplinger Publishing Co., Inc., New York, 1987.

Pearce, Charles. *The Little Manual of Calligraphy.* Taplinger Publishing Co., Inc., New York, 1981.

Pott, Gottfried. *Workshop Impression.* Die Kalligraphie Edition, Hardheim, 1989.

Svaren, Jacqueline. *Written Letters: 33 alphabets for calligraphers.* 2nd revised ed. Taplinger Publishing Co., Inc. New York, 1986.

4

GLOSSARY

Acrylic inks. Pigment suspended in synthetic resin emulsion. Waterproof when dry. Use with pen or brush.

Acrylic paints. As above, but thicker in consistency, cannot be used in pen.

Arches. Brand name. A wide range of high quality watercolour and text papers. Made in France.

Automatic pen. Large brass or nickel-plated nib with two blades. Ink flows through the gap between the blades.

Brause nib. Brand name. Rigid metal, with small reservoir flange attached to upper side.

Canson. Brand name. Paper available in a wide range of colours.

Chinese ink. General term for black inks from China. Available in liquid and stick form.

Cold pressed. A rough finish on watercolour paper.

Color Tag. Brand name. Heat sensitive foils and transfer colours that bond to photocopied images.

Copperplate nib. Fine pointed, flexible metal. Splits under pressured to allow line to swell.

Crowquill. Extra-fine flexible pointed nib. Requires a crowquill pen staff.

Gesso. A plaster-like preparation, used to seal a surface or lay a base for gold leaf.

Gold leaf. Thin sheet of gold, must be applied over a prepared base, such as gum ammoniac, gesso or acrylic medium.

Gouache. Opaque paint, mixed with water to desired consistency. Can be used with pen or brush.

Gum ammoniac. Sticky preparation used as a foundation for gold leaf.

Hot pressed. A smooth finish on watercolour paper.

Mitchell nib. Brand name. Flexible metal, small reservoir flange slips on to underside.

Monoline. Strokes of a uniform width, unlike marks made with the edged pen, which vary in thickness.

Paste paper. Paper decorated with coloured paste. Can be made with a base of prepared wheat, rice or other starch, or with methyl cellulose.

Pentel Color Brush. Brand name. Pointed tip, synthetic bristles, ink supplied in detachable barrel.

Pigma pen. Brand name. Fibre-tipped monoline pen, available in small sizes, which give a very fine line.

Reverse print. A photographically reversed image in which black becomes white and vice versa.

Roma. Brand name. Paper available in several colours, has a gritty texture. Made in Italy.

Rotring ink. Brand name. Acrylic ink, comes in intense colours, translucent or opaque.

Ruling pen. Originally designed to draw lines of a consistent width, can be used as a writing tool. Calligraphic ruling pens have a larger head and smoother finish than those intended for drafting.

Ruling Writer. Brand name. A calligraphic ruling pen, as described above.

Saunders. Brand name. A range of watercolour and printmaking papers. Made in England.

Shell gold. Fine powdered gold mixed with binder, can be applied like gouache.

Signature gold. Metallic foil, pressure-sensitive transfer.

St. Armand. Brand name. Handmade paper available in a wide range of colours and textures. Made in Canada.

Sumi ink. General term for black, glossy inks from Japan.

Technical pen. Hollow tubular metal tip makes lines of uniform width.

Techniquill. Brand name. Large brass pen with folded, slotted tip.

Watercolour. Translucent paint, mixed with water to desired consistency. Use with pen or brush.

Watercolour pencils. Coloured pencils with water-soluble medium. Can be wetted and blended after application.

X-acto knife. Brand name. Cutting tool with scalpel-type replaceable blades.

Xerography. Dry toner photocopy process.

1

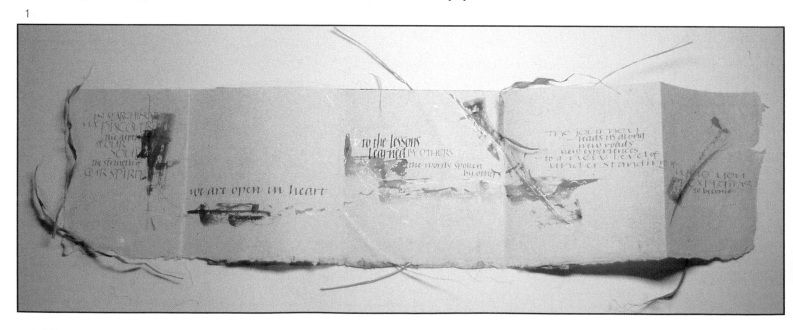

CANADIAN CALLIGRAPHY SOCIETIES

These organizations have been established primarily to promote interest in calligraphy. Some groups offer classes and workshops, and most publish a regular newsletter. The use of the word "Guild" does not imply any qualification required for membership: all of these groups operate as volunteer societies and welcome inquiries from anyone interested in studying or supporting calligraphy.

BRITISH COLUMBIA:

Alpha-Beas Calligraphy Guild
c/o 20025 - 36th Avenue
Langley, British Columbia V3R 2R5

Fairbank Calligraphy Society
Box 5458
Victoria, British Columbia V8R 6S4

Kamloops Calligraphy
1613 Sheridan Drive
Kamloops, British Columbia V2B 6B1

Kelowna Calligraphers Guild
233 Dalgliesh Court
Kelowna, British Columbia V1X 7A4

Northern Scribes
RR #3, Site 31, Comp. 10
Prince George, British Columbia V2N 2J1

Westcoast Calligraphy Society
Box 18150, 2225 West 41st Avenue
Vancouver, British Columbia V6M 4L3

Warmland Calligraphers
 of the Cowichan Valley
6103 Everest Way, RR #5
Duncan, British Columbia V9L 4T6

ALBERTA:

Bow Valley Calligraphy Guild
Box 1647, Station M
Calgary, Alberta T2P 2L7

Chinook Calligraphy Guild
c/o Box 77
Purple Springs, Alberta T0K 1X0

Edmonton Calligraphic Society
9768 - 170th Street
Edmonton, Alberta T5T 5L4

Lettering Arts Guild
Box 242
Red Deer, Alberta T4N 5E8

Northern Lights Calligraphers
186 Wolverine Drive
Fort McMurray, Alberta T9H 4L7

Pen Dancers Calligraphy Society
59 Rossdale Way S.E.
Medicine Hat, Alberta T1B 1X5

SASKATCHEWAN:

Regina Calligraphy Society
Box 801
Regina, Saskatchewan S4P 3A8

Saskatoon Lettering Artists
1505 Park Avenue
Saskatoon, Saskatchewan S7H 2N9

Wheatland Calligraphy Guild
Box 3845
Melfort, Saskatchewan S0E 1A0

Paper Arts & Calligraphy Guild
c/o 3111 Dunn Drive
Prince Albert, Saskatchewan S6V 6Y6

MANITOBA:

Calligraphers Guild of Manitoba
c/o 381 Oakwood Avenue
Winnipeg, Manitoba R3L 1E9

3 C's Group
19 Hazelwood Crescent
Brandon, Manitoba R7A 2J8

ONTARIO:

Calligraphic Arts Guild of Toronto
Box 115, Willowdale, Station A
North York, Ontario M2N 5S7

Calligraphy Society of Ottawa
Box 4265, Station E
Ottawa, Ontario K1S 5B3

Hamilton Calligraphy Guild
Box 57144, Jackson Station
2 King Street West
Hamilton, Ontario L8P 4W9

Niagara Calligraphy Guild
62 Royal Manor Drive
St. Catharines, Ontario L2M 4L6

Royal City Calligraphy Guild
c/o 31 Whispering Ridge Drive
Guelph, Ontario N1G 3Z3

Quetico Quills
590 Beverly Street, #504
Thunder Bay, Ontario P7B 6H1

St. Clair Society of Scribes
RR #2
Harrow, Ontario N2R 1G0

QUEBEC:

La Société des Calligraphes
Box 704, Snowdon Station
Montreal, Quebec H3X 3X8

South Shore Calligraphy Group
1865 St-Laurent
St-Bruno, Quebec J3V 4Z2

NEWFOUNDLAND:

Newfoundland Calligraphers Guild
Site J, Box 5
Portugal Cove, Newfoundland A0A 3K0

Please advise Arbor Studio Press of any changes of address.

1. CONNIE FURGASON. *UNTITLED BOOK.*

2. CHERRYL MOOTE. *FROM GHOULIES & GHOSTIES.* Copperplate nib, drinking straw, ink, gouache. 23 x 22 cm. Traditional Cornish saying.

3. FRED SALMON. *FCS LOGO.* Drawn with pointed pen.

4. VALERIE ELLIOTT. *THE RULE OF ST. BENEDICT.* Gouache, ink. 30 x 40 cm.

2

From ghoulies & ghosties and long leggity beasties & things that go bump in the night, Good Lord, deliver us.

4

SAINT BENEDICT ON HOSPITALITY

IF any pilgrim monk come from distant parts, with wish as a guest to dwell in this monastery, and will be content with the customs which he finds in the place, & does not perchance by his lavishness disturb the monastery, but is simply content with what he finds, he shall be received for so long as he desires. If, indeed, he find fault with anything, or expose it, reasonably, and with the humility of charity, the Abbot shall discuss it prudently lest perchance God had sent him for this very thing. But, if he have been found gossipy or contumacious in the time of his sojourn as guest, not only ought he not be joined to the body of the monastery, but also, it shall be said to him, honestly, that he must depart. —V. Elliott 1987

IF he does not go, let two stout monks, in the name of God, explain the matter to him.

CONTRIBUTORS' DIRECTORY

Irene Alexander
1014 West Keith Road
North Vancouver, B.C. V7P 3C6

Renée Alexander
2747 Crescentview Drive
North Vancouver, B.C. V7R 2V2

Bev Allen
20025 - 36 Avenue
Langley, British Columbia V3A 2R5

Ivan Angelic
1675 Martin Drive, #317
White Rock, British Columbia V4A 6E2

Carol Ayers
47 Cherrywood Avenue
Toronto, Ontario M6C 2X4

Sheona Ayles
489 Mountain Street
Hinton, Alberta T7V 1J9

Jo Baarschers
590 Beverly Street, #504
Thunder Bay, Ontario P7B 6H1

Judith Jaimet Bainbridge
180 Holmwood Avenue
Ottawa, Ontario K1S 2P4

Diannah Elizabeth Benson
Box 416
Bracebridge, Ontario P1L 1T7

Lynda Boesenkool
131 Lake Wasa Place S.E.
Calgary, Alberta T2J 3N5

Tanja Bolenz
12 West 10th Avenue, #5
Vancouver, British Columbia V5Y 1R6

Ruth Booth
3607 Flamewood Drive
Mississauga, Ontario L4Y 3P2

Francie Alberts Bredeson
5518 - 46 Avenue
Wetaskiwin, Alberta T9A 0H9

Laurie E.R. Broadhurst
955 Ballenas Road
Parksville, British Columbia V9P 1T4

Pamela Barlow Brooks
R.R. #1
Pender Island, B.C. V0N 2M0

Kelly Brown
333 - 6th Avenue N.E., #10
Calgary, Alberta T2E 0M1

Wendy Buckner
123 Spruce Street
Ottawa, Ontario K1R 6P1

Beverly Bunker
36 Milburn Crescent
St. Albert, Alberta T8N 1X8

Suzanne Cannon
13775 - 102 Avenue, #17
Surrey, British Columbia V3T 1N9

Margaret Challenger
4 Chandler Drive
Scarborough, Ontario M1G 1Z2

Mary Conley
1900 Richmond Avenue, #220
Victoria, British Columbia V8R 4R2

Nicole Guyot Coulson
53 Hill Street
Winnipeg, Manitoba R2H 2L1

Laya Crust
27 Lyonsgate Drive
Downsview, Ontario M3H 1C7

Karla Cummins
13755 - 102 Avenue, #7
Surrey, British Columbia V3T 1N9

Judith Bain Dampier
921 - 90th Avenue
Dawson Creek, B.C. V1G 1A3

Holly Dean
Box 574, 606 Elgin Street
Rosebud Cottage
Merrickville, Ontario K0G 1N0

Cristiane Deslauriers
463 Brittany Drive
Ottawa, Ontario K1K 0S1

Leo W. de Wit
18 Kingswood Drive
Hammonds Plains, Nova Scotia B4B 1J8

Beany Dootjes
Site 5, Box 4, R.R. #1
Niton Junction, Alberta T0E 1S0

Lorraine Douglas
381 Oakwood Avenue
Winnipeg, Manitoba R3L 1E9

Patricia C. Duke
8501 Bayview Avenue, #1204
Richmond Hill, Ontario L4B 3J7

Yannick Durand
4675 Mentana
Montreal, Quebec H2J 3B7

Valerie Elliott
c/o Judy Windle-Newby
1513 Charlton
Victoria, British Columbia V8X 3X1

Nancy Ellis
994 Harkness Avenue
Ottawa, Ontario K1V 6P2

Edith Engelberg
5531 Rosedale Avenue
Côte St. Luc, Quebec H4V 2J2

Kathy Feig
980 White Road
Hemmingford, Quebec J0L 1H0

Jean-Luc Ferret
1450 rue Ste-Irénée
Chicoutimi, Quebec G7H 4L1

Cynthia Foreman
33 Robinson Street, #303
Hamilton, Ontario L8P 1Y8

Connie Furgason
5105 - 24 Avenue South
Lethbridge, Alberta T1K 7C2

Rosemarie Gidvani
60 Ferguson Place
Brampton, Ontario L6Y 2S9

Joan Gooderham
Box 847
Ridgeway, Ontario L0S 1N0

Kathy Guthrie
1060 Losana Place
Brentwood Bay, B.C. V8M 1A3

Noreen Guzie
5267 Dalcroft Crescent N.W.
Calgary, Alberta T3A 1N6

Diana Haines
20715 - 39th Avenue
Langley, British Columbia V3A 2V7

Kirsten Horel
4915 Benson Road N.W.
Calgary, Alberta T2L 1R9

Roberta Huebener
44 Ralph Street
Ottawa, Ontario K1S 4A5

Marjorie Hughes
221 Ellerdale Street, #415
Saint John, New Brunswick E2J 3S4

Martin Jackson
2065 Creelman Avenue
Vancouver, British Columbia V6J 1C2

Inge Kern
Box 236
Maitland, Ontario K0E 1P0

Kristina Komendant
Box 306
Blaine Lake, Saskatchewan S0J 0J0

Margaret Lammerts
Box 127
Tofield, Alberta T0B 4J0

Tyler Lane
412 - 2nd Street N.E.
Calgary, Alberta T2E 3E7

Lynn Holliwell Lefler
30 Vasselle Crescent
Unionville, Ontario L3R 9P3

Amanda Lewis
R.R. #4
Perth, Ontario K7H 3C6

Betty Locke
6103 Everest Way, R.R. #5
Duncan, British Columbia V9L 4T6

Mavis Lueck
107 Harvest Glen Rise N.E.
Calgary, Alberta T3K 4C1

Mark Lurz
21 Birchview Crescent
Bolton, Ontario L7E 3W9

Gaye Mackie
130 Hendon Drive N.W.
Calgary, Alberta T2K 1Z1

M. Joyce Mackinnon
11 Norma's Avenue
Mount Pearl, Newfoundland A1N 1C3

Heather Mallett
453 Briar Avenue
Ottawa, Ontario K1H 5H5

Ronald Marshall
196 Hatt Street
Dundas, Ontario L9H 5G3

Lindley McDougall
1132 Lake Wapta Way S.E.
Calgary, Alberta T2J 2N7

Kathie Mcilvride
1166 - West 6th Avenue, #208
Vancouver, British Columbia V6H 1A4

Christine Mitchell
3623 - 118 Street
Edmonton, Alberta T6J 1W6

Cherryl Moote
128 Cassandra Boulevard
North York, Ontario M3A 1S9

Ginette Morin
1650 Lakeview
St-Bruno, Quebec J3V 4C2

Elaine L. Muth
1245 Avenue K South
Saskatoon, Saskatchewan S7M 2G6

Jacquie Myers
233 Dalgliesh Court
Kelowna, British Columbia V1X 7A4

Susan Nelson
33 Walnut Drive
Guelph, Ontario N1E 4B4

Trudy Novack
4656 Coolbrook Avenue
Montreal, Quebec H3X 2K6

Wendy Paterson
1505 Park Avenue
Saskatoon, Saskatchewan S7H 2N9

Susan D. Pinard
1995 Garfield Avenue
Ottawa, Ontario K2C 0W7

Elyse Proulx
240 Rte. Marie-Victorin
Nicolet-sud, Quebec J3T 1T5

Linda Prussick
235 Baythorn Drive, #310
Thornhill, Ontario L3T 3V6

Shannon Read
126 Shandwick Street
Sydney, Nova Scotia B1P 4V6

Cindy Romo
712 - 4th Street East
Saskatoon, Saskatchewan S7H 1K2

Fred Salmon
80 Howe Street
Victoria, British Columbia V8V 4K3

Luc Saucier
4210 Grand-Blvd.
Montreal, Quebec H4B 2X6

Lynn Slevinsky
38 Strathroy Bay S.W.
Calgary, Alberta T3H 1J9

Sandy Sommerfeld
1851 Millard Court West
Kelowna, British Columbia V1V 1R2

Gail Stevens
2703 - 8th Street S.W.
Calgary, Alberta T2T 3A5

Cheryl Tasaka
5030 Crescent Place
Delta, British Columbia V4K 4V1

E. Ann Bailey Tresize
1970 Fairfield Place
Victoria, British Columbia V8S 4J4

Margaret Van Diest
212 Douglas Woods Court S.E.
Calgary, Alberta T2Z 1M1

Dirk Van Wyk
2122 Broadview Road N.W.
Calgary, Alberta T2N 3H9

Karny Vorona
27 Chieftain Crescent
North York, Ontario M2L 2H3

Ruth Stern Warzecha
19 Robingrove Road
North York, Ontario M2R 2Z6

Jean Wegerhoff
627 Ranch Estates Place N.W.
Calgary, Alberta T3G 1M2

Sarah Widdowson
1619 - 7A Street N.W.
Calgary, Alberta T2M 3K2

Myken Woods
6724 Legare Drive S.W.
Calgary, Alberta T3E 6H2

Renate Worthington
99 Westover Drive S.W.
Calgary, Alberta T3C 2S7

Suzzann Anderson Wright
2412 Iris Street
Ottawa, Ontario K2C 1C6

Arlene Yaworsky
646 Simcoe Street, #1
Victoria, British Columbia V8V 1M5

Lily Yee
1455 Lawrence Avenue West, #503
Toronto, Ontario M6L 1B1

Marion Zimmer
687 Grosvenor Avenue
Montreal, Quebec H3Y 2T1

CREDITS

The information below has been provided by the contributing artists. While the author and the publishers believe that this listing is correct and complete, we cannot be responsible for inaccuracies.

Photo credits: 4, 158, Michael Hemming. 18.1, 24.2, Lawrence McGillvery. 18.3, Dale Wilson. 19.4, 108, 154.2, Colleen Nagel. 42, Sylvia Skelton. 47, John Stockwell. 64, Larry Thompson. 71, Peggy Jacobson. 74, Stan Jones. 102, Stewart Marsden. 109, Marcel Juteau. 146, 149, Wendy Buckner. 159.7, Margot Campbell.

Author credits: 142.1, The Human Soul/Mannssálin, from *Aurora,* Guttormur J. Guttormsson. Used by permission of Helen Alda Ireland, publisher. 155.3, Fireflies, Margaret Holmes. Used by permission of the author. 159.7, Candle in the Dark, Rolanda Kane. Used by permission of the author.

CALL FOR ENTRIES

Arbor Studio Press is planning future editions of *ABC Canada.* Our goal is to continue to document the development of calligraphy in Canada, and to introduce the Canadian lettering artists to readers everywhere.

Contributors must be residents of Canada, or Canadian citizens living temporarily outside the country. A Call for Entries, detailing complete submission requirements, will be issued in early 1998.

Other contributory collections, open to all calligraphers, will also be compiled from time to time. To receive information about current projects, please send a stamped, self-addressed envelope to the address below.

ORDERING INFORMATION

ABC Canada: the first Canadian collection of contemporary calligraphy is available through Arbor Studio Press.

Please send cheque or money order to the address below. $38.95 per copy, plus $5 shipping & handling for the first book, $2 for each additional book to the same address. Canadian residents, please add 7% GST. U.S. and overseas orders are payable in U.S. funds (no GST).

Discounts are available to book sellers and distributors, and to calligraphy societies or groups ordering six or more copies.

Arbor Studio Press Ltd.
Box 81091, Lake Bonavista Promenade
Calgary, Alberta, Canada T2J 7C9

(403) 271-1731 FAX (403) 278-4327

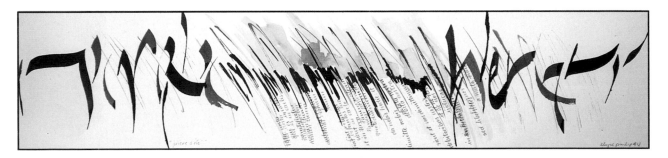

ELYSE PROULX. *PRIÈRE D'ÉTÉ/SUMMER PRAYER.* Watercolour, walnut ink, 2B graphite.

INDEX

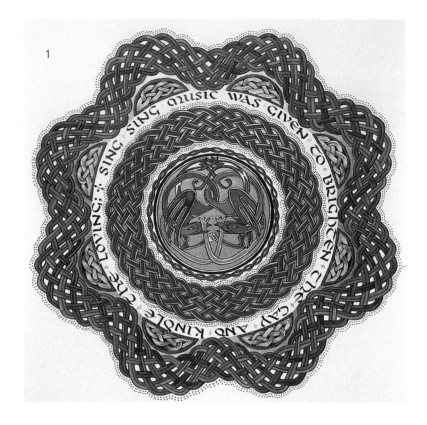

1

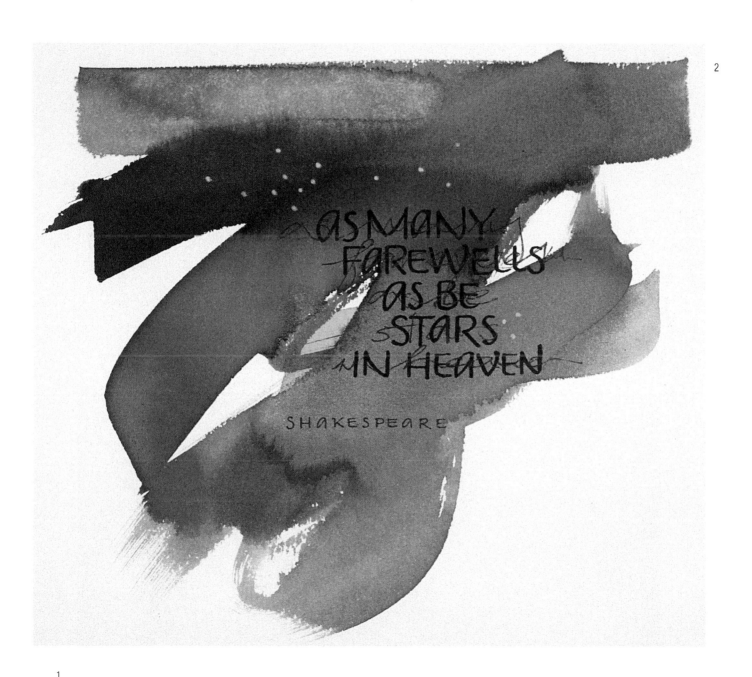

AS MANY
FAREWELLS
AS BE
STARS
IN HEAVEN

SHAKESPEARE

1
LYNN SLEVINSKY. *CELTIC BIRDS.* Steel nibs, sumi ink, Rotring ink, coloured pencils and watercolour on Arches hot pressed paper. 47 cm diameter.

2
LYNDA BOESENKOOL. *AS MANY FAREWELLS.* Watercolour and ink. 17 x 15 cm. Author: William Shakespeare.

COLOPHON

Page layout was input by Patti Duddridge Riegert on Microsoft ® Publisher and output at 1200 dpi at By Design Services, Calgary.

Fonts: Switzerland Condensed Light, Switzerland Condensed, Times New Roman.

Laser-scanned halftones by Precision Colour Imaging Ltd., Calgary. Colour separations by Friesens Corporation.

Text stock: 70 lb. Patina Matte.

Two thousand five hundred copies were printed and bound at Friesens Corporation, Altona, Manitoba.

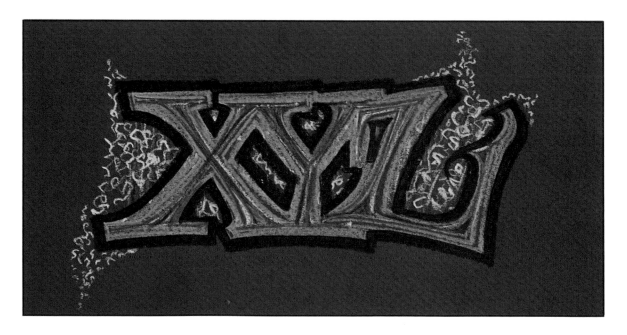

LYNN HOLLIWELL LEFLER. *XYZ.* Coloured pencil on Canson paper. 21 x 11 cm.

ABCDEFGHIJK Lmnopqrstuvwxyz
abcdefghijk lmnopqrstuvwxyz